Catherine Lee

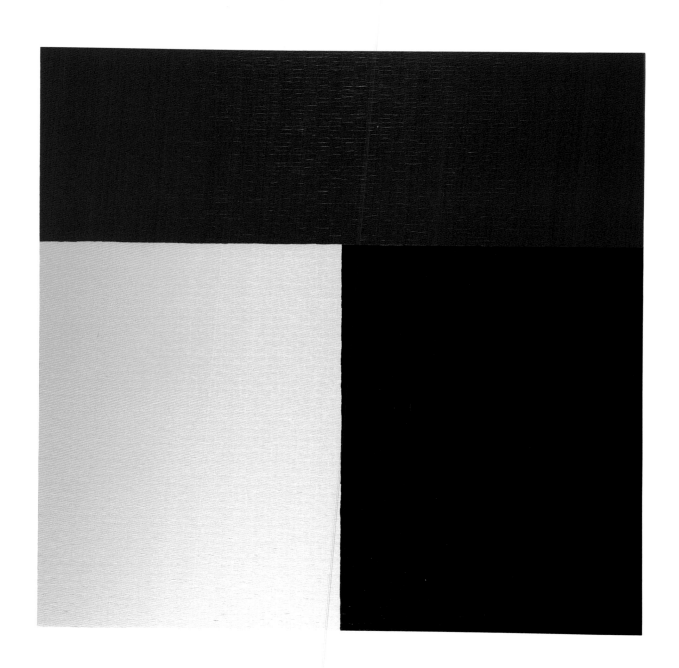

Catherine Lee

CHARTA

Irish Museum of Modern Art

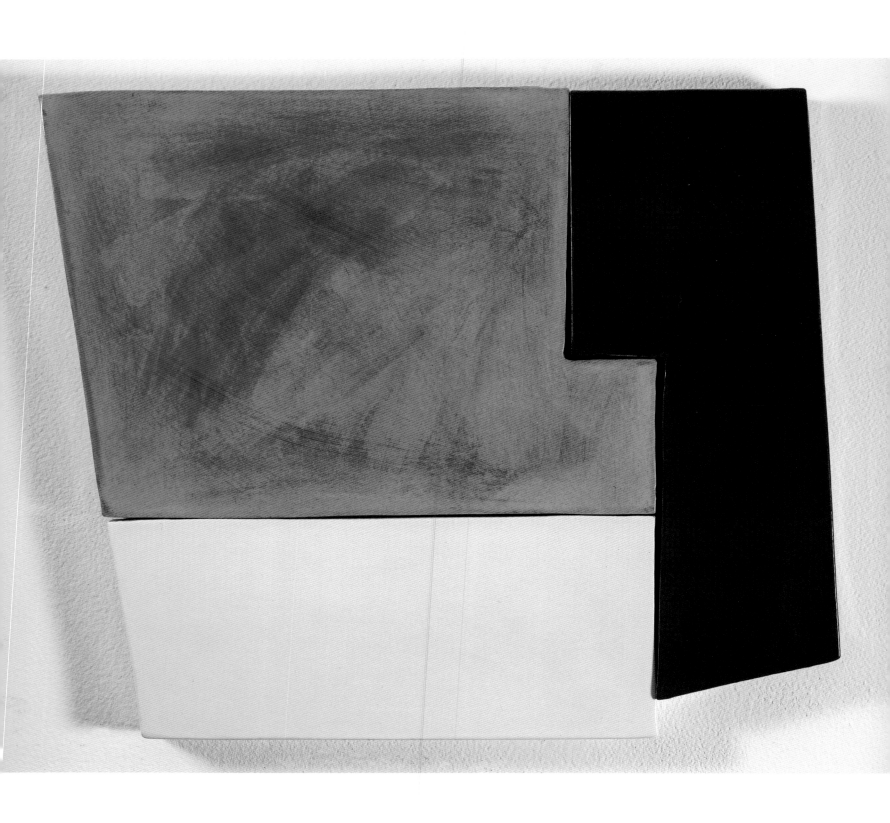

Contents

Foreword

This exhbition, the work of American sculptor Catherine Lee, focuses on the artist's work from the past decade and explores the point at which her work began to deploy pure three-dimensional space through the powerful use of material, colour and form. Born in Texas in 1950, her sculptures are a hybrid of painting, sculpture and installation, in which she juxtaposes the simplicity of a repeated form with a richness of materials, such as wax, bronze, glass and fibreglass. She first exhibited in New York in 1980 and since then she has participated in numerous exhibitions internationally. Her exhibition *The Alphabet Series and Other Works* toured throughout the United States. More recently, her work has been shown in NY, Paris, Barcelona, Cologne, Copenhagen, Tokyo. Her art is included in the collections of the San Francisco Museum of Modern Art; MOMA, NY; the Tate Gallery, London; the Carnegie Museum, the Institue of Art, Pittsburgh and the Boston Museum of Fine Art.

Over the course of the last fifteen years, I have been lucky enough to have seen some of these shows. Sometimes this happened by chance, like in 1993 when I saw Lee's powerful exhibition at London's Annely Juda Fine Art, which I reviewed for the Spanish art magazine *Lápiz*, or, two years later, her show at Galerie Karsten Greve in Cologne. On both occasions I just happened to be passing through those particular cities on other business. Eventually, however, in 2000, when her first exhibition in Spain took place at Barcelona's Galeria Carles Taché, I was honoured when asked to write the introduction to the catalogue. At that time, Lee and I began to discuss the idea of working together on an exhibition. And here we are in Dublin with the resulting exhibition, in a city that the artist happens to know well.

Lee's work, in the meantime, developed steadily, moving away from painting and becoming ever more sculptural. Her recent large-scale bronzes, the result of this evolution, were presented at an exhibition last year at Galerie Lelong in New York and are now seen here in Dublin, displayed in the museum's courtyard. Lee is also participating in IMMA's Artists' Work Programme, which provides artists with a studio and accommodation for a period of time, allowing them to interact with the exhibition's visitors. The fact that this program has already attracted several established artists is probably proof of its success.

The work of Catherine Lee was the subject of a museum survey in 1992, organized by Helmut Friedel, director of the Städtische Galerie im Lenbachhaus in Munich, which later traveled to the Neue Galerie der Stadt Linz. The exhibition that we present here at IMMA, therefore, focuses mainly on works made since that time. Like many abstract artists, Lee has developed her art within a clear theoretical framework. However, this has allowed her to produce a most varied and rich body of work. She uses an astonishingly diverse range of materials and achieves effects of amazing virtuosity from coloured ceramics to patinated bronze.

Lee's work is comprised of a series of large 'families', which range from small, single wall-pieces to large, formal arrangements with many units to three-dimensional, free-standing forms. They can be made of bronze, iron, lead, copper, resin, glass, fibreglass, ceramic, canvas or encaustic. One could dedicate pages to describing them formally, and previous books have often categorized them according to the families to which each belongs. Here, in this book, both complementing and expanding the exhibition itself, we have decided to dismantle that schema by which her works are usually categorized, and present the works chronologically. In so doing, we are able to emphasize aspects concerning content as well as form.

I believe that Lee's work belongs to that generation of artists whose practice has developed after Minimalism and which, in spite of having learnt a great deal from this movement, is interested in questions of meaning as well as form. This diverse group of painters and sculptors—from Martin Puryear, Susana Solano and Richard Long to Sean Scully or Terry Winters—probably believes that form and visual pleasure should be accompanied by intellectual rigour, but goes beyond certain ideas about purity and reduction.

Furthermore, Lee's work is suggestive of objects such as masks, shields, ancient tools and weapons from archaeological and even prehistoric sites. A photograph that she took of the prehistoric standing stones of Callanish in Scotland, which was reproduced in *Catherine Lee: The Alphabet Series and Other Works* (1997), gives a new context to her *Sentinels*, for example. Her titles, which often refer to the names of cities, rivers, islands or other places, not only literally suggest ideas about memory and myth, but also the notion that form is just an instrument and not an end in itself.

The production of an exhibition is always a collaborative undertaking and I would like to take this opportunity to thank a number of people who made this exhibition possible. The artist's galleries Galerie Lelong, New York and Galerie Karsten Greve, Cologne. The authors of the catalogue, Lóránd Hegyi, Caoimhín Mac Giolla Léith and Nancy Princenthal, for their revealing texts which greatly contribute to our enjoyment of these works, and to Giuseppe Liverani and his team at Charta who have been a pleasure to work with at all times. At IMMA, my thanks go to Seán Kissane who worked closely with the artist to produce the exhibition. I would like to thank a number of individuals who contributed in various ways: Seán Scully, Mary Sabbatino and Giles Altieri. Finally, I would like to thank Catherine Lee for her unique vision as well as her patience and support during the organisation of this exhibition.

Enrique Juncosa
Director

The Passenger, 1986

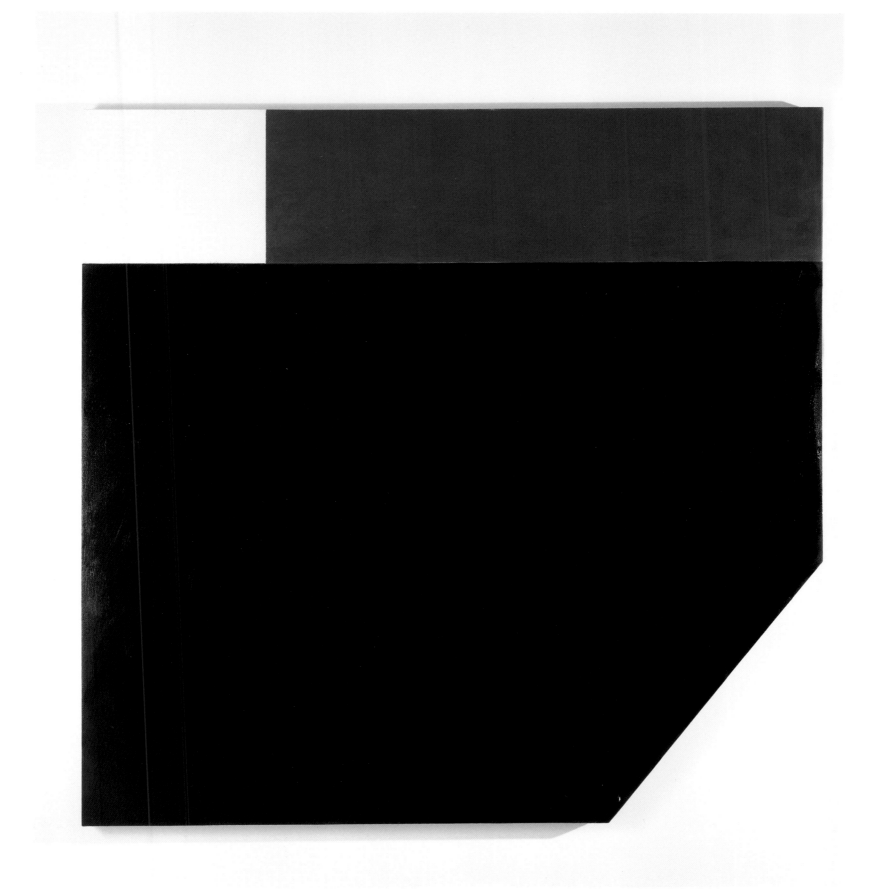

Navigator, 1986

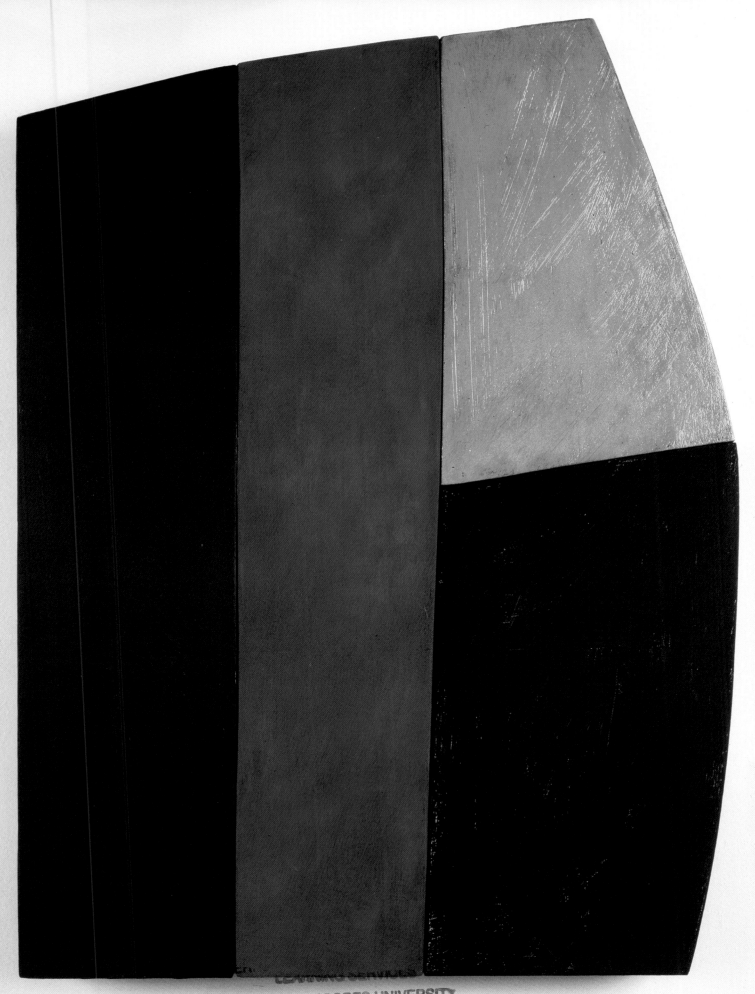

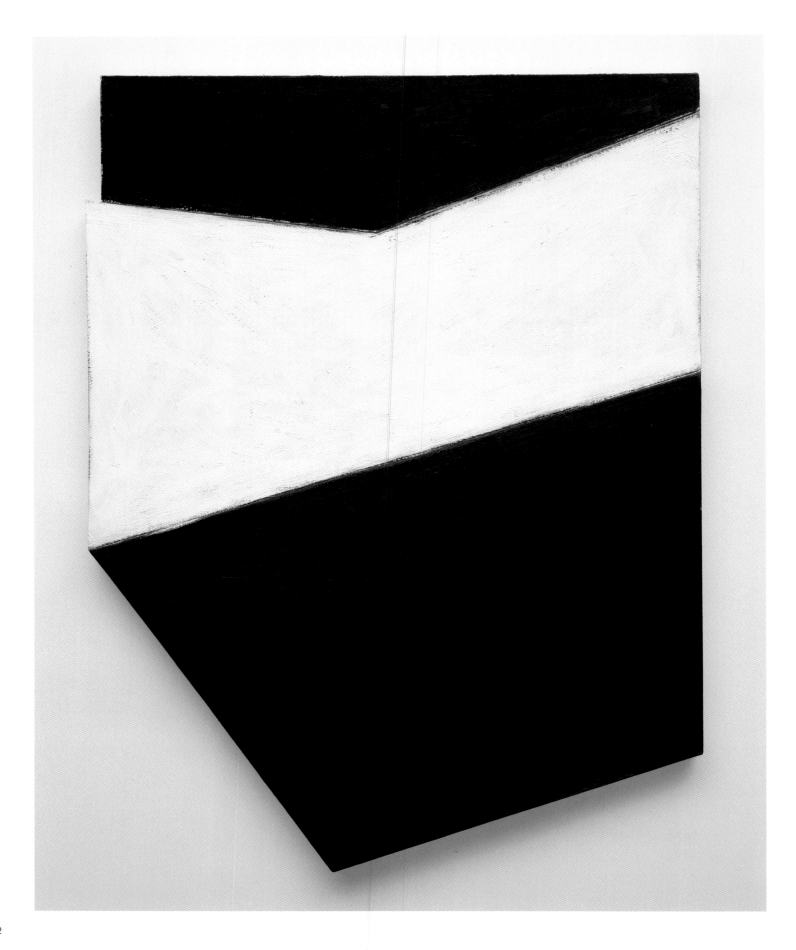

Sojurn, 1986 Undertow, 1988

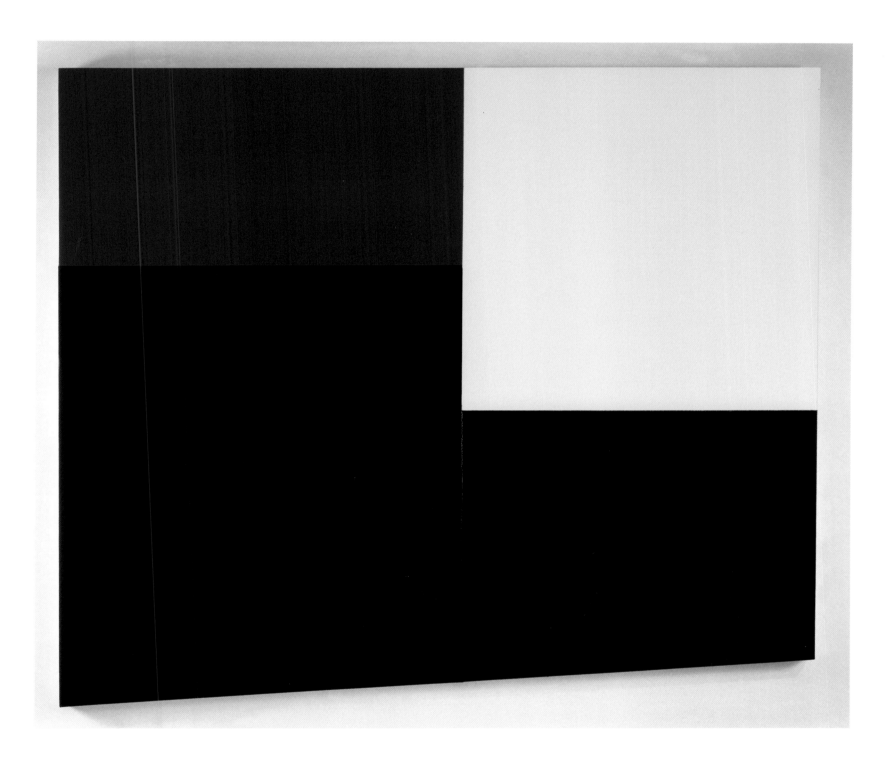

Past Taps Morning, 1985

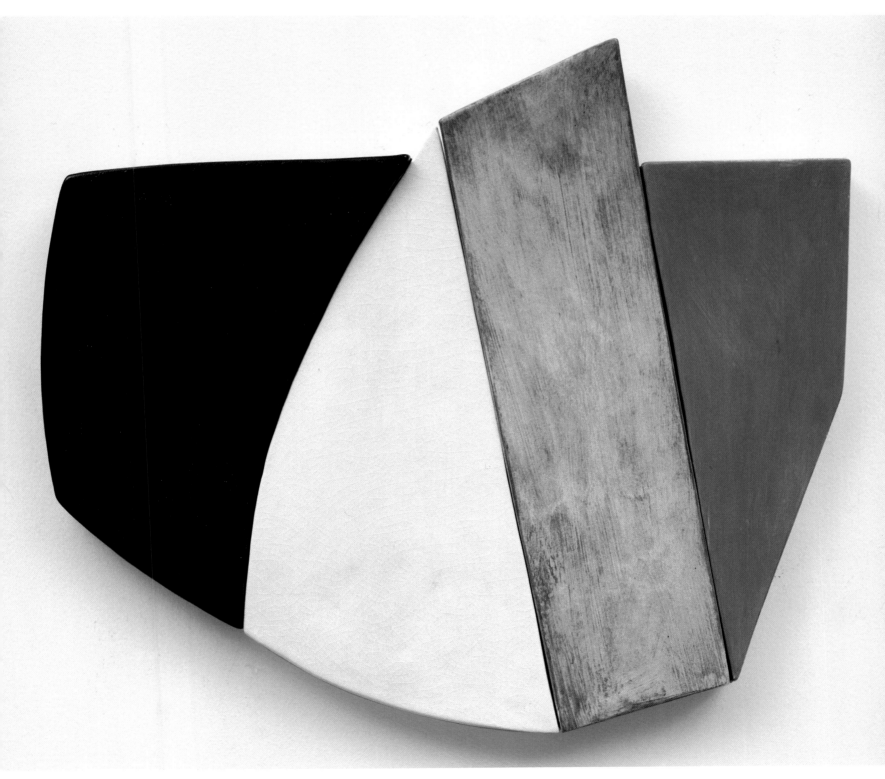

Adak, 1989

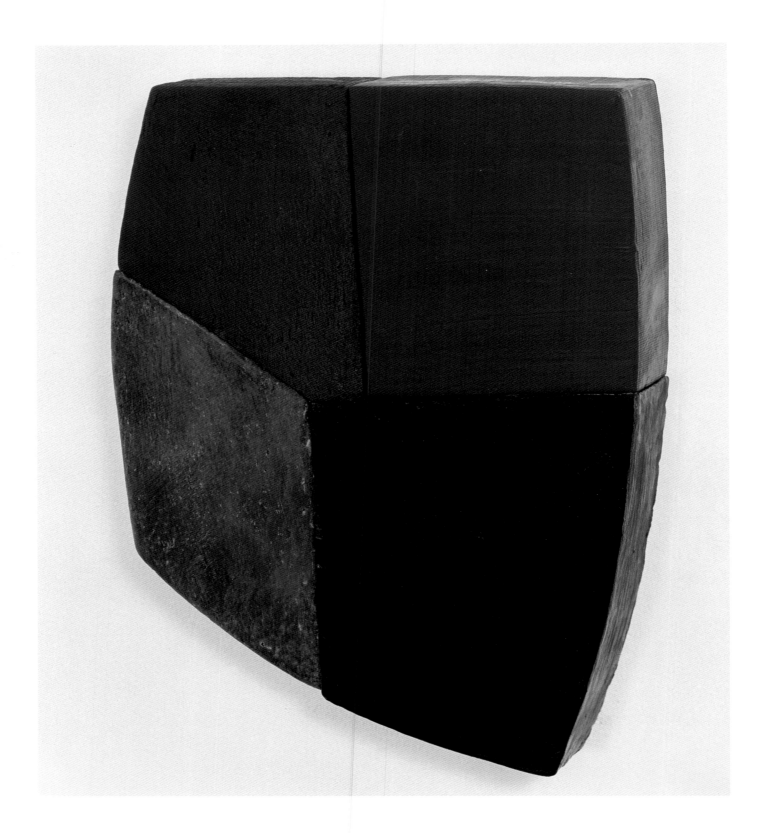

Yellow Seas, 1988

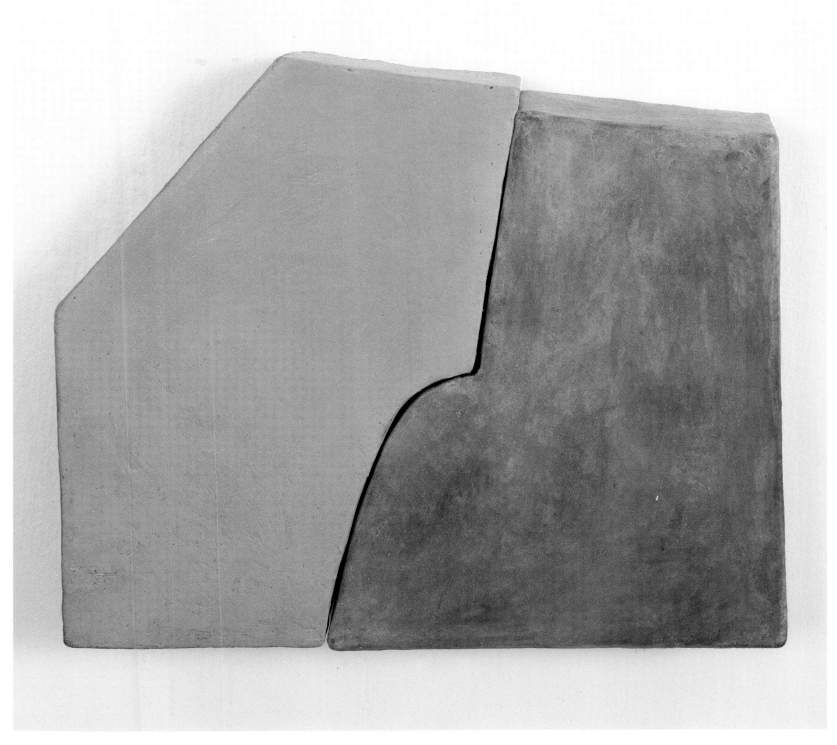

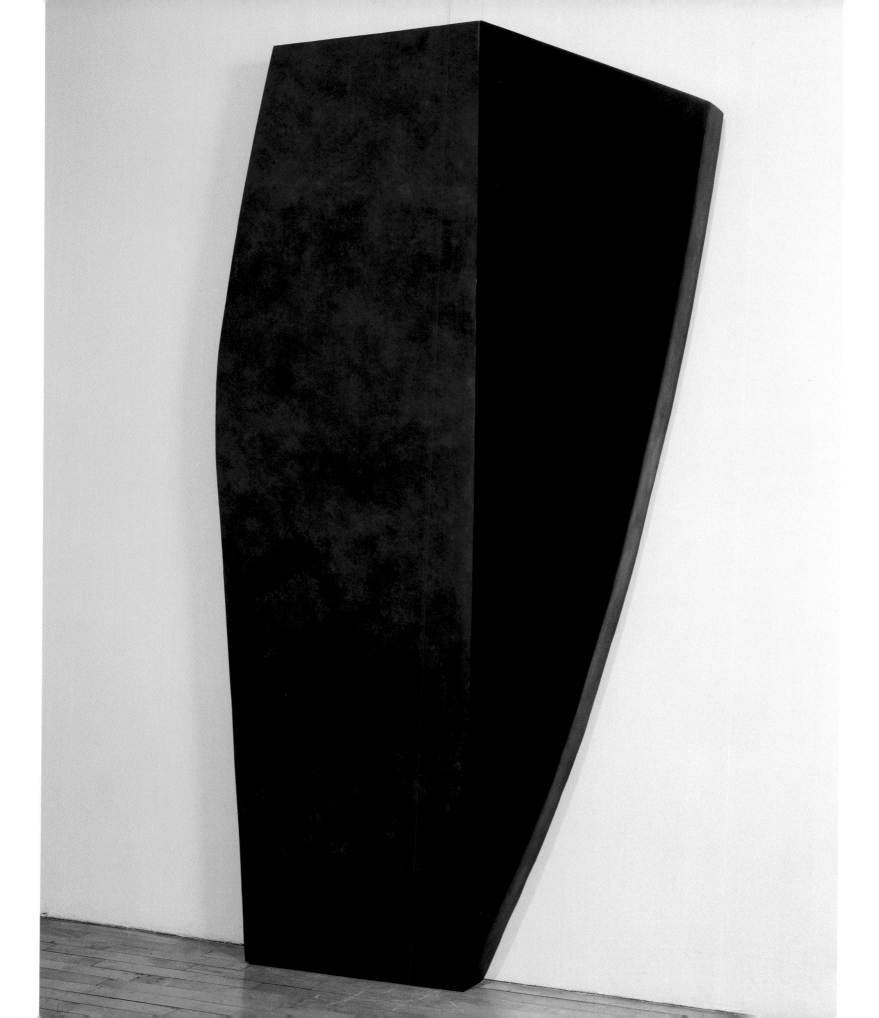

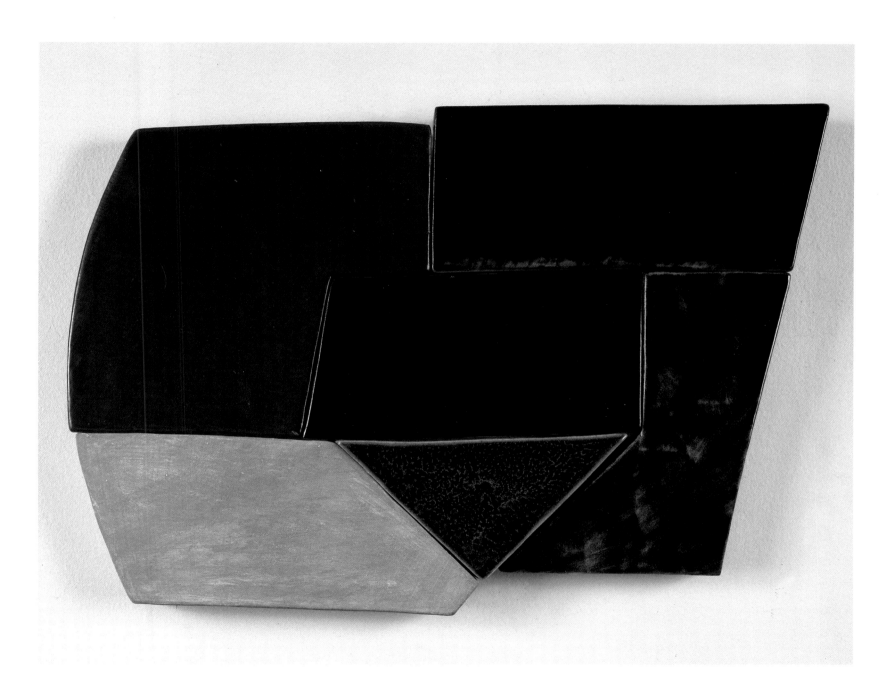

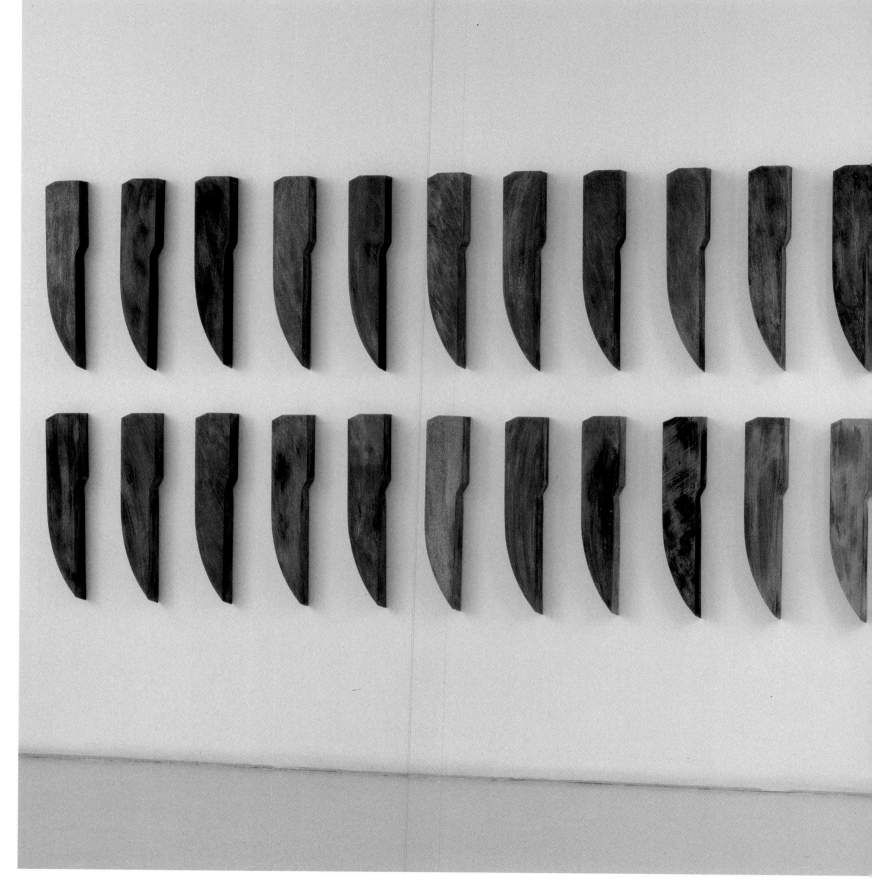

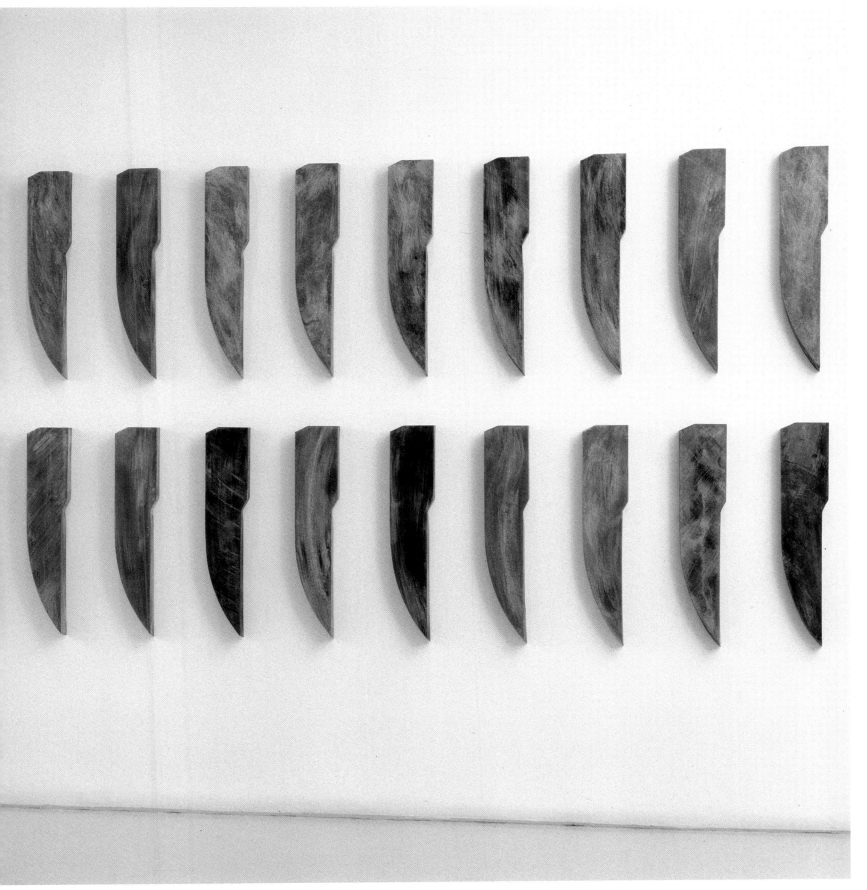

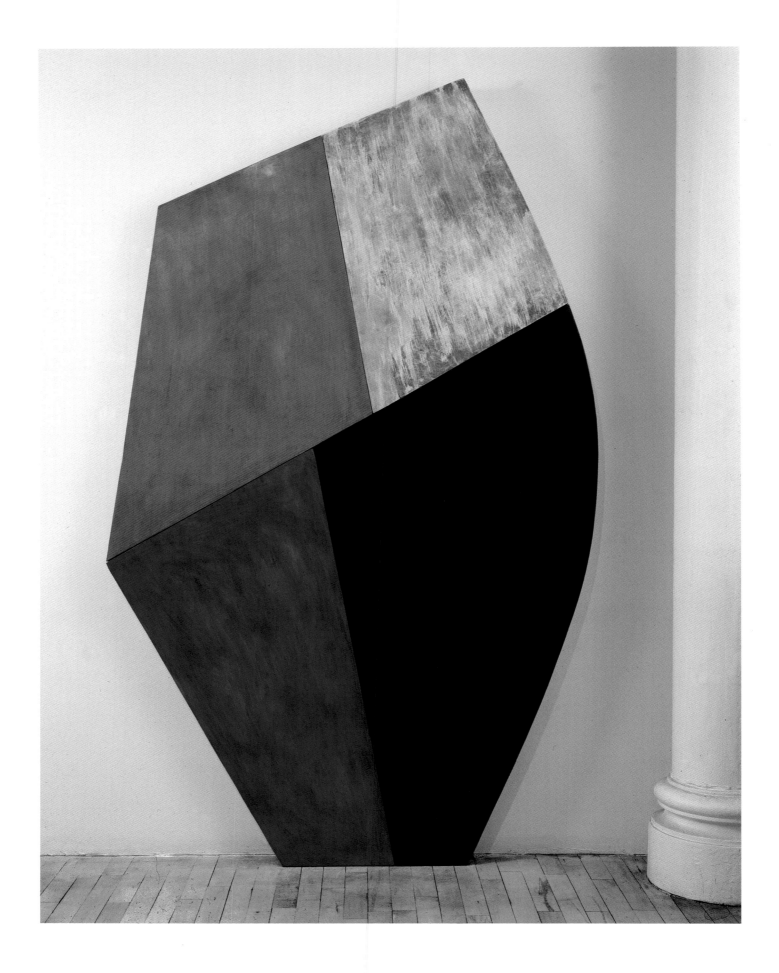

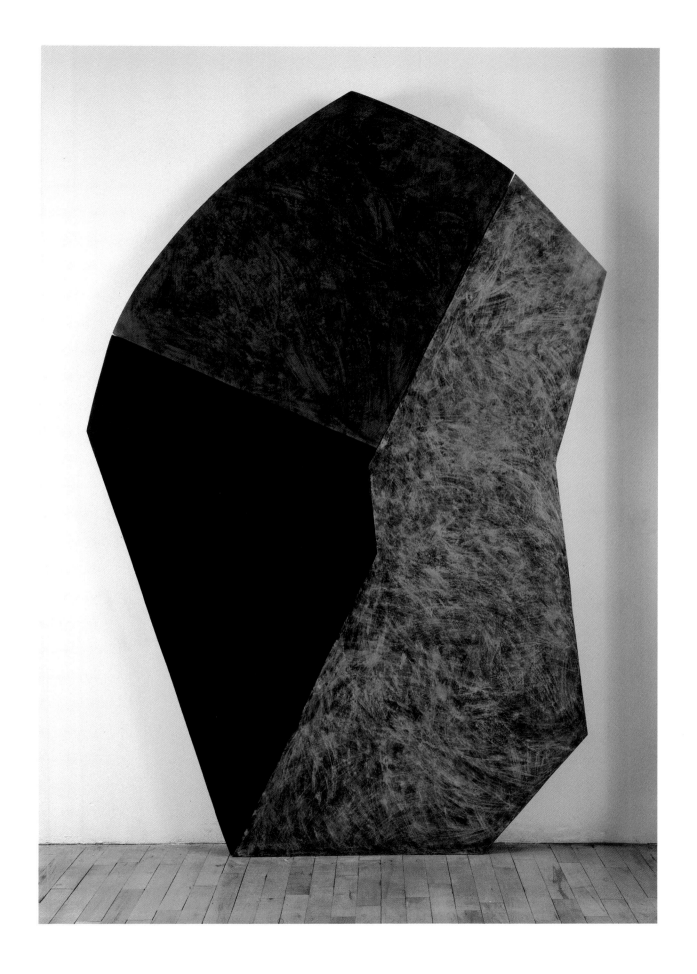

Machynlleth, 1989

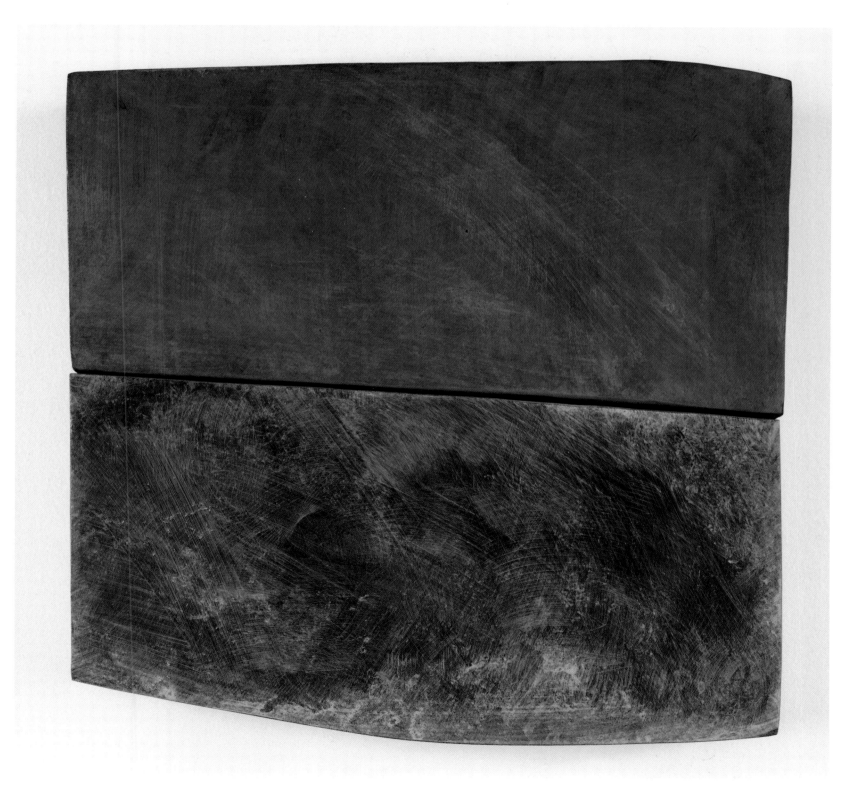

Assortments: The Art of Catherine Lee
Caoimhín Mac Giolla Léith

Sometime in 1992, Catherine Lee made a small, wall-hung, patinated, cast bronze sculpture, which she titled *Leodhas*. It is a shallow, flat form with a straight horizontal baseline and an otherwise irregular outline in which gentle, sweeping curves alternate with slightly more angular crenellations. Just one and a half inches deep, and roughly one foot by one foot at its outer edges, *Leodhas* is made up of four interlocking segments. Three of these have a charcoal-grey or slate-black patina and between them account for over ninety per cent of the perimeter of the piece. They surround, but do not entirely enclose, the fourth segment whose patina is a weathered sea-blue, much as a dark, rocky shoreline might encircle a well sheltered inlet. More than a decade later, in 2003, Lee produced another bronze, in this instance a free-standing sculpture roughly eight feet high, almost four feet by three feet at its widest girth, and weighing somewhere between three and four hundred pounds. This solidly-based, brooding mass is a dark, reddish-brown in colour. Its title is *Lewis*. Its imposing bulk at first belies the complexity of its surface topology. Its sharply angled, multifaceted surface ensures that the viewer's perception of its basic outline changes dramatically depending on the vantage point from which it is viewed. Moving around it, we are likely to find ourselves as persistently surprised and confused as an amateur climber faced with a difficult and intimidating mountain peak.

To compare these two works may appear somewhat arbitrary, though the comparison does serve to illustrate some fundamental contrasts between two disparate areas of Lee's art of recent years in the matter of formal topology, compositional and chromatic complexity, scale in relation to the human body and relative historical indebtedness to the traditional media of painting as opposed to sculpture. Nevertheless, this specific comparison was motivated, to some degree at least, by a cross-linguistic coincidence between the works' respective titles. And this may seem both misguided and misleading, especially given the artist's avowal that she never intends a title "to be a key into the work", and that her titles have a largely "abstract interest". Her persistent use of the names of far-flung places, all of which she has visited, however briefly, is not meant to imply any direct formal link between a given place and a given piece. At most, as she has observed specifically of her *Alphabet Series*, of which *Leodhas* forms a part, the title is based on a highly personal association of a particular colour with her memory of a given place. The proliferation of place-names also, however, chimes with her occasional deployment of collective titles connoting a nomadic existence, as in the two related pieces entitled *Travelers* (1998) and *Wayfarers* (1998–2001), each of which comprises a ten unit series of small works in encaustic on paper. It must be noted that this persistent invocation of restless travel is, in one sense, at variance with the ever assured, occasionally commanding, presence of Lee's various works. As Carter Ratcliff has observed: "[some] of Lee's titles may be feints: cues

that, if followed too closely, will throw us off balance."[1]

Yet it is worth pursuing the question of titling a little further. As it happens, *Leodhas* is the Gaelic form of the place-name Lewis, the name given to the northern part of the northernmost island in the Outer Hebrides. Gaelic speaking Lewis is in fact physically attached to Harris—*Na Hearadh*—in the south. *Na Hearadh* is the title of a small wall-piece from 1993 that, like *Leodhas*, forms part of the second of Lee's *Alphabet Series* (1991–1995). *Harris*, on the other hand, is the title of another large bronze from 2003. Within the relatively restricted confines of contemporary Scottish Gaelic culture, the physical, cultural and linguistic profiles of these two localities are commonly perceived to be quite distinct, despite their close geographic proximity. In a comparable fashion, Lee's *Harris* is broadly similar in height, volume and weight to *Lewis*, and both belong to a series of related sculptures collectively entitled *Hebrides* (2003–2004). Yet the differences between the two works are equally noteworthy. *Harris* is dark green in hue and stands on a narrower base, which, from certain angles, gives it an air of potential instability that is not at all evident in *Lewis*. If we examine a third sculpture in the Hebrides series, *Scalpay* (the name of several different, tiny Hebridean islands), we will note that it appears less forbidding and monolithic than Lewis, and less precipitous than *Harris*. If we push to the limit our comparison of these sculptures to large-scale natural rock formations, we may even perceive its gradually broadening base as suggestive of physically inviting foothills or lower slopes.

Of course there is a danger here of becoming carried away with a loosely associative, if suggestive, reading of this particular series of sculptures—whose surface morphology is, after all, considerably more geometric than it is organic—in terms of a schematic translation of topologies familiar from our observation of the natural world. This may prove severely limiting, but is not unreasonable. As a variety of previous commentators have noted, all of Lee's works, in their different ways, situate themselves on the borders between abstraction and representation. They accommodate, more or less equally, a primarily formalist mode of exegesis as well as more subjective readings founded on the works' evocations of various objects in the "real world". Even the most cursory overview of Lee's work as a whole will, for instance, reveal an abundance of formal echoes of various archaic artifacts such as masks and heraldic devices, vessels, weapons, tools and implements. These echoes are occasionally made explicit in the works' titles, as in the recent *Archaic Figures* (2004), a wall-hung row of eight small pale-green figures in glazed raku ceramic with varying intensities of craquelure. In other instances, the formal associations remain implicit. *Other Voices* (1993), for example, comprises four rows of small wall-hung sculptures. Each row contains sixteen small pieces, which are as identical in material, colour and shape as the accidents of individual facture will allow. Yet each row differs significantly from the other in material, colour and shape. The top row is in cast aluminium, the second in a blue-green patinated copper, the third in grey-black patinated bronze, and the bottom, a rust-coloured iron. Each of the four disparate, long, narrow, flat shapes recalls that of the head of an ancient weapon or digging implement. Viewed within the context of a standard contemporary exhibition space, it almost appears as if the contents of a Victorian museum vitrine had been inexplicably reinstalled on the walls of a modernist White Cube. As David Carrier has noted, Lee has a fondness for "ancient materials [such as cast bronze, iron and ceramic], which she has set in the specific context of Modernism".

Previous commentators have discussed Lee's work in the wake of the various strains of modernist abstraction, both organic and geometric, that preceded and informed it. Less attention, however, has been paid to another crucial aspect of her work, i.e. her ongoing investigations into the properties of sameness and difference. Briony Fer has recently argued that the pronounced tendency toward repetition and seriality that occurred at the moment of Modernism's decline has, in fact, gained ground in its aftermath and continues to shape much of the art being made today.[2] In light of this observation, it is worth turning briefly to one final sculpture in the Hebrides series, *Calanais*, the title of which points to one geographically specific, visual reference point for this entire series. *Calanais* also, however, provides a useful point of departure for a discussion of seriality and repetition as it functions in Lee's art. The catalogue accompanying her 1997 exhibition, Catherine Lee: the Alphabet Series and Other Works, which toured various institutional venues throughout the United States, includes a photograph taken by the artist on a visit to Lewis. It depicts the prehistoric standing stones of *Calanais* (English "Callanish") rising in an open, roughly circular formation above the wind-blown gorse, their dark silhouettes starkly outlined against a blustery grey sky. Faye Hirsch has noted that, in keeping with Lee's fondness for venerable materials, she also "seems drawn . . . to places with long, sometimes mysterious histories". Two other illustrated photographs, which closely follow the Calanais snapshot in the same catalogue, invite us to see Calanais in a somewhat different context vis-à-vis Lee's work. The first is a photograph, once again taken by the artist, this time of the military cemetery at Fort Sam Houston, Texas, where her father is buried. It depicts row upon row of virtually identical standing headstones receding into the distance. The second is a detail from Lee's *Lead Constellation* (1990), showing two long rows of small, flat lead sculptures laid out on her studio floor. Though not exactly typical, the floor-bound *Lead Constellation* is by no means unique in Lee's work. It is comparable, for instance, to *Outcasts Water Iron* (1990), which comprises one row of twenty-one repeated units in oxidised cast iron, and which was designed to be installed either on a wall or on a floor. The consistently identical but geometrically irregular units in works such as these serve to highlight their similarities with and difference from the serial sculptures of classic Minimalism.

Outcasts Water Iron (detail), 1990

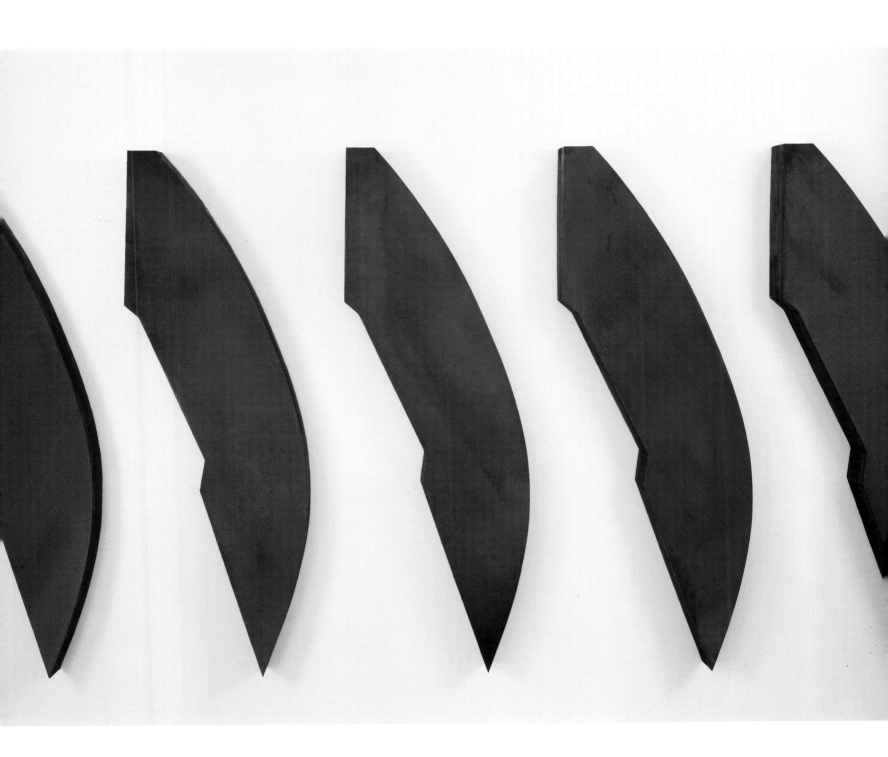

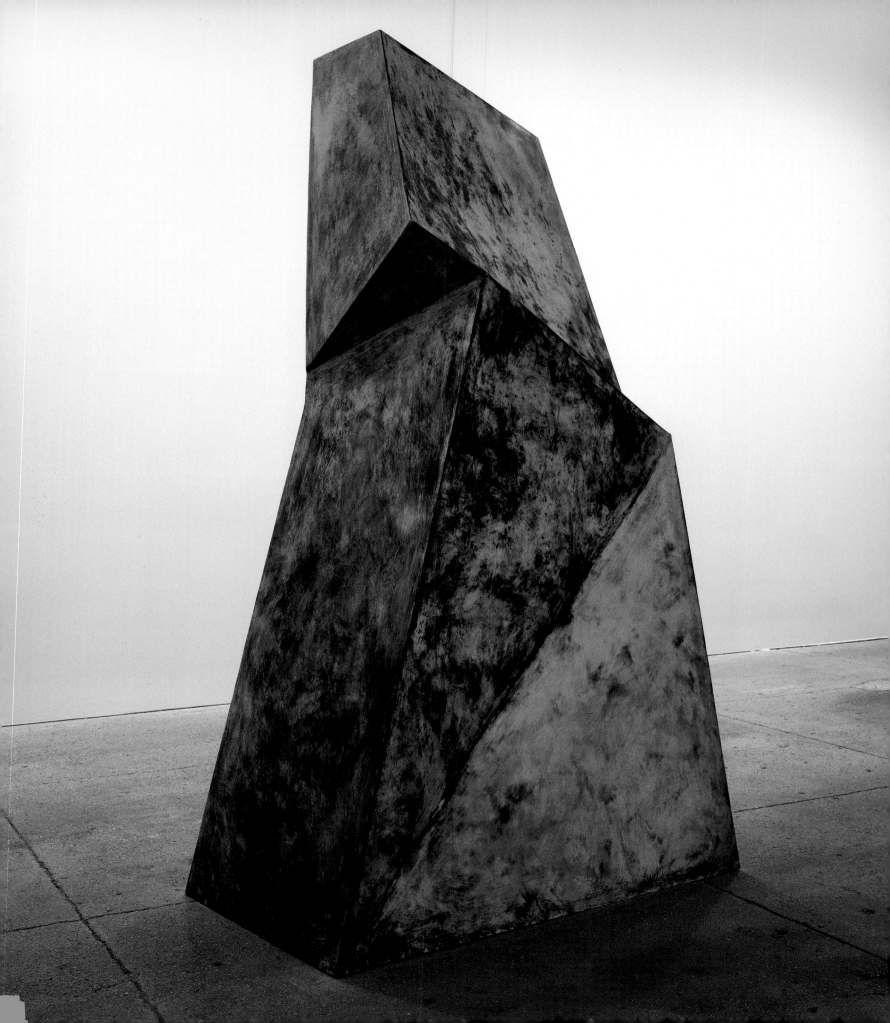

"Serial art" and '"Systems art" were just two of the labels applied early on to the nascent art movement we have come to know historically as Minimalism, the movement to which the strategies of seriality and repetition seem most central. For Lee, however, the art of what is more loosely termed Post-Minimalism would appear to provide a more significant antecedent, in particular works such as Eva Hesse's *Repetition* works of 1967–1968, informal floor arrangements of small, similarly misshapen vessels, each one of which is clearly unique to the discerning eye. Hesse shared with her most significant peers an interest in the entropic, and she favoured highly unstable contemporary materials such as fibreglass and polyester resin, or paint and papier mâché on aluminium screening. Lee, too, has stated that "I have an innate tendency to monitor and define, to exert too much will over my work - so much so, in fact, that I've come to seek out methods of confounding myself and derailing this tendency toward control. The patination of metals is one method, because there are enough critical variables at work that I can never quite command the outcome."

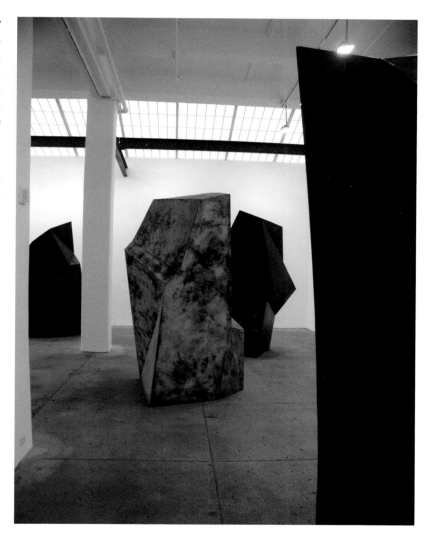

Yet, despite her readiness to relinquish the possibility of absolute control over certain materials and processes—for example, the notoriously unpredictable method of firing raku ceramic—Lee is naturally drawn to materials which, when all is said and done, are both venerable and durable, as previously noted. The decided informality of Hesse's arrangements is likewise at odds with the methodical, formal assortments characteristic of Lee's serial works. Lee marries a contemporary fascination with seriality and repetition to a kind of pseudo-taxonomic impulse whose origins might be traced back at least as far as the display culture of Victorian antiquarianism and its romance with the prehistoric past. While Carter Ratcliff's account of Lee's serial works may underestimate their affinities with more contemporary, generally anti-humanist, explorations of repetition and difference, it is hard to disagree with his implicit suggestion that they are rooted in a fundamentally Romantic conception of the ancient world: "The repeated forms of these serial pieces allude to such things as pottery shards and arrow heads, objects made by hand in a time when culture had not yet begun to extricate itself from nature. Lee doesn't evoke artifacts so much as the power of artifacts to symbolise the plenitude—the blend of the natural and cultural—that generated ancient forms."[3]

1. Carter Ratcliff, "The Art of Catherine Lee", in Carter Ratcliff and Faye Hirsch, *Catherine Lee: The Alphabet Series and Other Works* (Seattle: University of Washington Press, 1997), p. 14. All quotations from the artist are either from Ratcliff's essay or from Hirsch's accompanying essay, "*Placing Memory: Catherine Lee's Alphabets Series*", pp. 30–35.
2. Briony Fer, *The Infinite Line: Re-making Art After Modernism* (New Haven and London: Yale University Press, 2004).
3. Ratcliff, op. cit., p. 26.

Calanais, Hebrides series, 2004 (right)
Scarista, Hebrides series, 2003 (left)

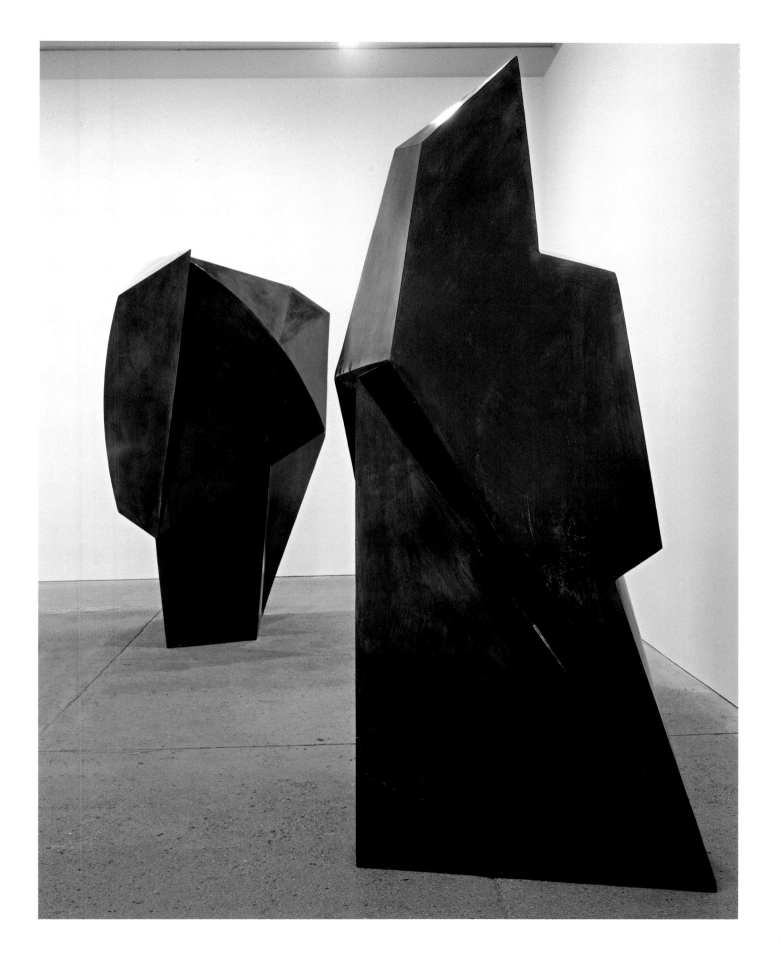

Lead Constellation, 1990

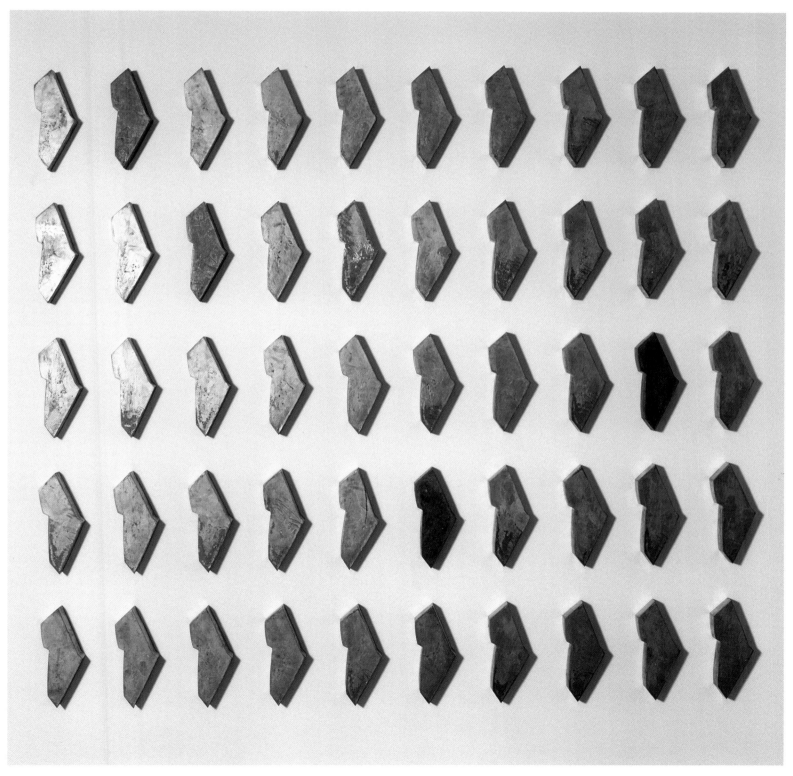

Sentinels, in progress, 1999

pp. 38–39
Strata, 1990

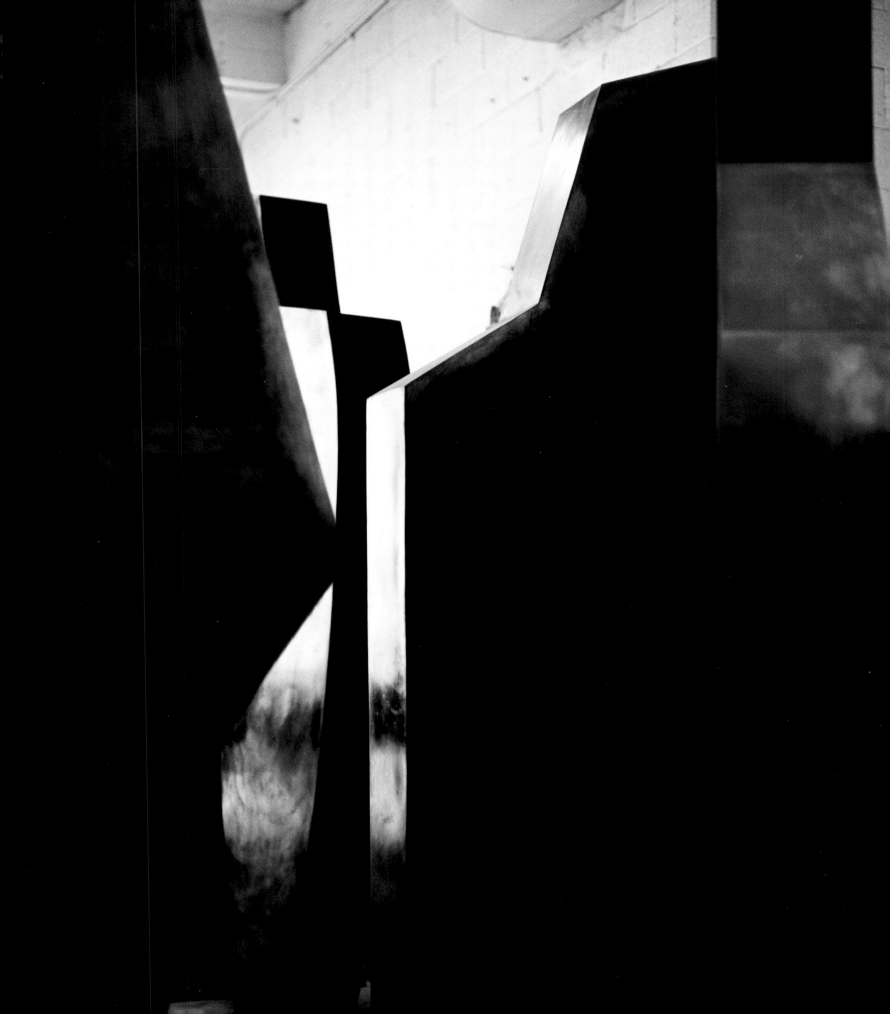

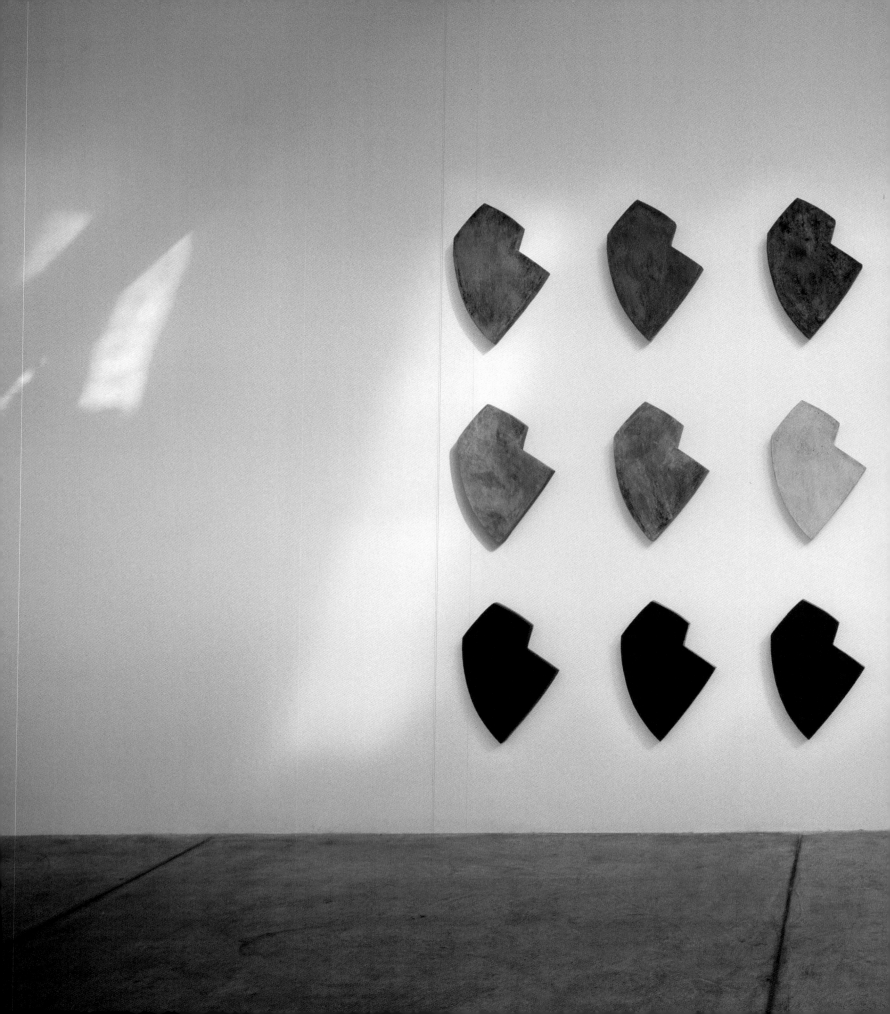

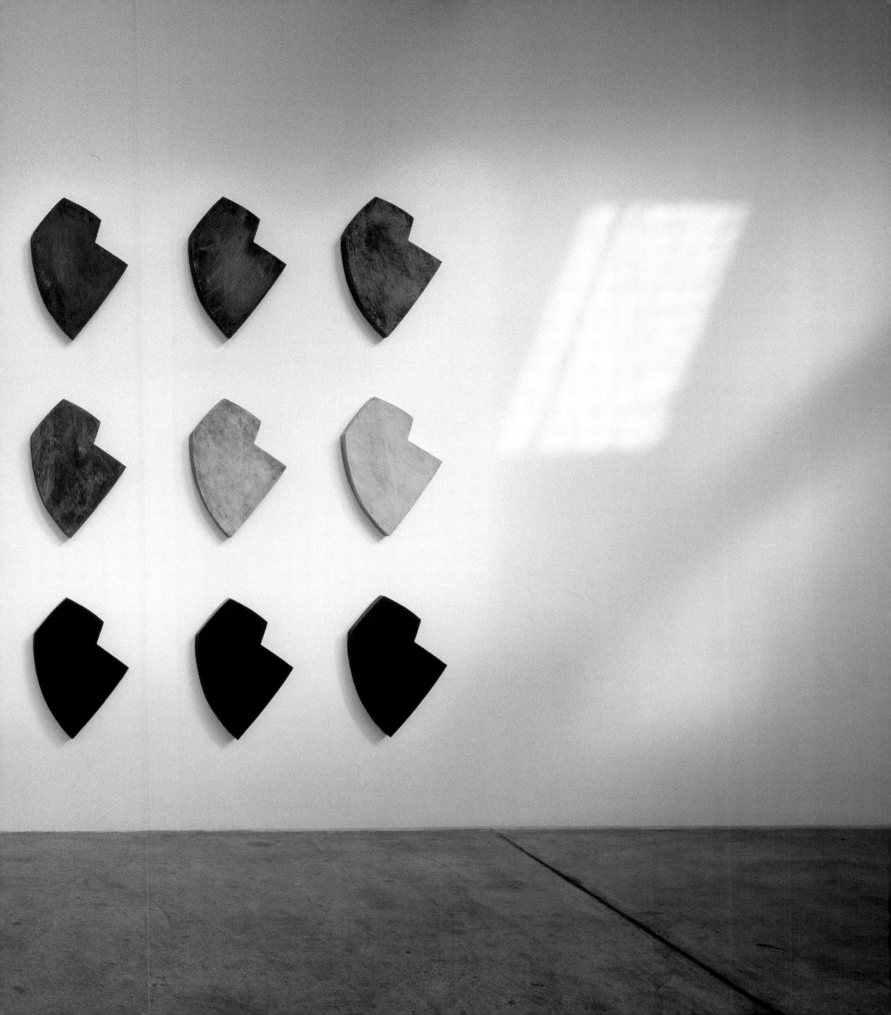

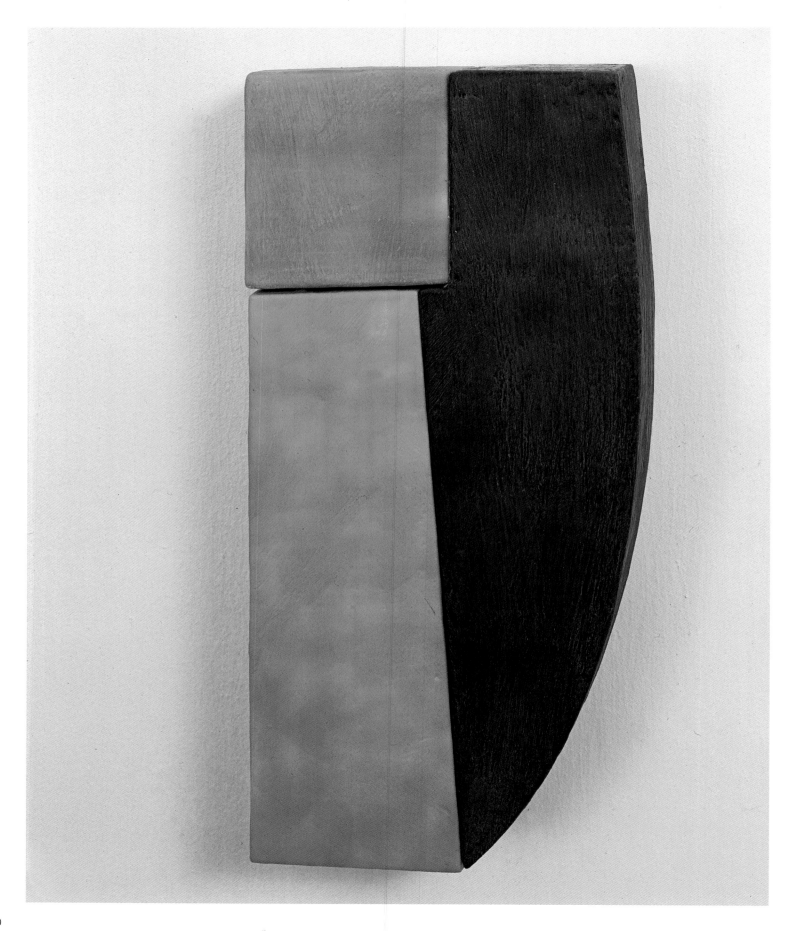

Lag, 1990

Harbinger, 1990

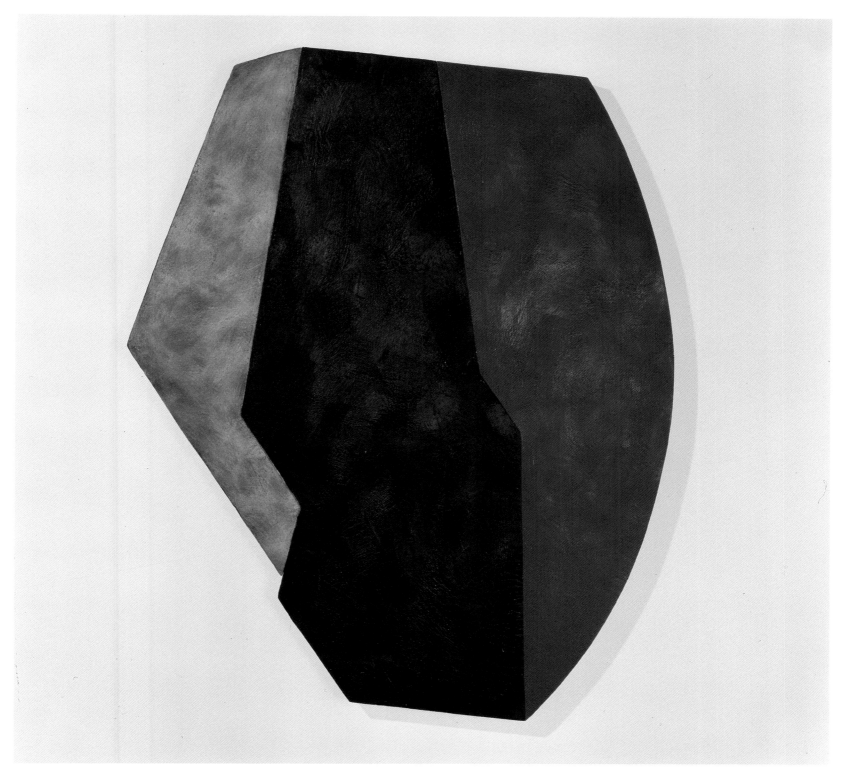

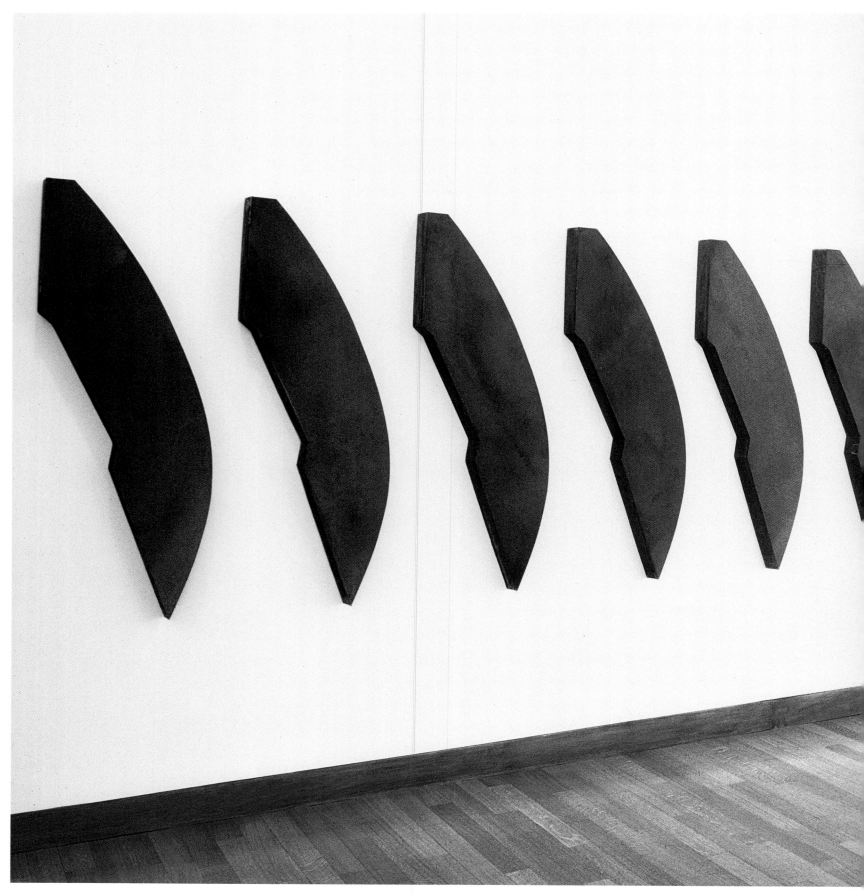

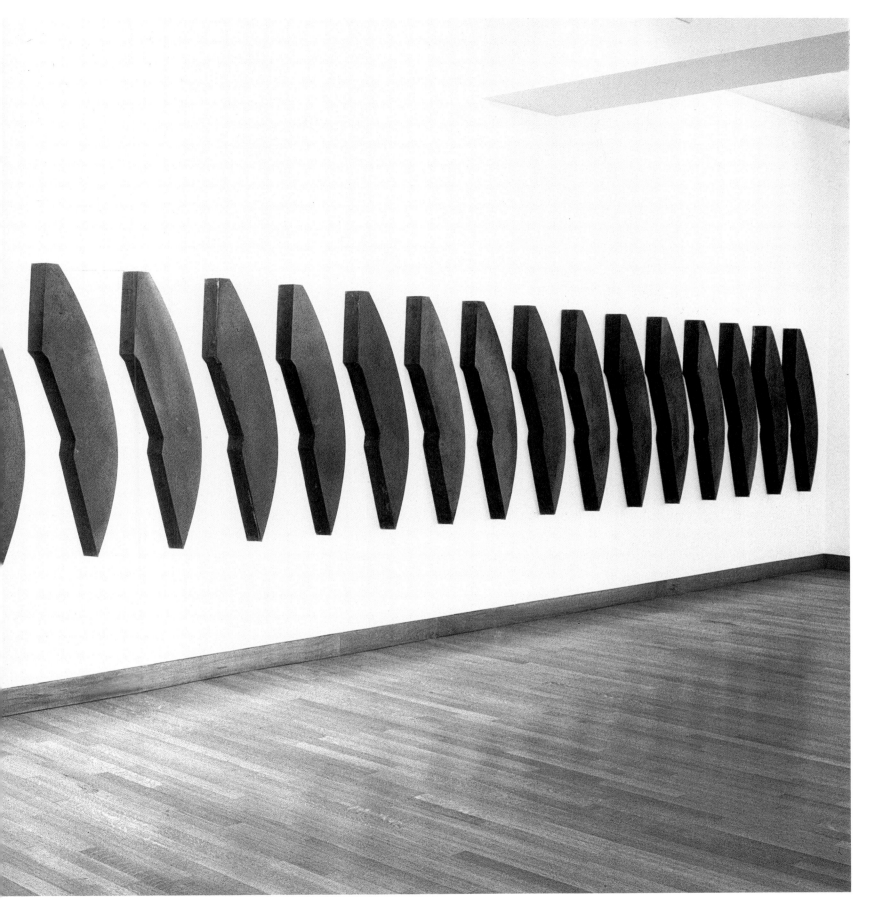

pp. 42–43
Outcasts Water Iron, 1990

Wyoming, 1990

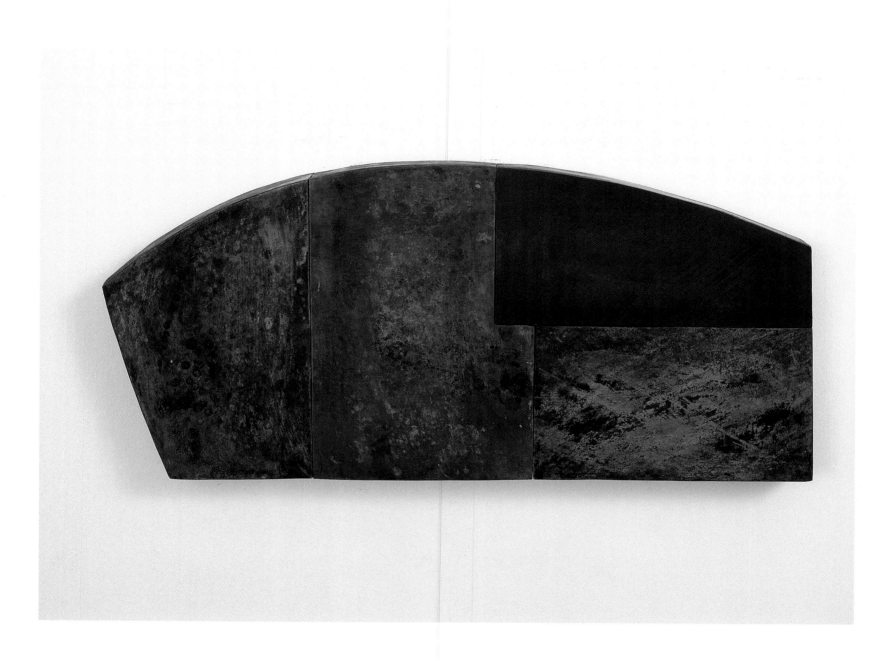

Land, 1990

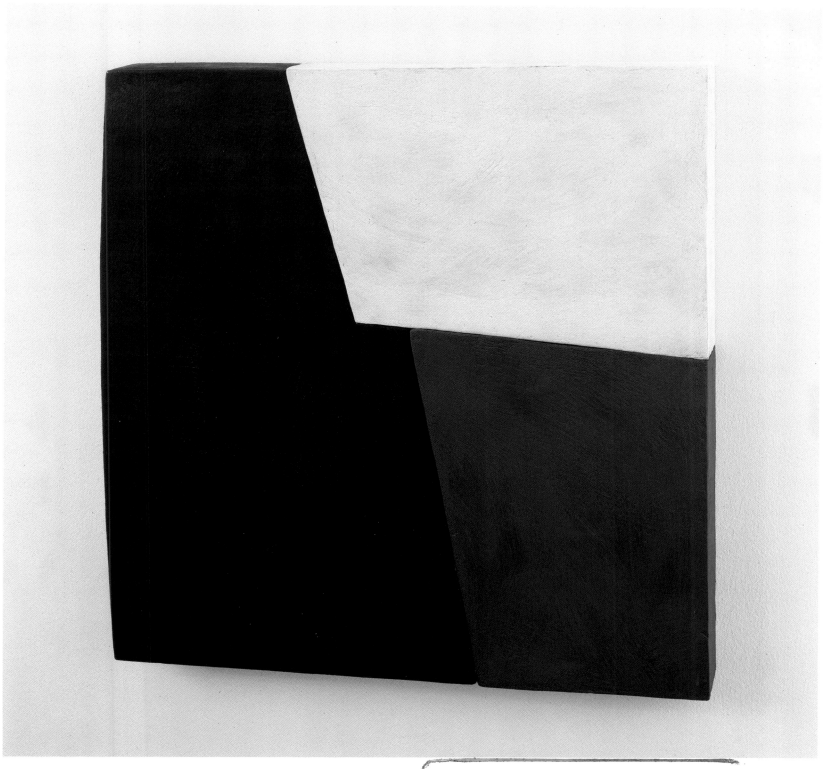

Bronze Flight, 1990

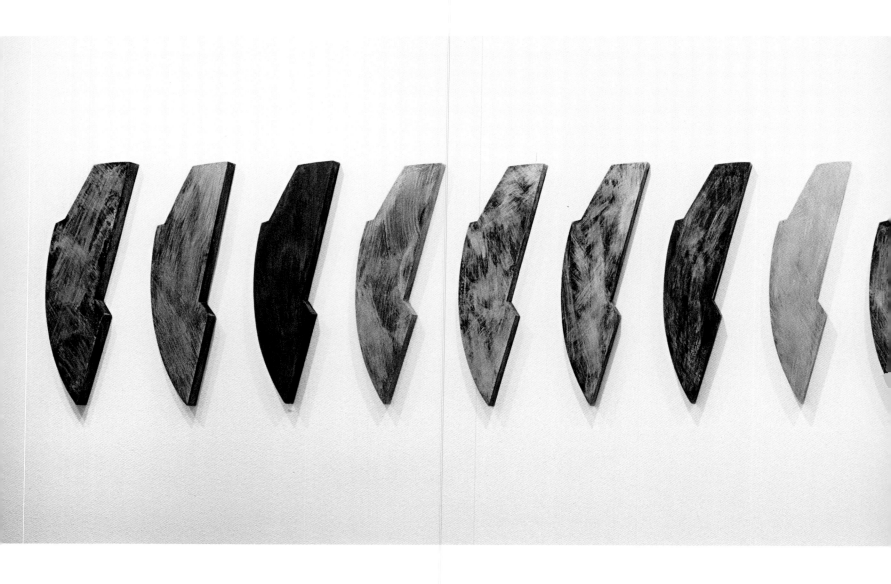

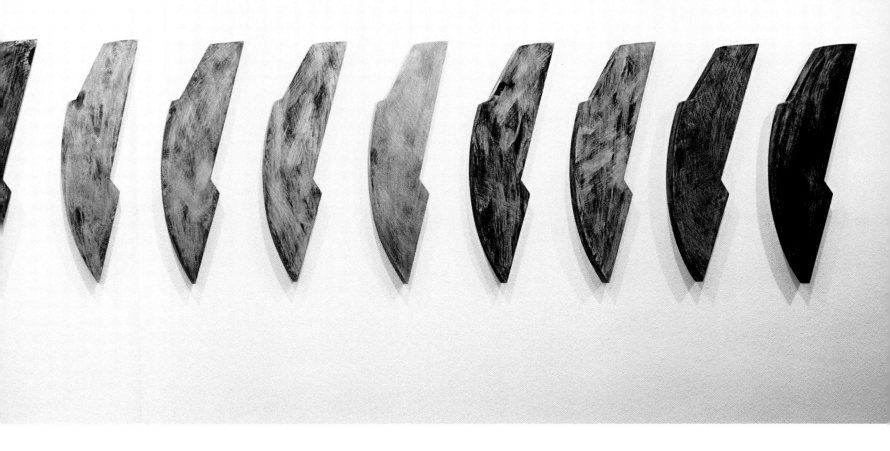

Callanish, 1991

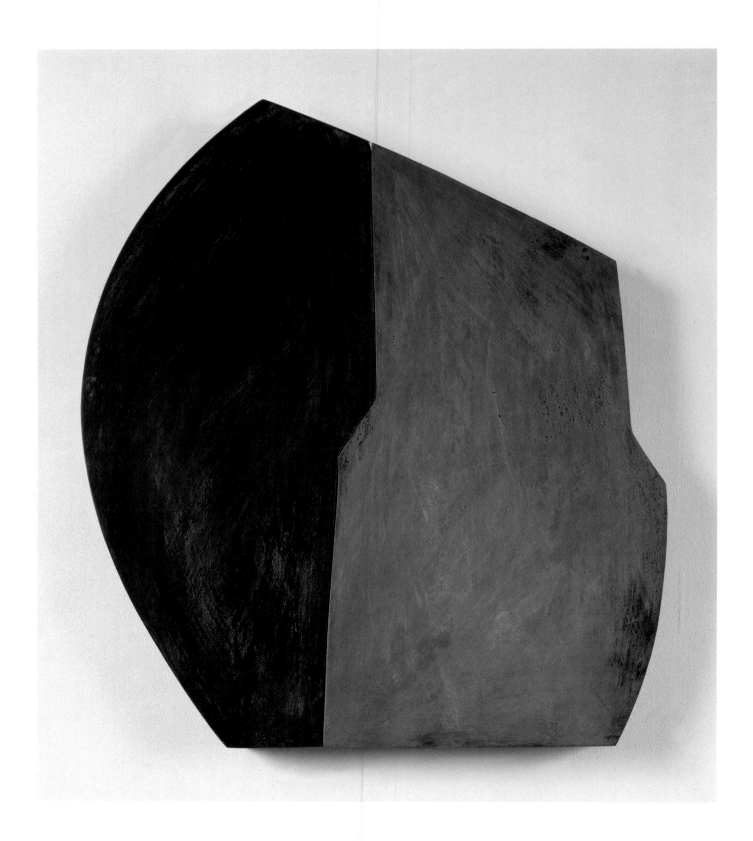

Tempest, 1991

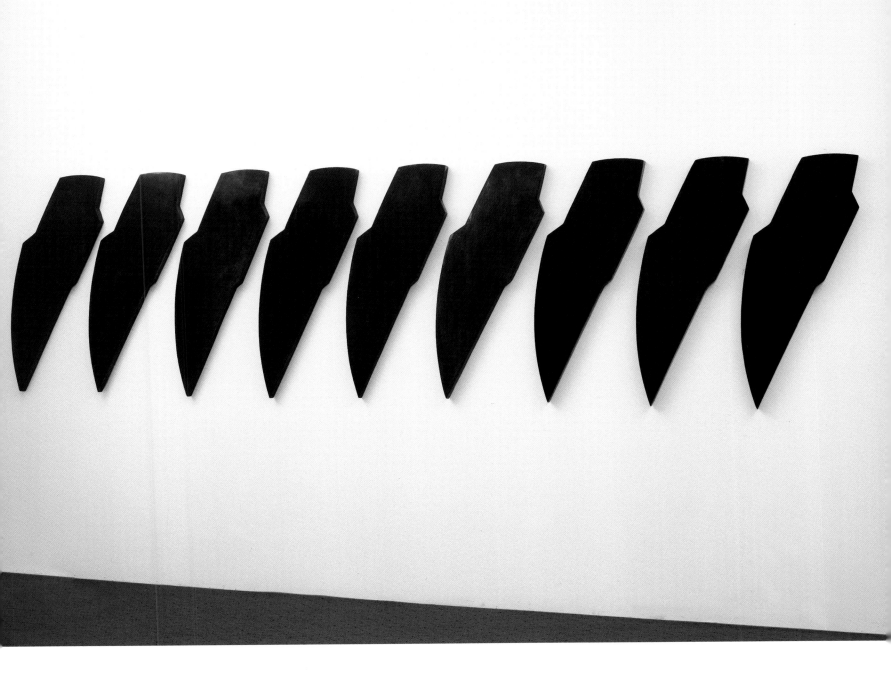

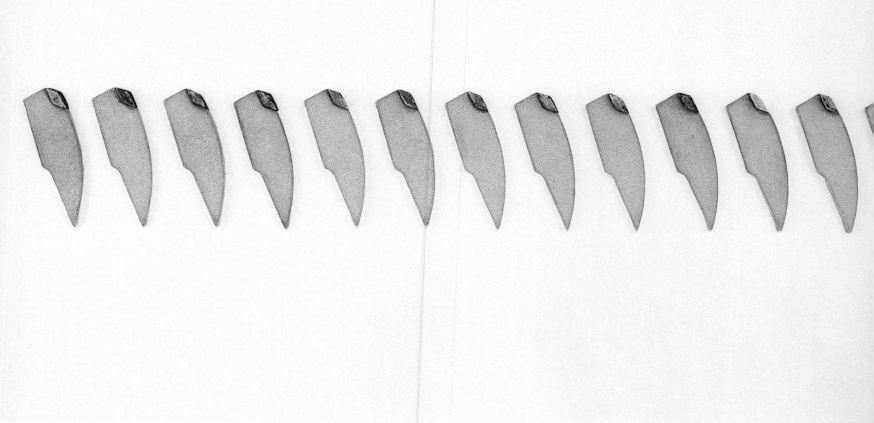

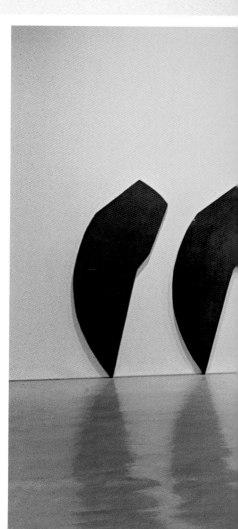

Mercury, 1992 Iron Return, 1991

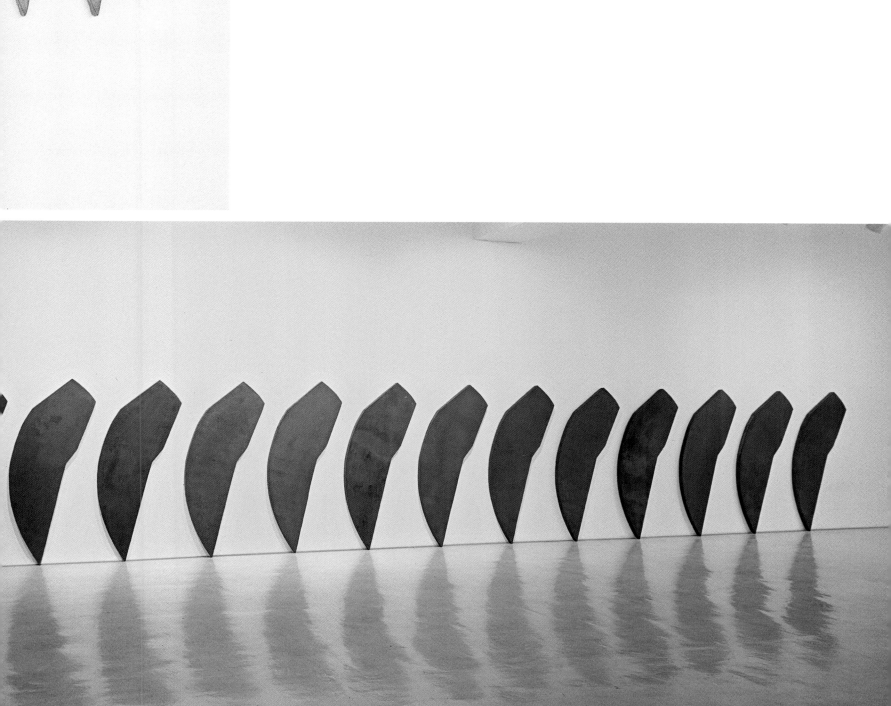

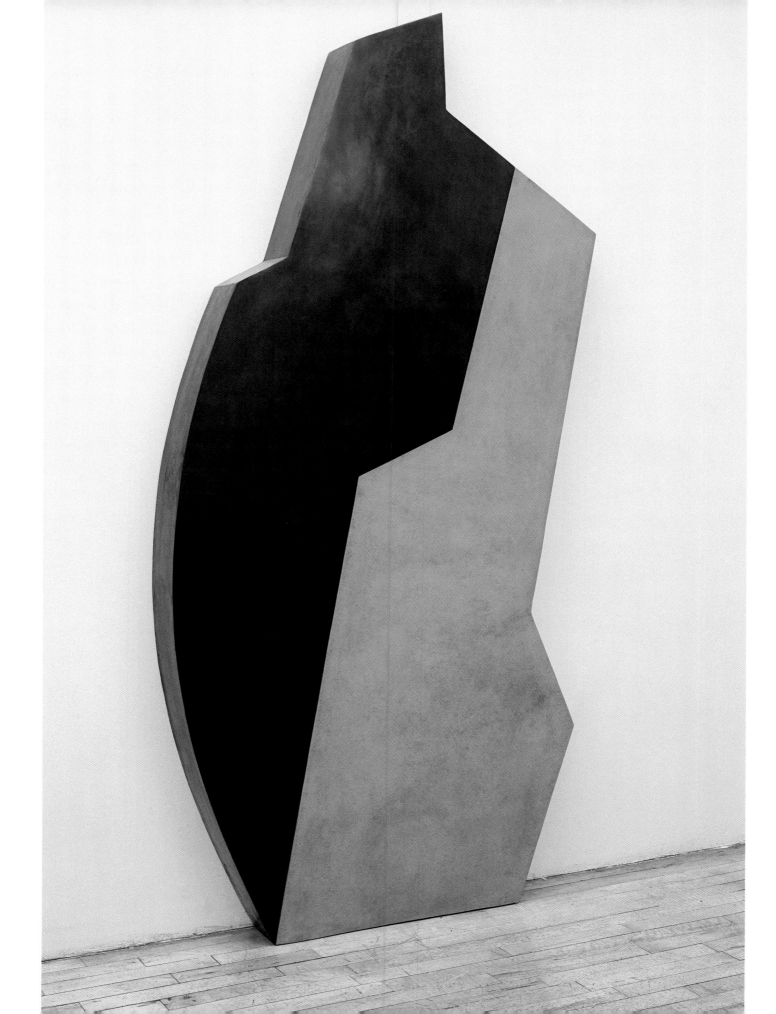

Union Two, 1992 Johnstown, 1992

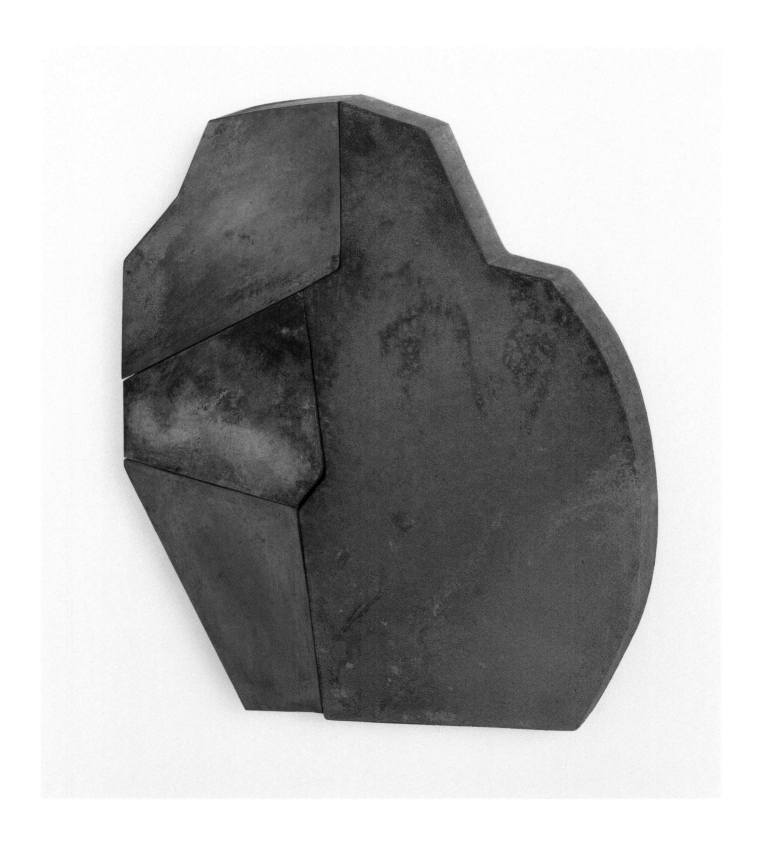

At Odds, 1992

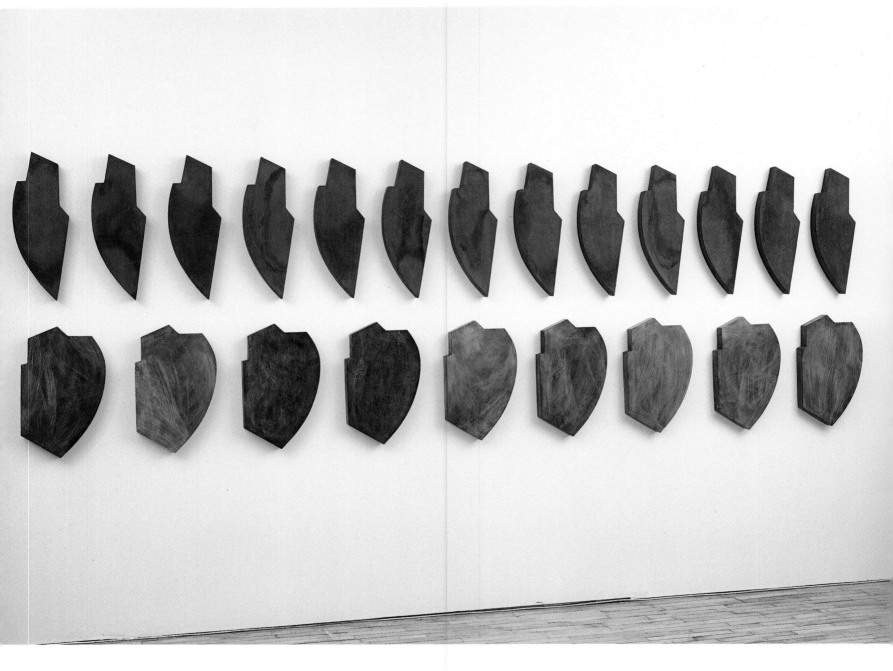

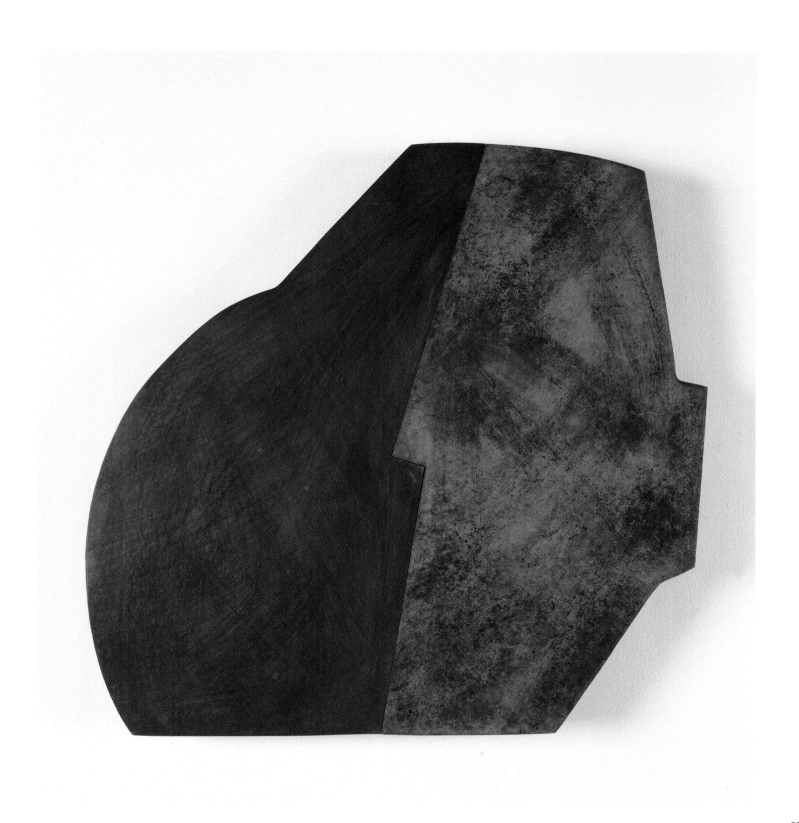

Ore, 1992

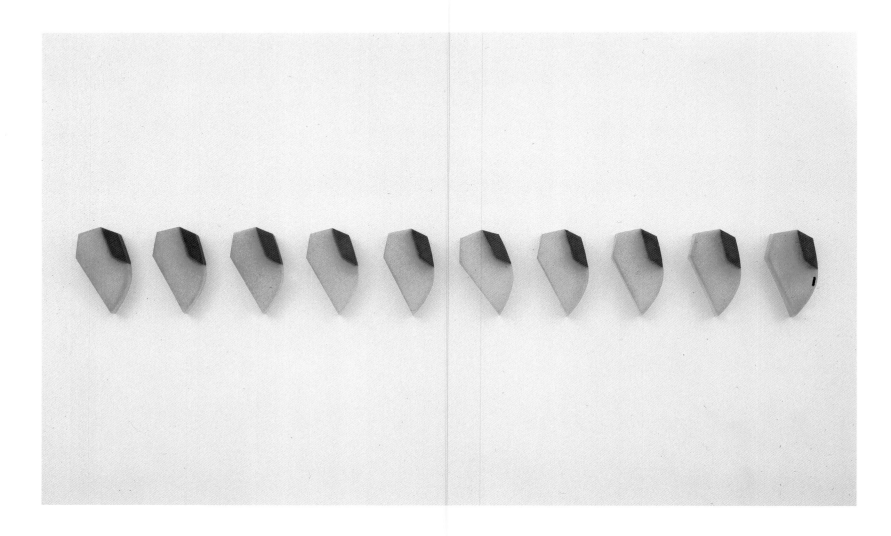

Gift (Lead, Copper), 1993

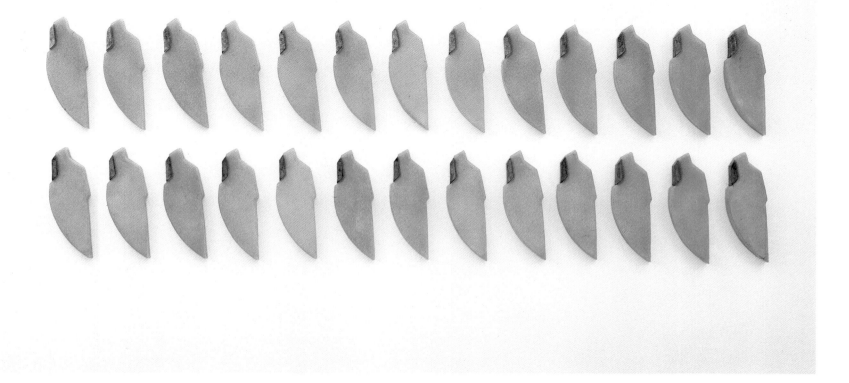

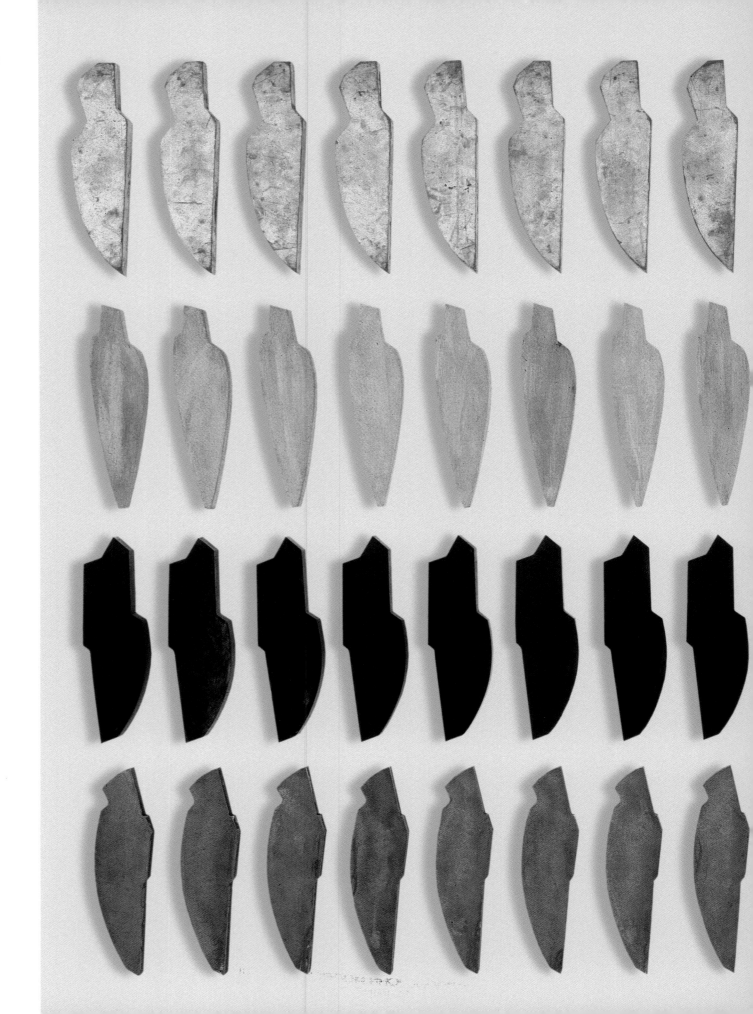

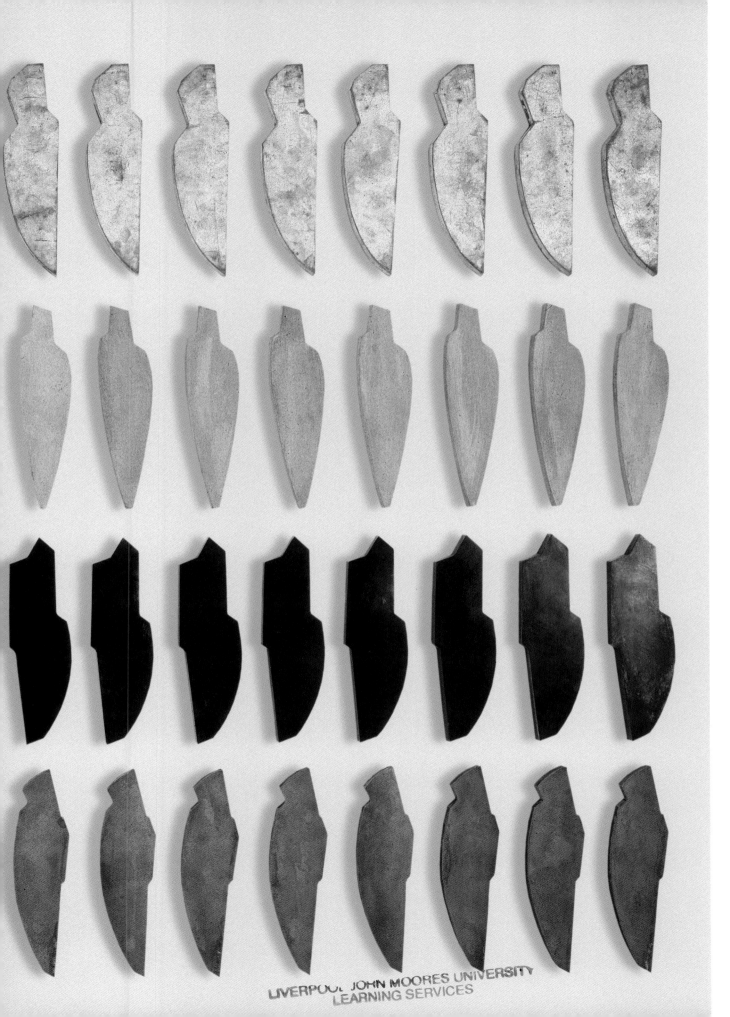

59

Tar Baby, 1993

Red Wait, 1993

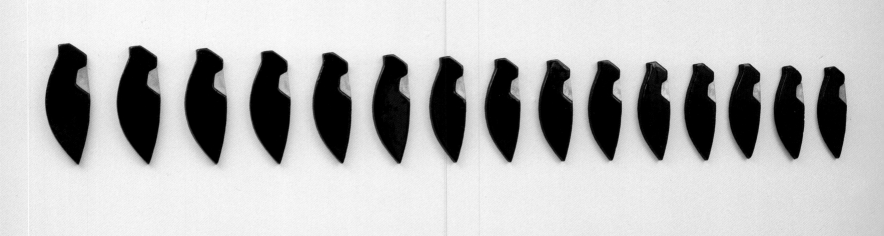

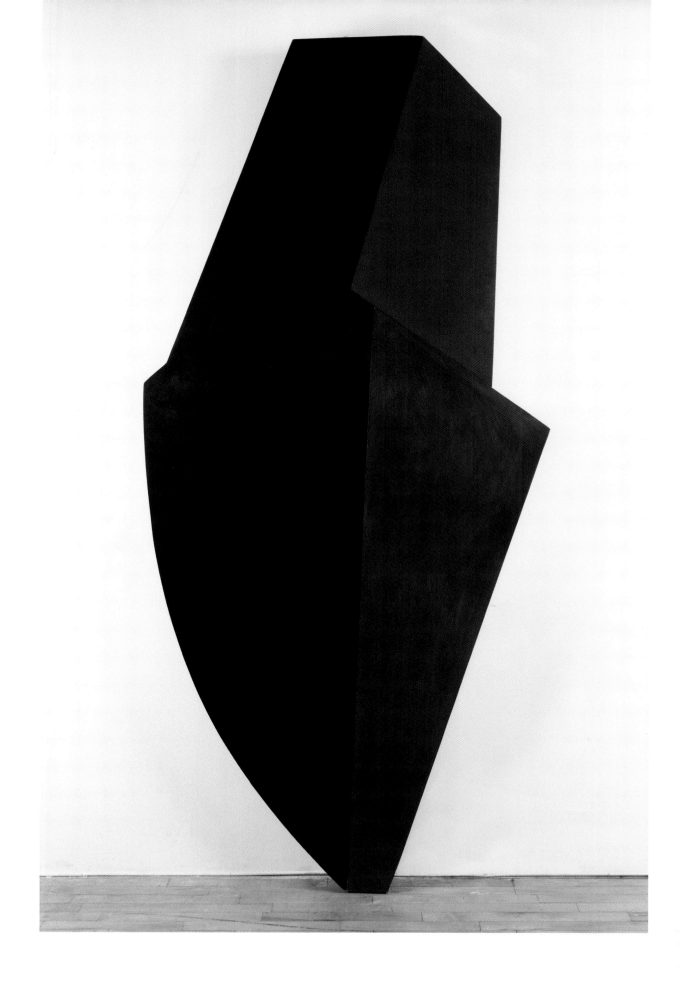

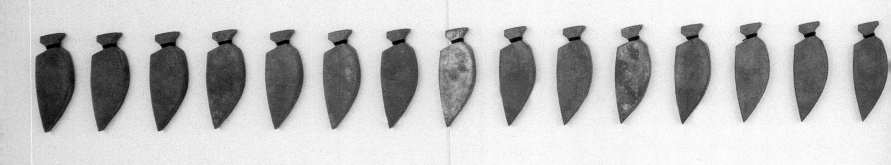

pp. 62–63
Lead Depending, 1993 Sleat, 1993

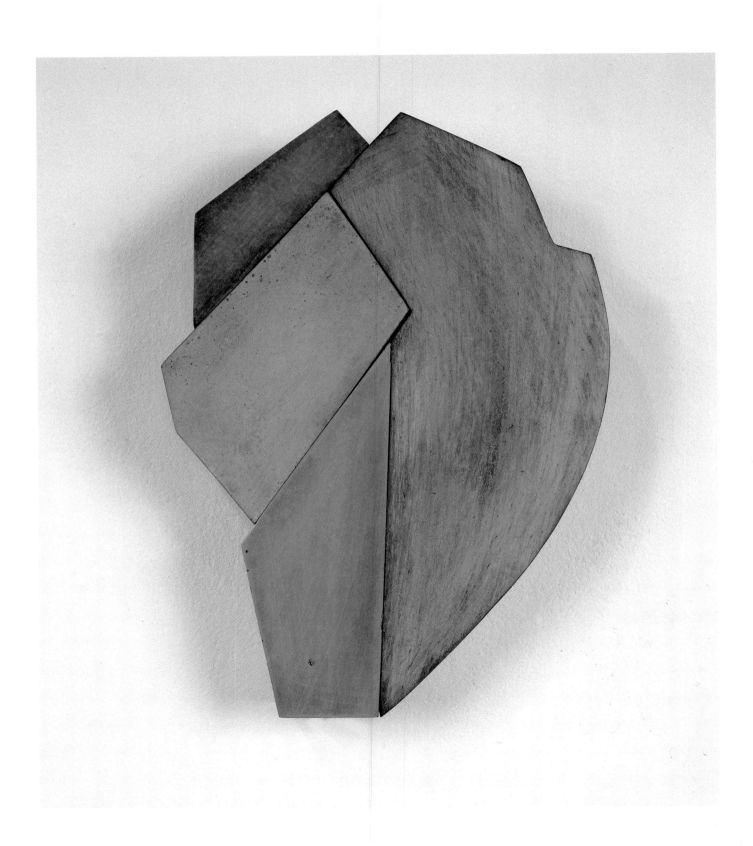

Questa, 1993

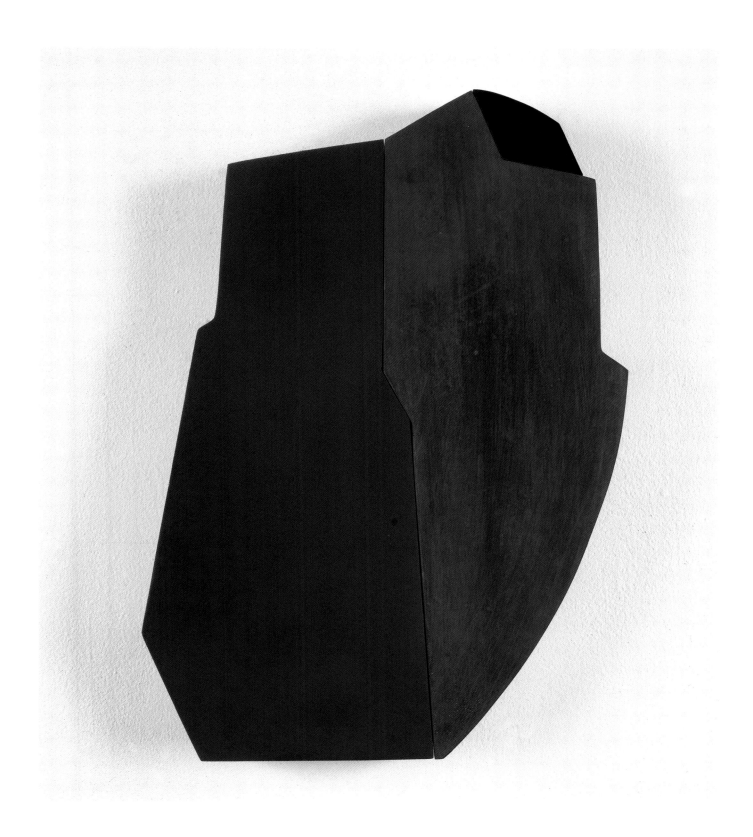

Wicklow, 1994

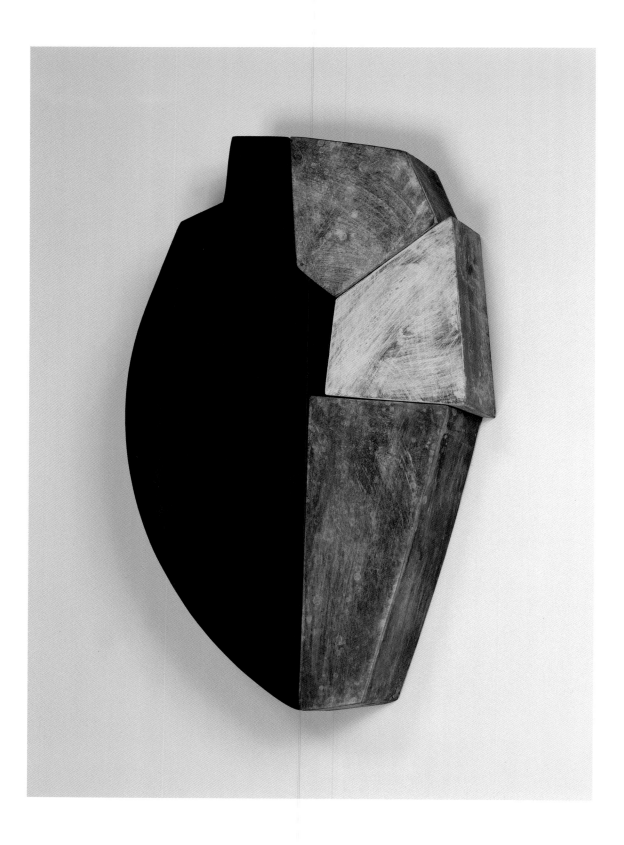

Verona, 1994

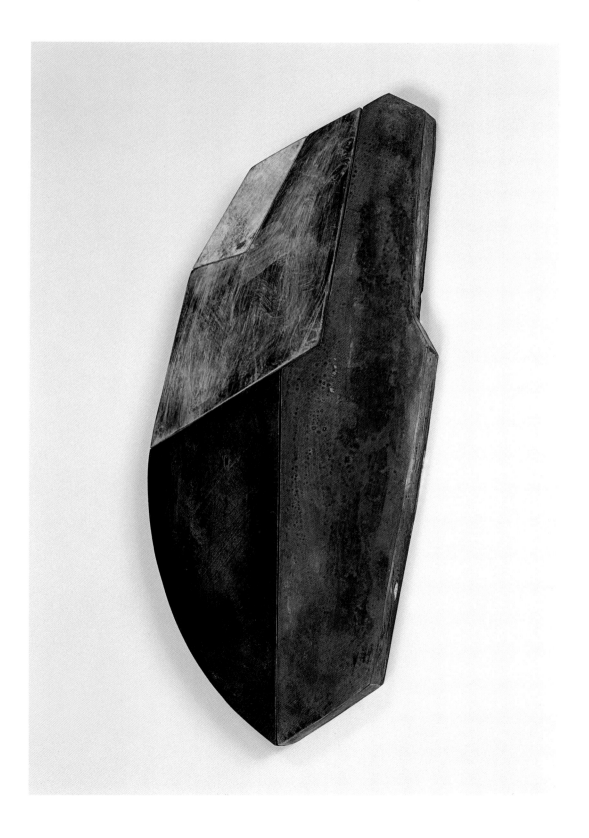

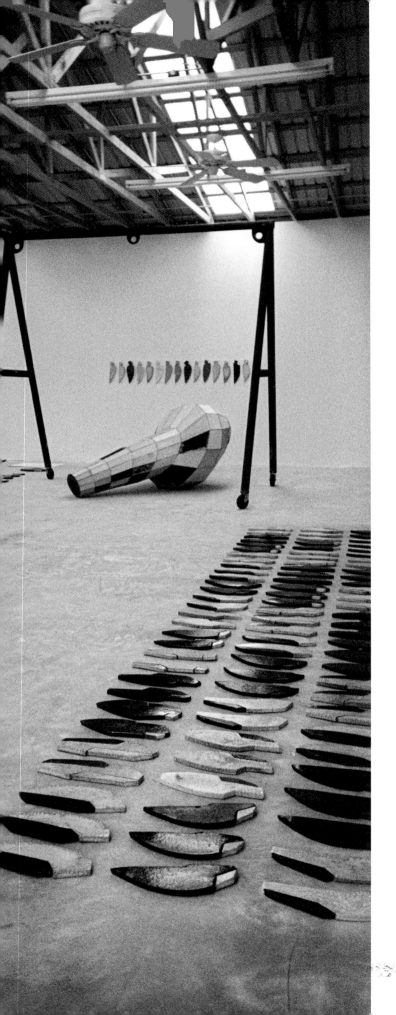

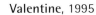
Valentine, 1995

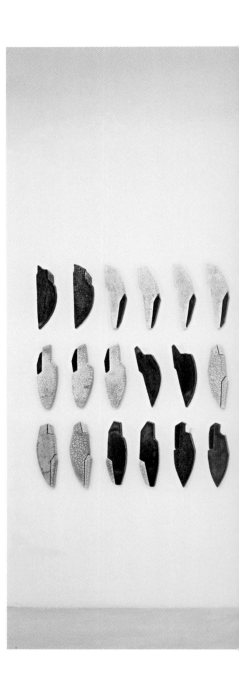

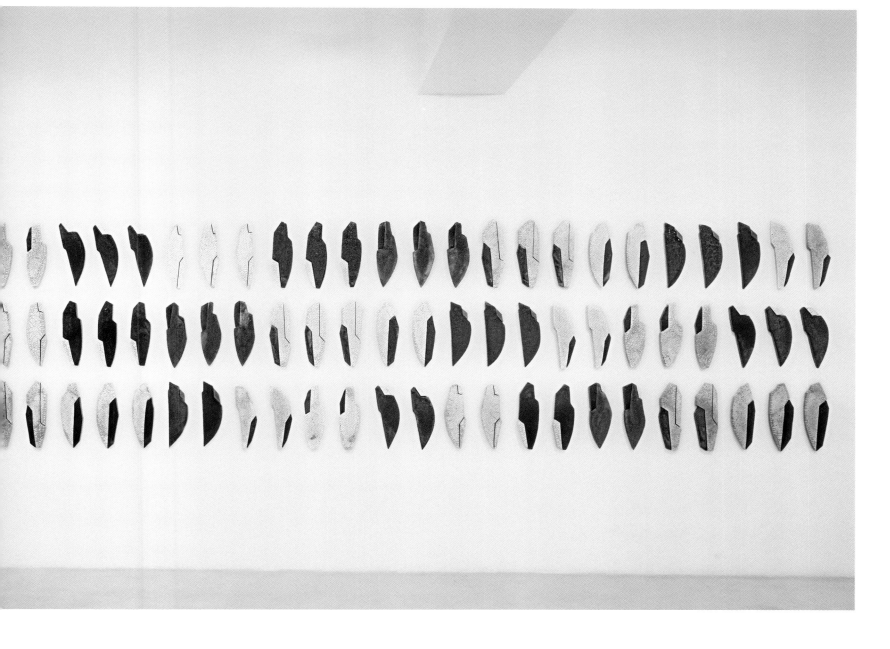

Harbour, 1995

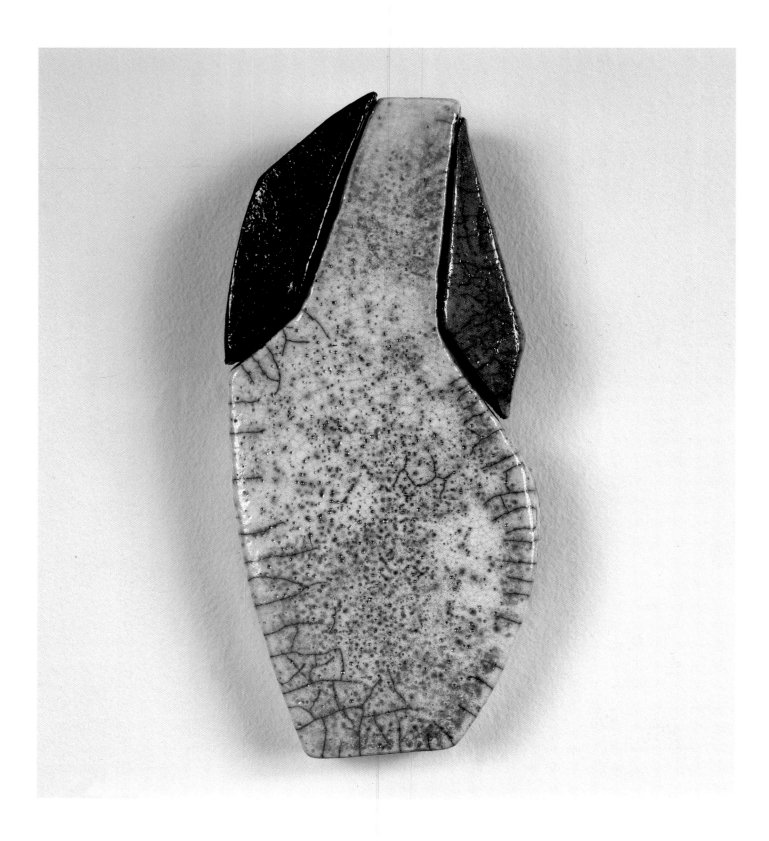

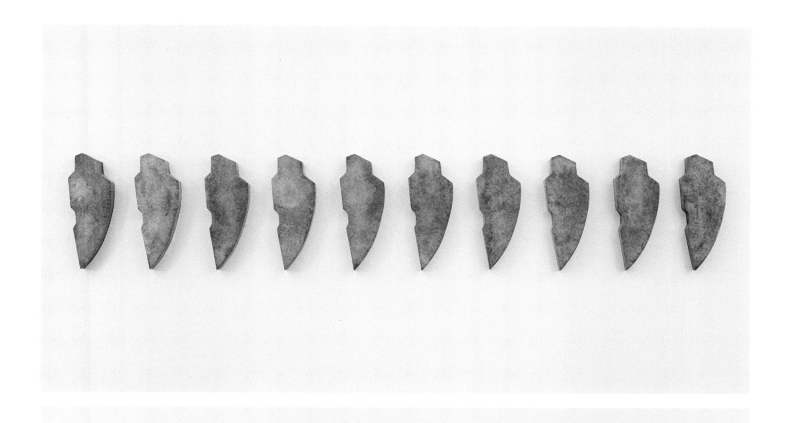

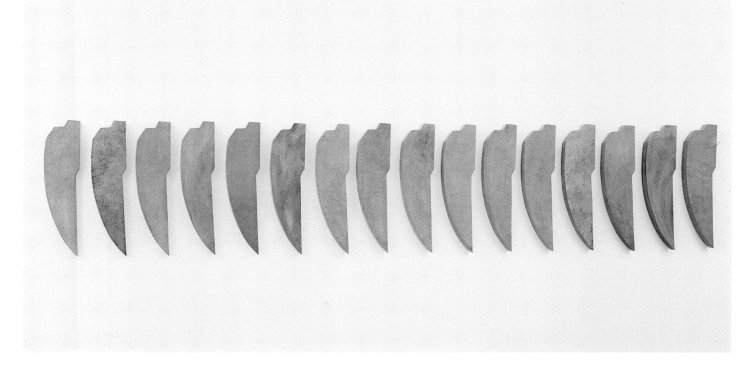

Lilies, 1995

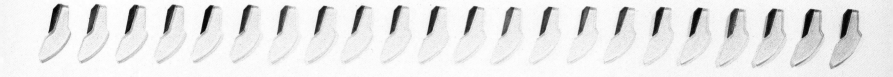

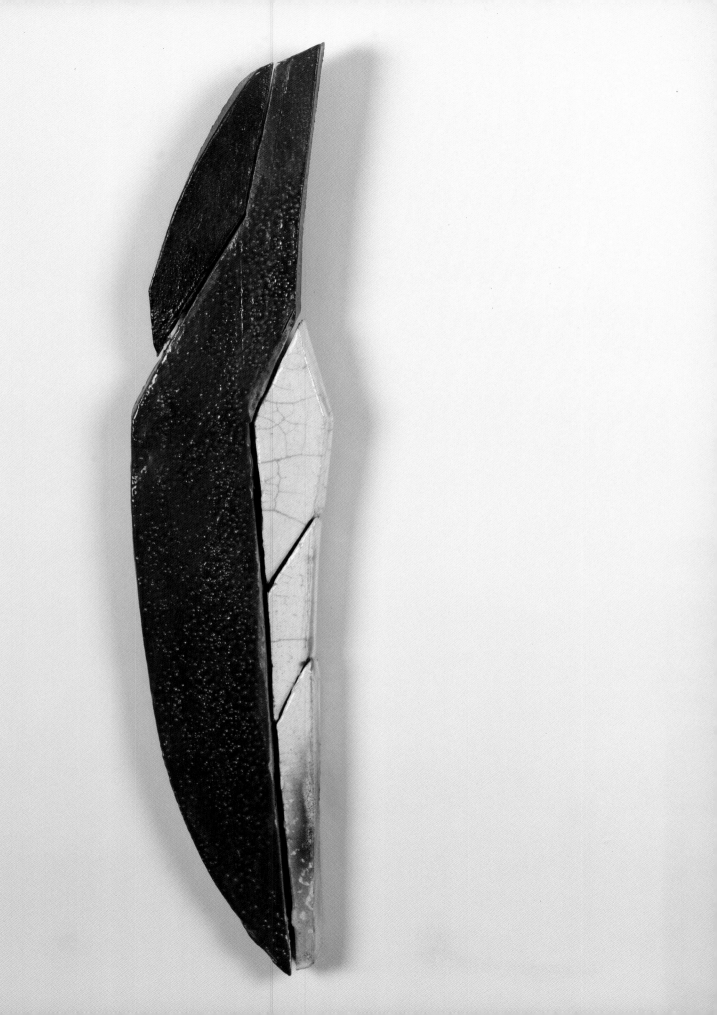

The Blanco, 1995 Bracken, 1996

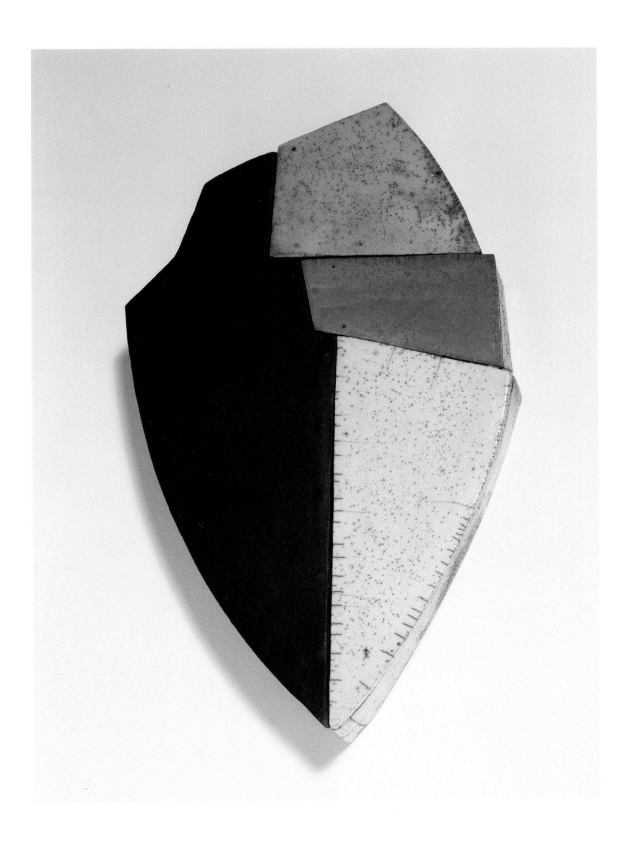

Bronze Plummets, 1996

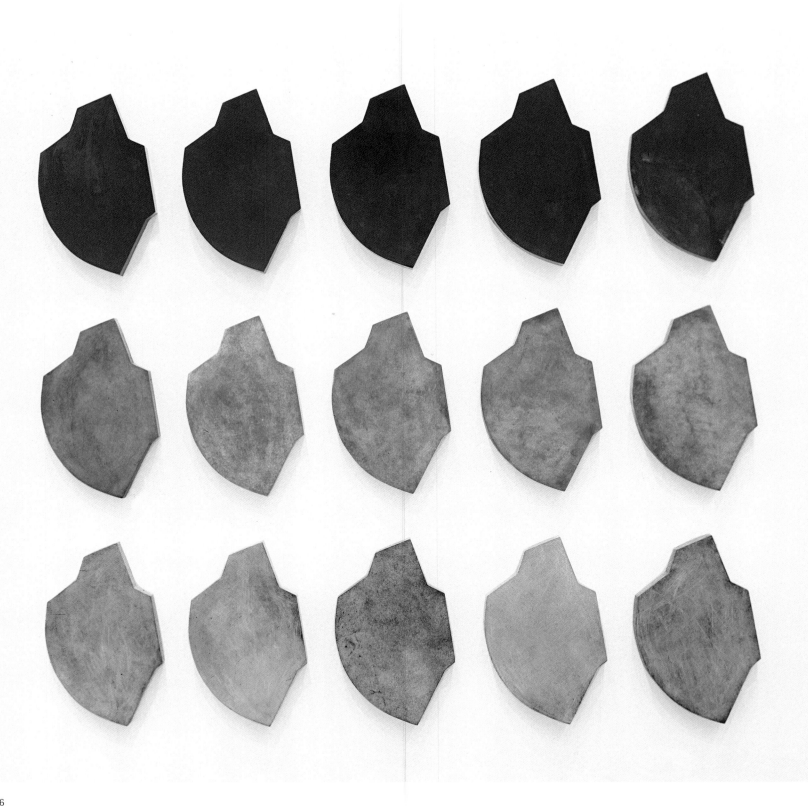

Forebearance, 1996

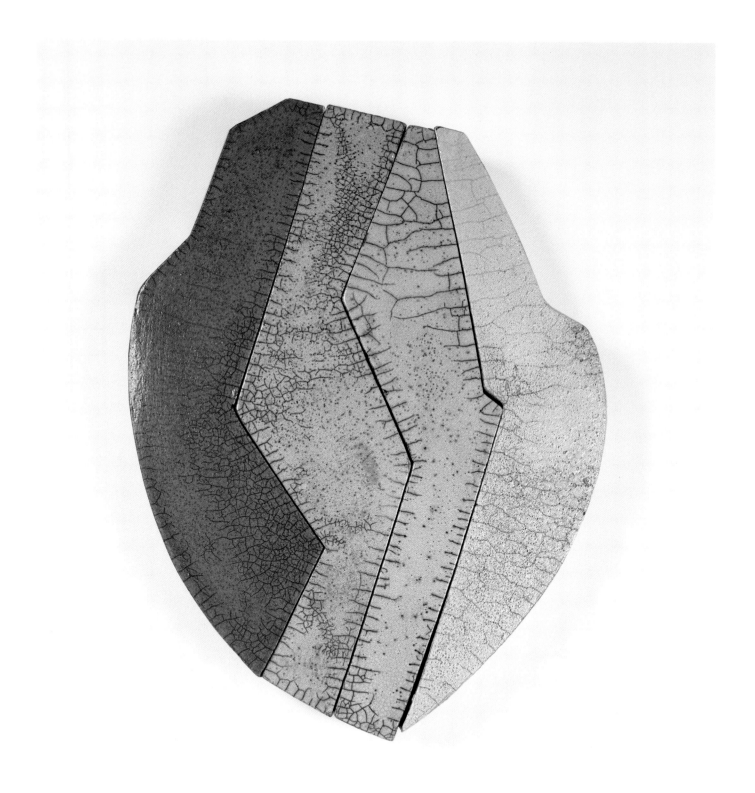

Wishes, 1996

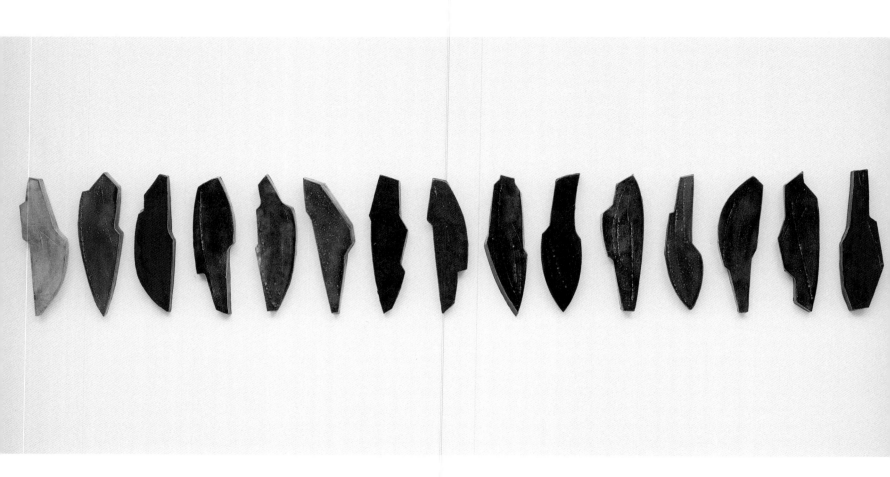

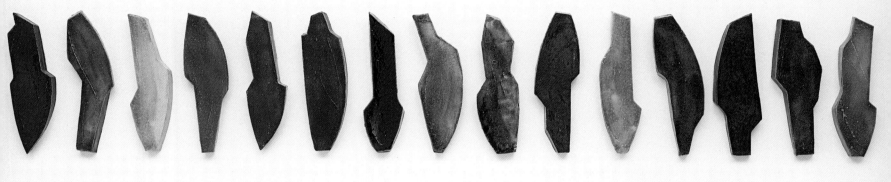

Catherine Lee: Every Form Reflects a Force
Nancy Princenthal

"Visibility is a form of growth," writes John Berger. "The hyacinth grows into visibility. But so does the garnet or sapphire." What Berger means, in part, is that visibility is a process. Appearance is flux and interdependence, he goes on to say, and "looking is submitting the sense of sight to the experience of that interdependence."[1] But Berger also alludes to a very particular, and hauntingly elusive, sense in which the distinction between animate and inanimate can be seen to dissolve under close observation, a quality of seeing that is central to Catherine Lee's work. From her most intimate table-top ceramic objects to the large, free-standing bronze sculptures, Lee's work is endowed with a presence that is simultaneously geological and human. Indeed, although all sculpture can be said to participate in the fourth dimension, demanding from viewers a physical engagement that takes place over time, Lee's sculptures cross a further threshold between still imagery and moving pictures. Their painterly surfaces and distinct, eccentrically shaped facets create isolated images that assemble themselves, as one engages with them in turn, into almost filmic sequences.

Some of the recent, large, free-standing sculptures are named after the Sibyls, and like much of Lee's work they originate in personal experience. She writes: "During the restoration of the Sistine Chapel, I was allowed to go up the scaffolding, and stepping out onto the narrow platform found myself face to face with one of the Sibyls. It was a fearsome moment in my life, the power was immense."[2] The titles of others refer to islands off the coast of Scotland that Lee has visited. The strength of the mythical women and the force of Lee's encounter with them, like the powerful romance of the wind-swept Scottish outcroppings, can be felt in the patinated bronze sculptures' tensile balance and their stout, unshakeable poise, their contours seemingly hollowed and then filled by salt air. The rock-steady *Delphica* (2000), its surface a brackish green, thrusts its regular, rectangular face forward with disarming openness, shoulders squared, chin up. From another vantage point, it appears slightly hunched but still formidable. The bright blue *Libica* (2001) is broader and its contours freer, a gently curved leading edge advancing, with bulky rectangular forms massed behind, like a ship at full sail. *Sibylla* (2000), a lighter Mediterranean shade of greenish-blue, unfolds with even more complexity, its upthrust central element chiselled like crystalline quartz. *Scalpay* (*Hebrides series*, 2004), which like *Delphica* is a deep lightless green, seems from a certain angle to flaunt a pleated, flared skirt; the briny, pale green *Stornoway* (*Hebrides series*, 2004) is broader and more expansive.

Generous though their invitation is to figurative metaphors, Lee's sculptures at human scale (these are roughly five to six feet tall) are nonetheless resolutely abstract. Their relationship to living form can be defined in the terms that Rosalind Krauss used in her early treatise on sculpture, where she wrote that for modernists "sculpture is a medium peculiarly located at the juncture between stillness and motion."[3] Moreover, Lee's descent from high

Modernism and its several idioms can be traced along the same lines that Krauss applies to Minimalism, which she says "can be seen as renewing and continuing the thinking of those two crucial figures in the early history of modern sculpture: Rodin and Brancusi. The art of both men represented a relocation of the point of origin of the body's meaning—from its inner core to its surface—a radical act of decentering that would include the space to which the body appeared and the time of its appearing."[4] To the extent that this equation holds—and its attraction is strong—it is clearly part of Lee's inheritance. Like Rodin, or Judd, her sculptures are manifestly hollow (when not nearly two-dimensional), their lives organised on their surfaces. But the psychological legacy of Minimalism, as Krauss construed it, is less apt. "The art that emerged . . . in the early sixties . . . staked everything on the accuracy of a model of meaning severed from the legitimising claims of a private self."[5] Lee's work ardently embraces personal subjectivity, the only position from which penetrating psychological engagement can be generated—even if it is, in Krauss's terms, a sense of self "constructed in experience rather than prior to it."[6]

Of all the modernist idioms, it is Cubism that is most closely identified with the uneasy accommodation between the real time of perception and the stasis of image or object, between the dimensions of the living world and those of art. The legacy of Cubism is pronounced in Lee's sculpture, a debt acknowledged openly in the tabletop sculptures, which include a current series made in raku and called Cubics. At this scale (the smaller sculptures range from roughly one to two feet high), Lee's vocabulary of form, though consistent with the larger work, assumes a completely different identity. Comparable in size to domestic objects—they are kin in scale to kitchen ware, desktop accessories or boxes for treasured personal items—the smaller sculptures also invoke ritual objects: reliquaries, talismans. They are assembled (like the larger work) from irregular geometric facets, most of them flat but a few gently curved, which meet at junctures that are articulated by little nails. Though Lee uses a standard hardware-store variety (the nails secure the wet clay, and do not melt in the kiln, allowing an unorthodox but singularly freeing technique for joining slabs in raku firing), these distinctive metal details have something of both the jewel-like allure, and discomforting provocation, of metal studs used as body adornment. The association depends on a connection between clay and flesh, between ceramic vessels and human bodies, so deep and established it can hardly be called metaphorical. But Lee's smaller sculptures are powerful precisely because they trouble this connection. Often, they have crackled glazes; they are generally papery white, with occasional facets of aqueous blue. Sometimes seemingly brittle and frail to the point of friability, they are as close to bones as they are to living tissue.

Nonetheless, being made of a substance that starts out malleable, they partake of both. It is pertinent that throughout her practice, Lee favours materials that are changeable. They include, she says, "anything that has been in a liquid state—clay, concrete, fibreglass resin, all sorts of metal. I have difficulties with wood, because it begins as one thing and remains that one thing. Mutability is what interests me."[7] This sensitivity to inherent instability contributes to the distinctive liveliness of the sculptures cast in bronze, a material that more often lends itself to obdurate stasis. Similarly, the smaller table-top objects made of fired clay have some of the protean fluidity with which the material is associated. It can be seen in the instability of their forms, a resistance to formal resolution that echoes the large work but is compounded at the smaller scale. That fluidity is also apparent in some of the glazed surfaces, which shimmer and gleam with a lustre that is specifically watery. The attention to surface in work at all scales reveals a painterly sensibility, and reflects the priorities of Lee's early work, which was in paint on canvas. Reductive but powerfully resonant, the earliest paintings, from the late seventies, were grid-based. By the mid-eighties, Lee had begun to experiment with other support materials and with shaped surfaces. No longer paintings, though still flat, these objects had become wall sculptures, a hybrid that remains of great importance to Lee.

The closest to free-standing sculptures among the wall sculptures are the standing bronzes, which, Lee notes, "are all named for human actions or states of being" and occupy space in a distinctly human way. Red Wait (1993), for instance, is a big (the standing figures are all roughly seven feet tall), roughly shield-shaped cast-bronze form that leans against the wall, its narrow bottom resting on the floor. (In all the wall sculptures, each plane is associated with a single colour, though the composition may include as many as five.) Boldly split down its spine into constructivist-like black and red fields, Red Wait has the martial aggression, and the graceful slouch, of a young soldier standing at ease. In Union Two (1992), which is similarly bipartite, a robin's-egg-blue figure reaching upward seems to cast a deep grey shadow behind and above, which both embraces and threatens its source. About this work, Lee writes, indelibly: "Here is what I think I am about in terms of objective vs. non-objective art. This is not representational, yet it has some sense of two entities in a serious, organic sort of union. One weighs on the other, one lifts, one aspires to higher realms, one is more beautifully coloured, like a duet in ballet, one cannot be without the other. It is not about a union but about union, as a metaphor, as an imperative in life as we know it."

The strength of that dynamic, the irrepressible will toward union, can be seen throughout the wall sculptures, though degrees of tension and complexity vary. Machynlleth (1989; it is part of the Alphabet Series, in which titles refer to places of meaning for Lee, their first letters spanning the alphabet) is a small cast bronze diptych of irregular rectangles that combines a greenish field above and a sea-blue field below to create a landscape of imperturbable serenity. In the alphabet work Quincey (2003), a

tight-knit tripartite composition in blue and rust, as in the fan-shaped *Kilkenny* (1998), in greys and greenish-blue, there is the unyielding opacity and gravity (in both senses) associated with Richard Serra's oilstick drawings, or early encaustic paintings by Brice Marden. David Carrier has compared Lee's work to the shaped canvases of some minimalist painters[8] and indeed early paintings by Frank Stella come to mind, as do those of Robert Mangold, whose intuitively-determined geometries, and the time it requires to discover their logic, seem particularly relevant to Lee's work.

Often Lee's wall works suggest puzzles; they also evoke tribal artefacts, including not just shields but also masks (and in fact, one wall work is named as such). All three associations come into play in such ceramic wall-works as *Loft* (2000–2004) and *July* (1995–2004). Both involve a quartet of irregular shapes, dominated by the strong graphic colours of white, black and red, joined together into tight-knit but unfamiliar wholes: notched medallions, a saw-tooth-sided faceted oval. Forebearance (1996), in pacific shades of white and pale blue, is also reminiscent of a shield, but fractured vertically by jagged seams and, further, by crackle glazing. The misspelling of the title is deliberate; the word appears, in this form, in the first line of a poem Lee wrote for Cormac McCarthy. It inclines, she says, toward two complementary meanings (parentage, as well as dogged patience).

Some of the most difficult to define of Lee's works are the wall sculptures composed serially, in small, regularly spaced units that are similar but generally not identical. The individual components of these repeating works often combine menace and protection: knives and shields, or amphorae and lynched bodies. *Forty Faults* (1989), the first of the repeating works, refers, Lee says, to the grid-based early paintings; in its dagger-shaped forms "the beat, the pattern, moves more piercingly out into space". *Shards* (1989–2004), also from early in this body of work, makes reference in its title to archaeology, a practice —unearthing the past and participating in its preservation—that contributes to Lee's thinking on many levels. Carter Ratcliff has written that the allusions in this work to pottery shards and arrowheads invoke "a time when culture had not yet begun to extricate itself from nature"[9] and indeed this distinction (among others) is often blurred in Lee's sculpture, and in the repeating works in particular. The twenty-one blade-like, wing-like iron forms of *Outcasts Water Iron* (1990) are typically multivalent. The title, Lee says, "refers to the casting process, of course, but also to something that is so dangerous as to be exiled. They have a sense of foreboding, perhaps it is the weight of the iron."

Lee likens the slender, arching blue forms of *Bronze Flight* (1990) to angels' wings, a comparison anomalous for the simple joy it evokes. In *Other Voices* (1993), there are four rows of sixteen units each; the first is of aluminium forms that look much like daggers. Next are copper forms closer in shape to trowels. They are followed by iron forms that seem a hybrid of knives and platters. Last are vaguely knife-like bronze shapes. The repe-

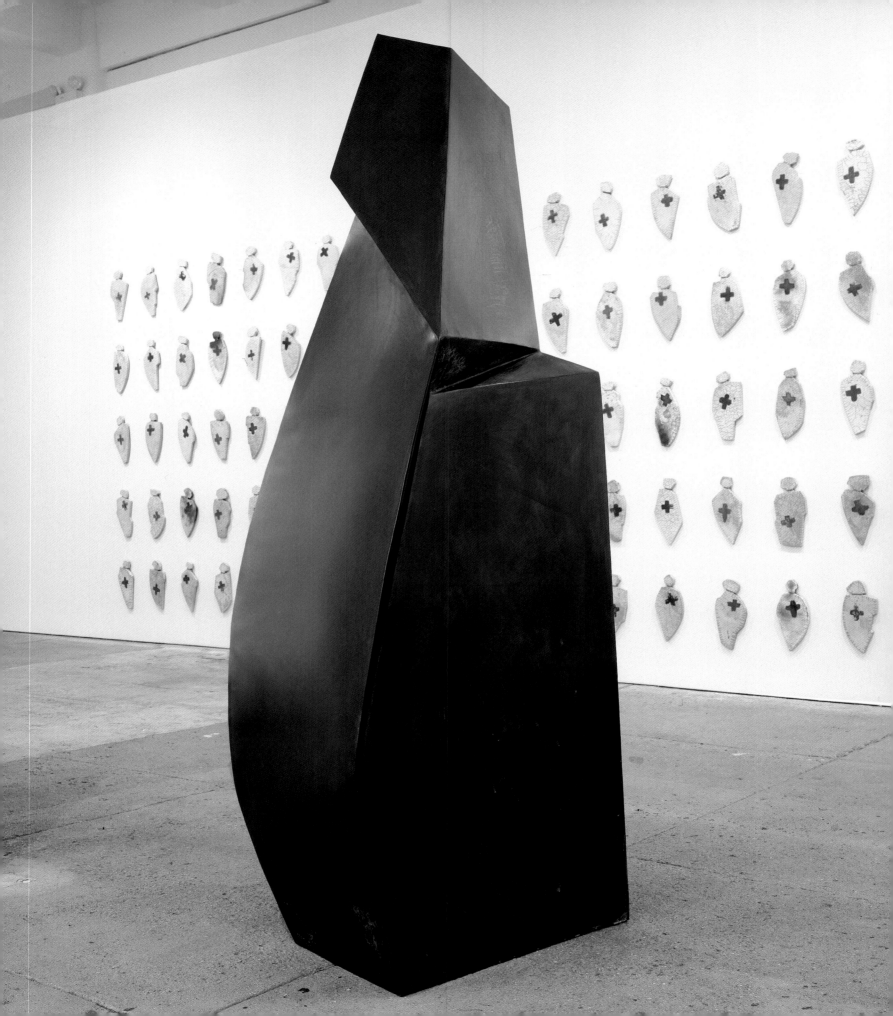

tition of the blade forms undermines their menace, and makes them more equivocal, though not less potent: they establish a climate of ordinary danger, of violence regular as tableware. *Archaic Figures* (2004) is comprised of eight glazed raku shapes that are also close to broad-bladed knives, though the material of which they are made links them as well to serving trays. Among the darkest of these works is *To Alabama* (2002–2004). Three years in the making, it involves 110 unique units, each of which has a small handle/head, and a stoutly curved and pointed body. All are hung—a double meaning is surely intended—by copper wire collars; each has a black cross at its heart. "I'd never allowed an interior mark before, and didn't know what they were or where they came from," Lee says, explaining that this work emerged after the death of her beloved dog, Alabama. "I think now that they are bandages. Mine or hers, I don't know."

In a cultural moment when digital technology has made mechanical reproduction nearly obsolete, the creation of repeating forms by hand is a provocative anachronism, a discipline that is close to ritual, if too physically demanding to be called meditative. But it is not ahistorical: Eva Hesse's perturbations of the grid are involved, as is Alan McCollum's exploration of natural replication. At once impersonal and intimate, the repeated handmade forms refer to seminal modernist encounters with functional design, including the Arts and Crafts movement and the Bauhaus, with their concern to restore dignity to objects of general consumption. These are the most basic coordinates of the field on which Lee's repeating sculptures take shape. But in all her work, physical and metaphorical solidity are set in counterpoint to inherent vulnerabilities. Stubbornly repetitious though they may be, or obdurate in their integrity, Lee's sculptures suggest a tendency to fracture—whether, as in the standing bronzes, into disparate facets, or, as with the crackle-glazed ceramics, into irrecoverable fragments.

In the pressure throughout Lee's work of gesture against stasis, inflec-tion against uniformity, there is evoked a theme explored by Guy Davenport in his essay "Every Force Evolves a Form". In it, Davenport traces the recurrence in poetry of the bird as daimon, a nearly universal figure (and particularly potent before the era of mechanised manned flight) of transcendence. Davenport begins with Wordsworth's robin redbreast, and progresses to (among others) Poe's raven and Whitman's osprey. "Time for Poe was the monotonous tick of the universe, the unstoppable tread of death, coming closer second by second (like walls closing in, the swing of a pendulum, the sealing up of a wall brick by brick, footsteps evenly mounting a stair) . . . Whitman's time was tidal, migratory, the arousal and satisfaction of desire."[10] The saturnine Poe is trapped, and feverishly propelled, by the mechanical repetitions of his own lyrical invention, while Whitman soars, tethered only by the arc of yearning. These antipodes exert their attractions in Lee's work, too, which is pulled equally by the regular pulse of material necessity and the soaring flight of sheer sensual delight.

1. John Berger, "On Visibility," in The Sense of Sight (New York: Pantheon Books, 1985), p. 219.
2. All otherwise unattributed quotes of the artist are from e-mail correspondence with the author, May 2005.
3. Rosalind Krauss, Passages in Modern Sculpture (Cambridge, MA and London: The MIT Press, 1981), p. 5. William Tucker's formulation, à propos of Rodin, is in some respects complementary: "The life of sculpture has in fact always subsisted in [the] gap between the known and the perceived." (William Tucker, The Language of Sculpture, New York: Thames and Hudson, 1974, p. 145).
4. Ibid., p. 279.
5. Ibid., p. 266.
6. Ibid., p. 230.
7. Carter Ratcliff, "The Art of Catherine Lee", in Catherine Lee: Alphabet Series and Other Works (Seattle: University of Washington Press, 1997), p. 10.
8. David Carrier, "Catherine Lee's Art", Outcasts: Catherine Lee (Munich: Lenbachhaus, 1992).
9. Ratcliff, op. cit., p. 26.
10. Guy Davenport, "Every Force Evolves a Form", in Every Force Evolves a Form (San Francisco: North Point Press, 1987), p. 155.

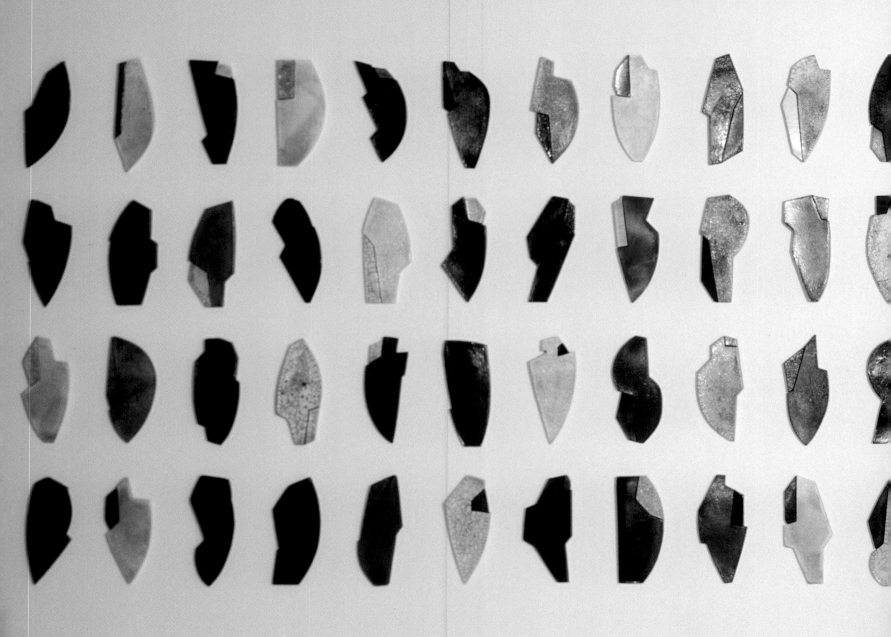

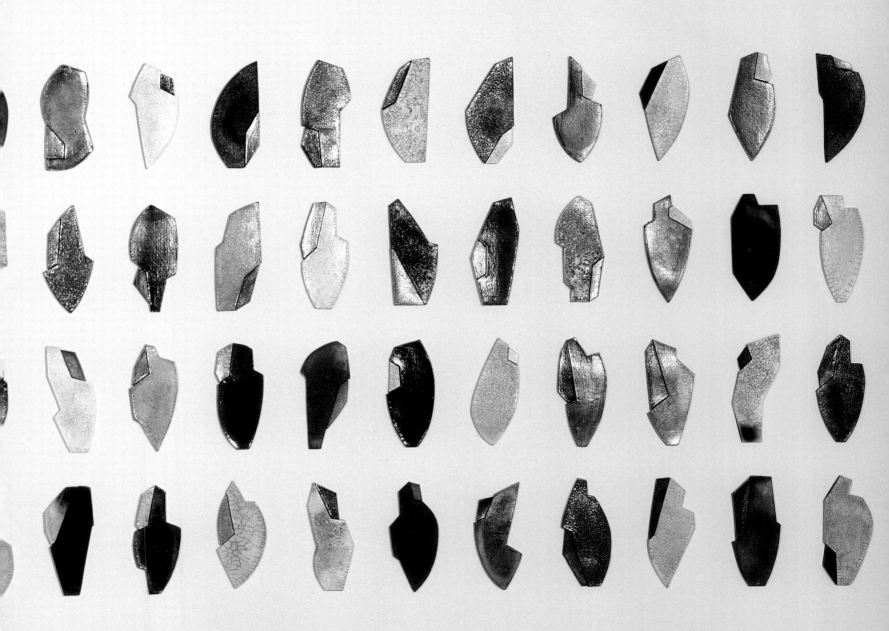

pp. 86–87
Granted Wishes, 1997

Ixtlán del Rio, 1997

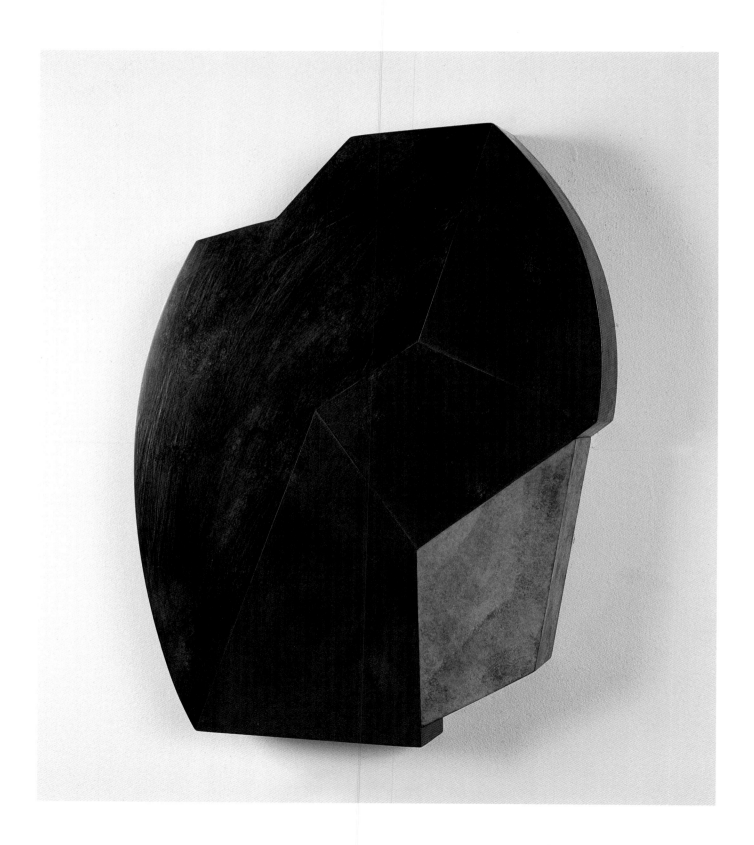

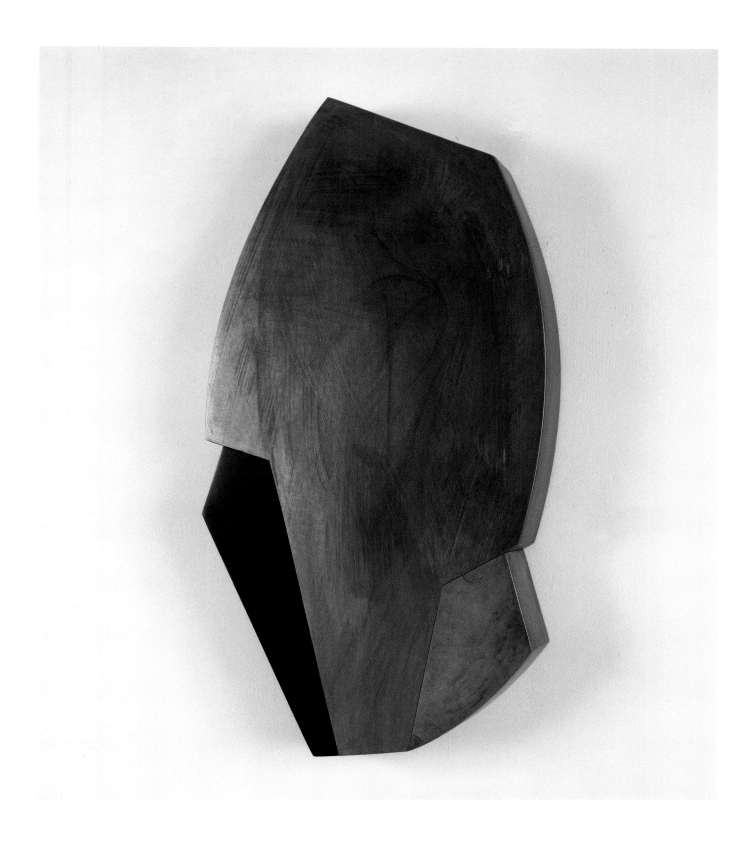

Cape Fear, 1997

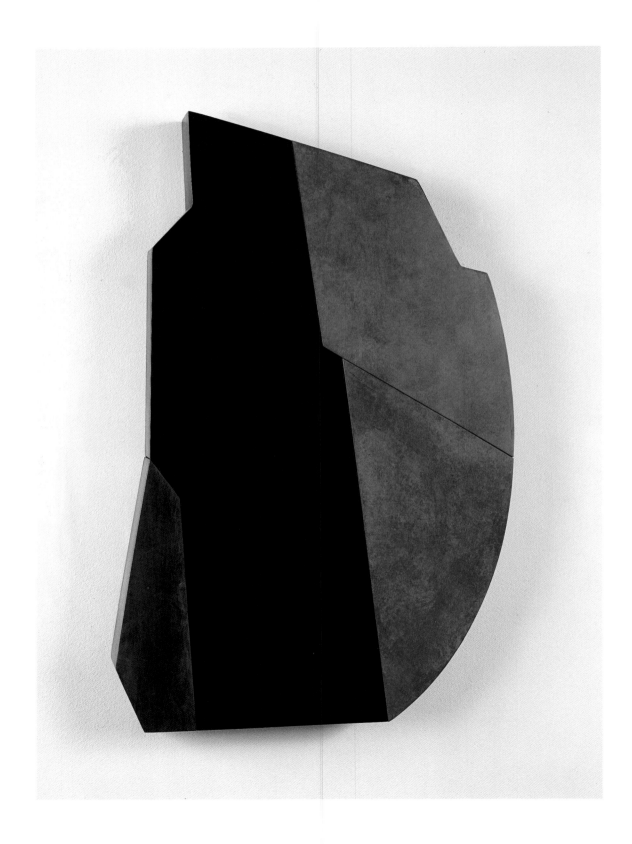

Henderson's Swamp, 1997

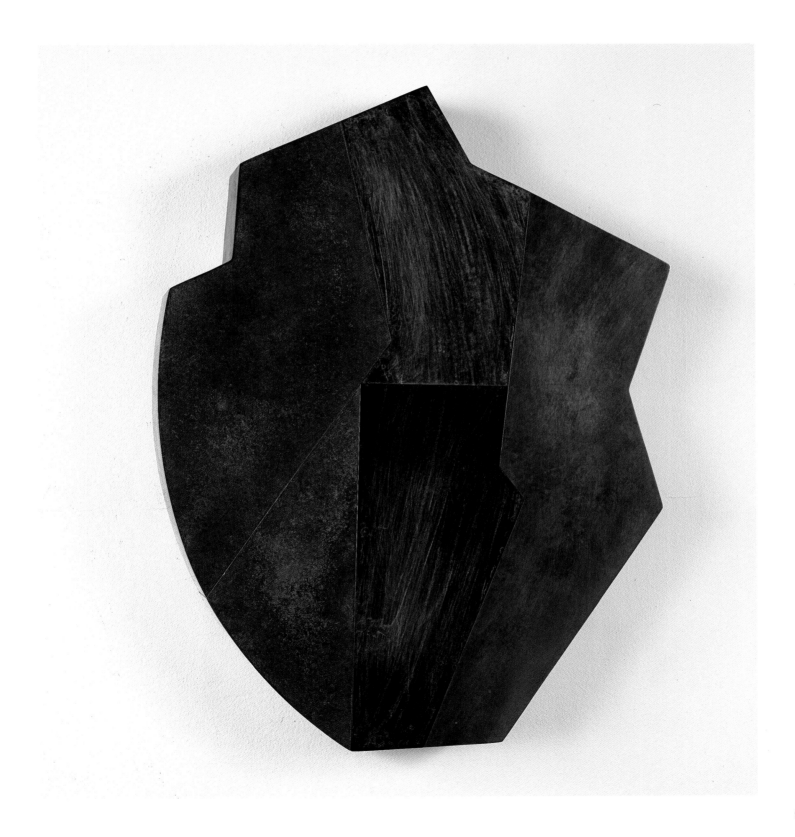

Catherine Lee
Galerie Karsten Greve, Paris, January 1998
Photo: Manfred Förster

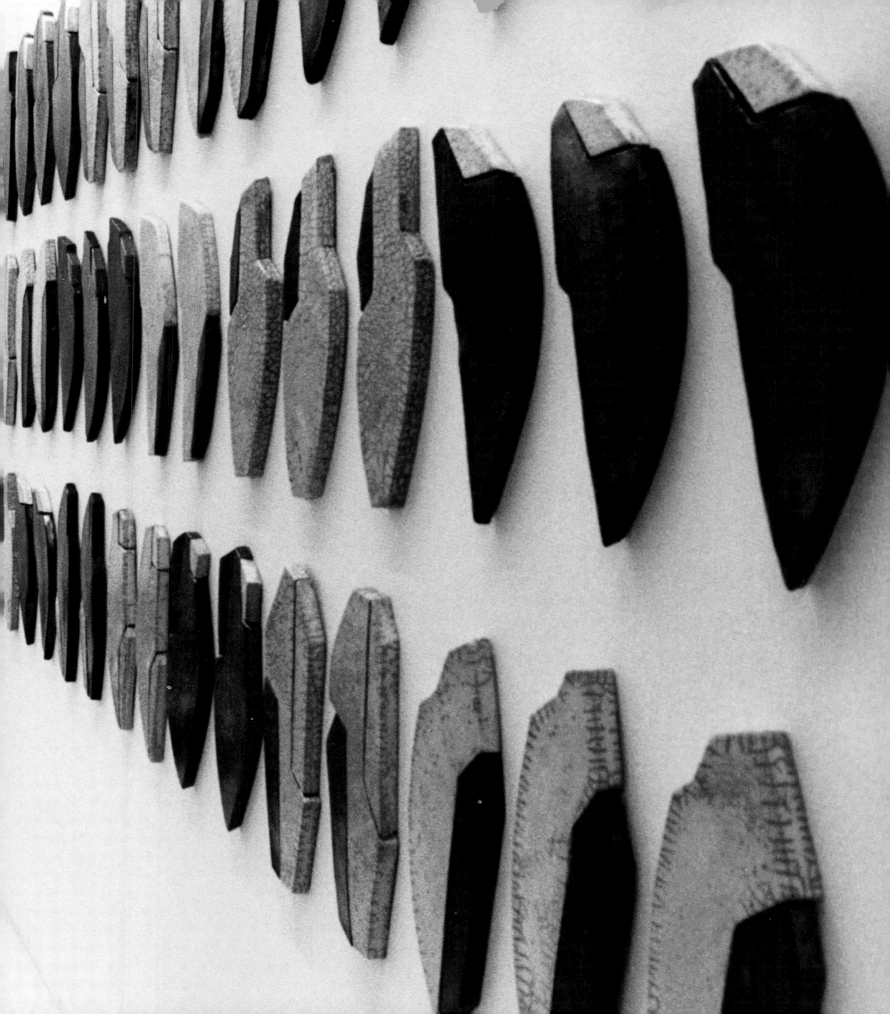

Kilkenny, 1998

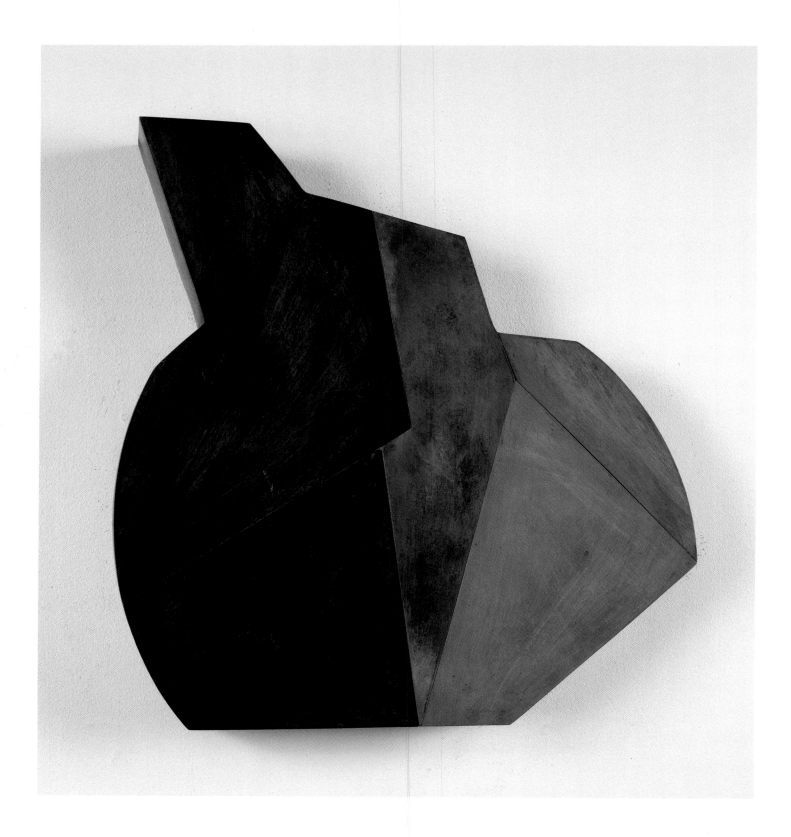

Travelers, 1998

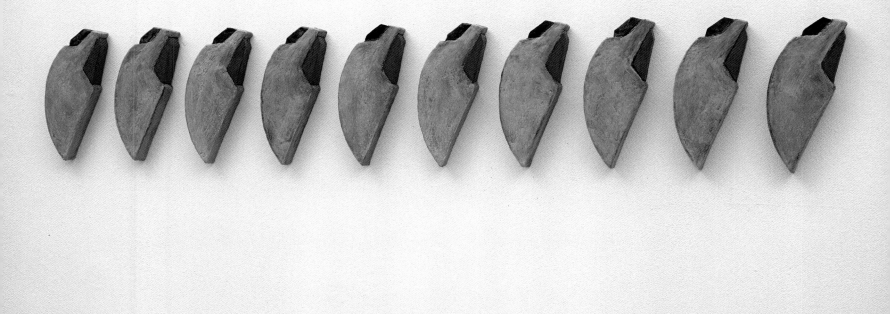

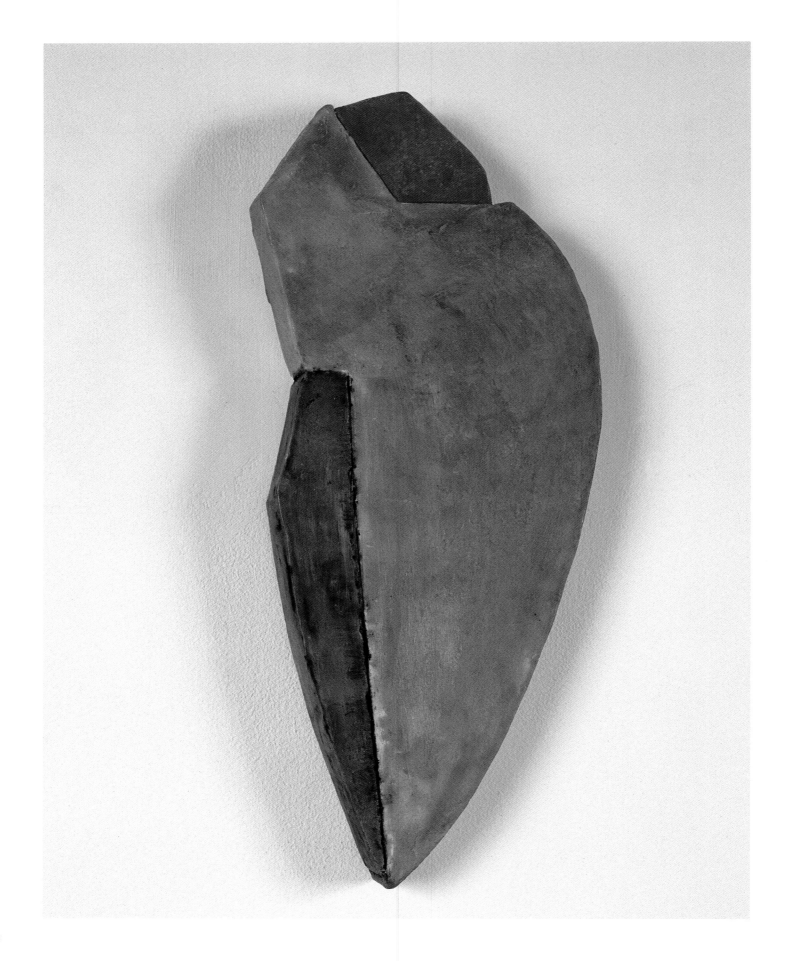

Waxen Minds 4, 1998 The Sea The Sea, 1998

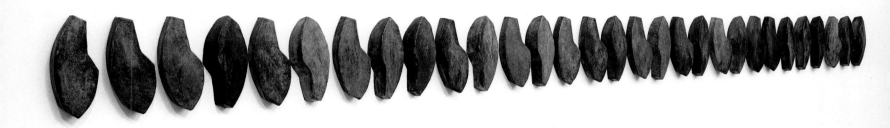

Waxen Minds Twelve, 1998

pp. 100–101
Voyager, 1998

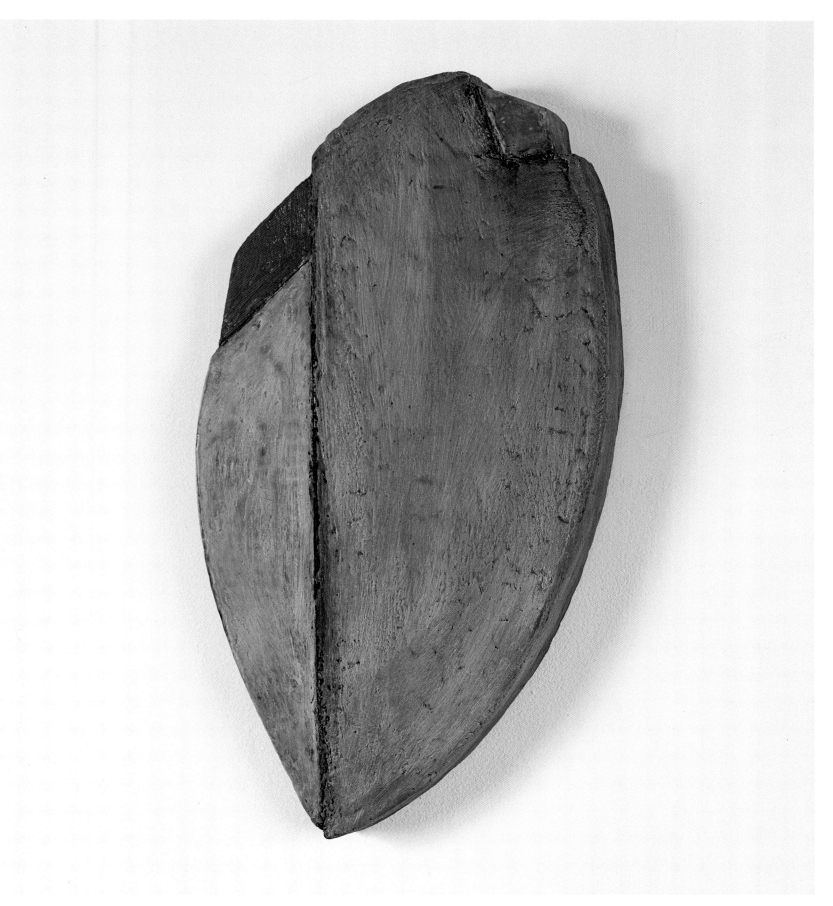

99

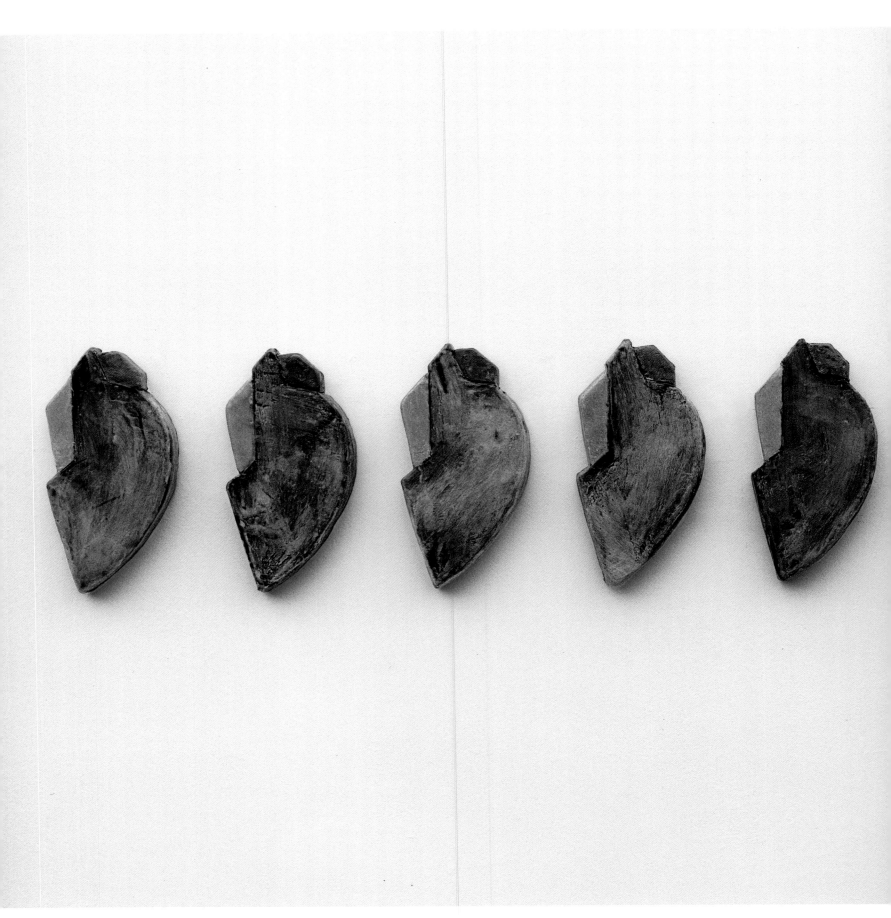

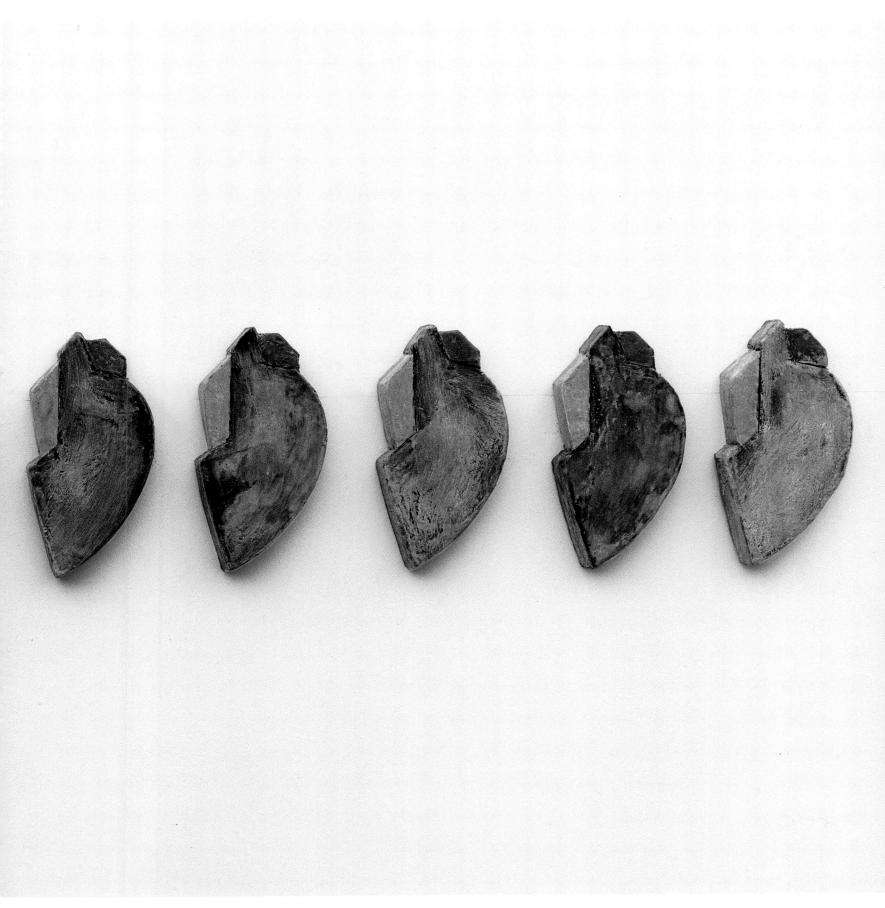

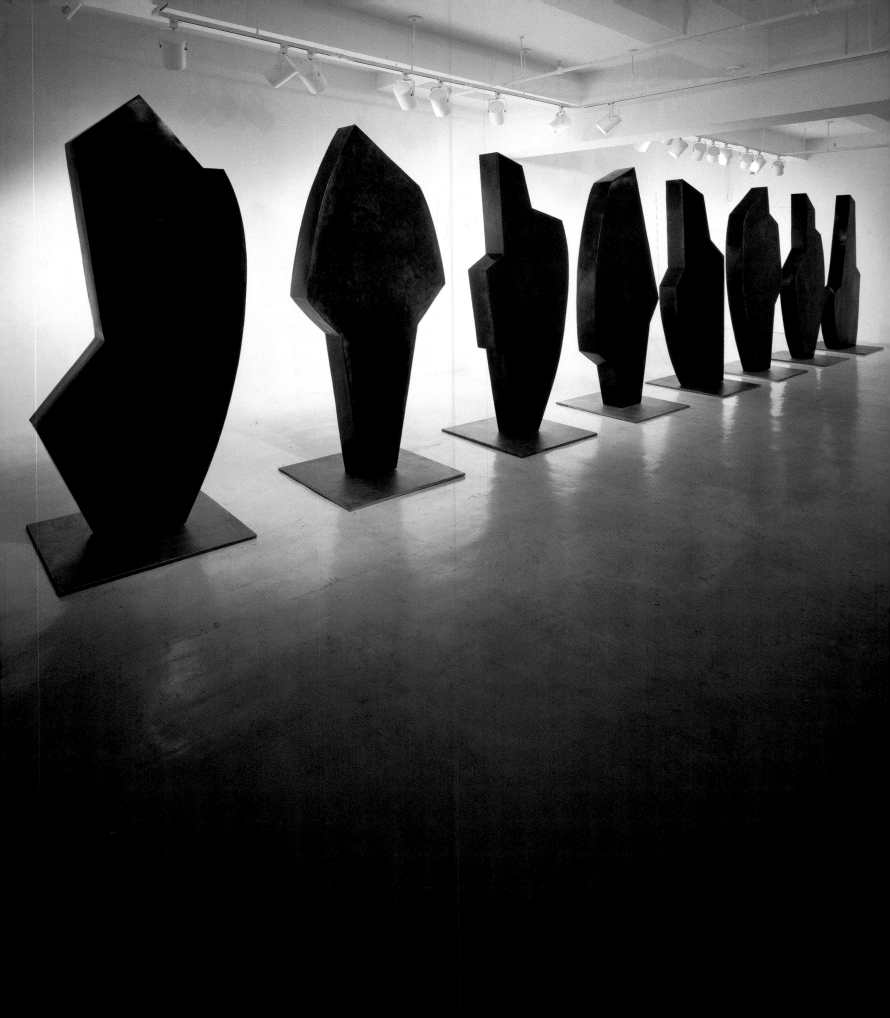

Sentinels, 1999 Sentinel VIII, 1999

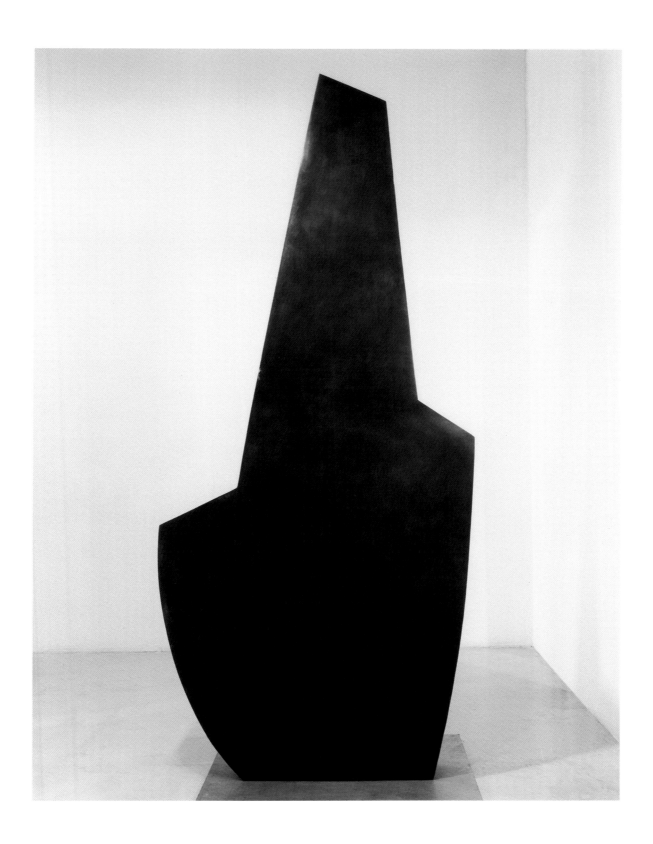

Sentinels, in progress, 1999

Wooden Sentinels, in progress, 1999

Wooden Sentinels, 1999

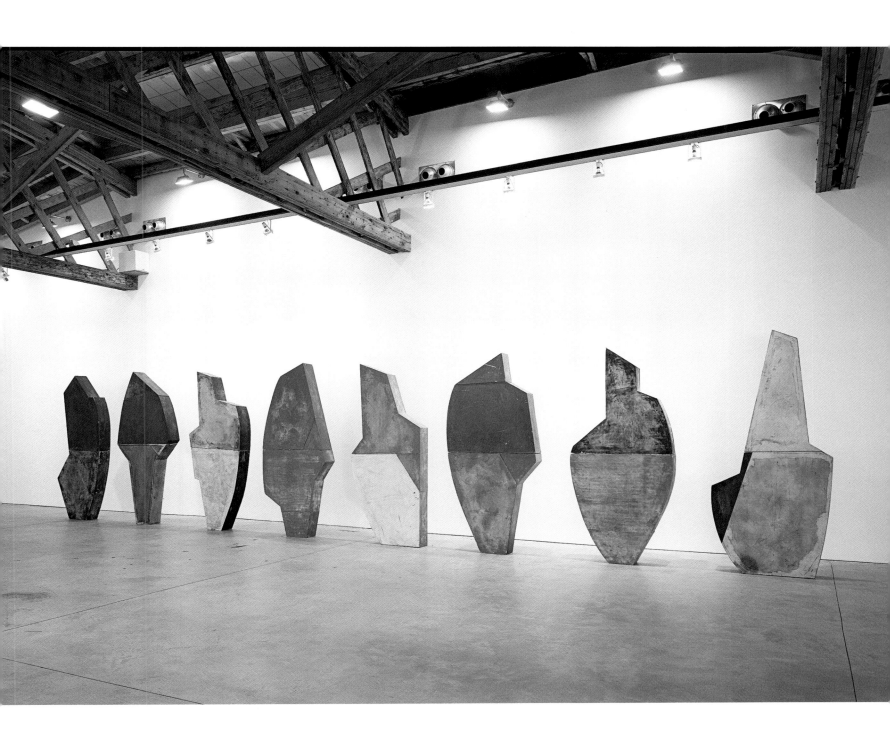

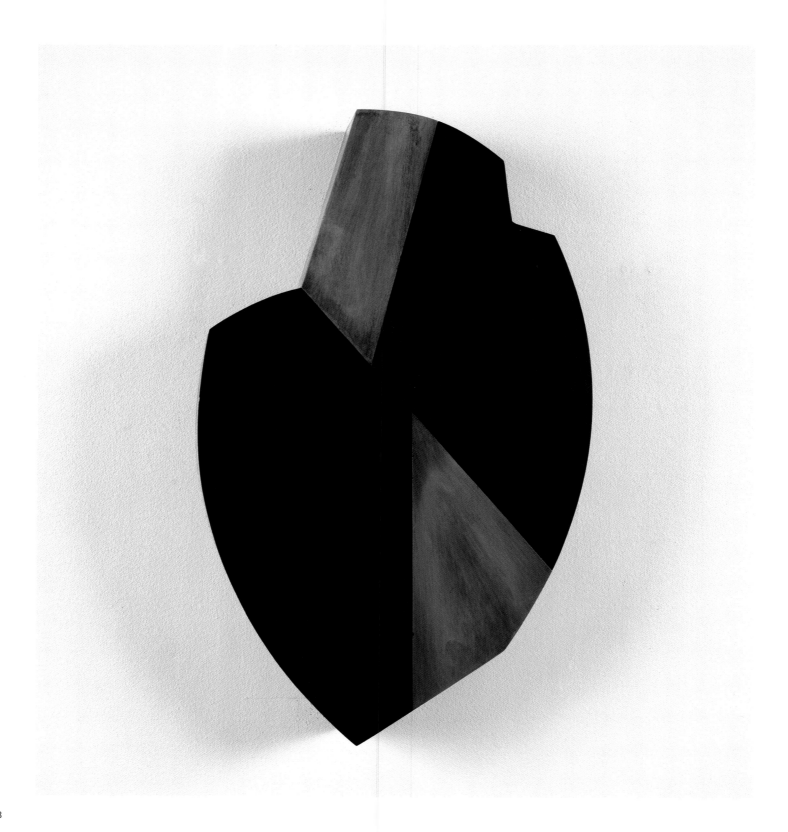

Martindale, 1999

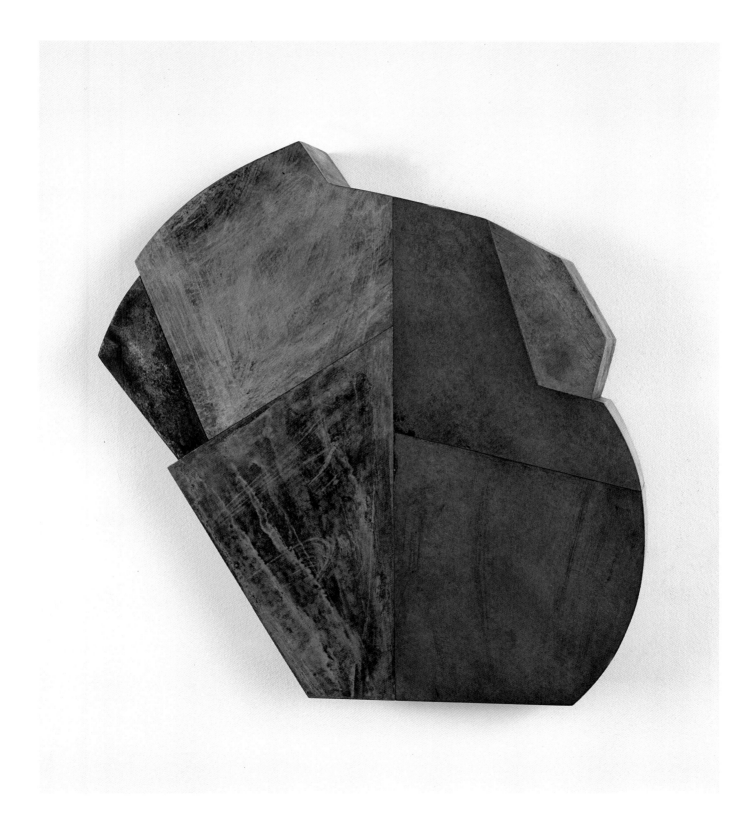

Laredo, 1999

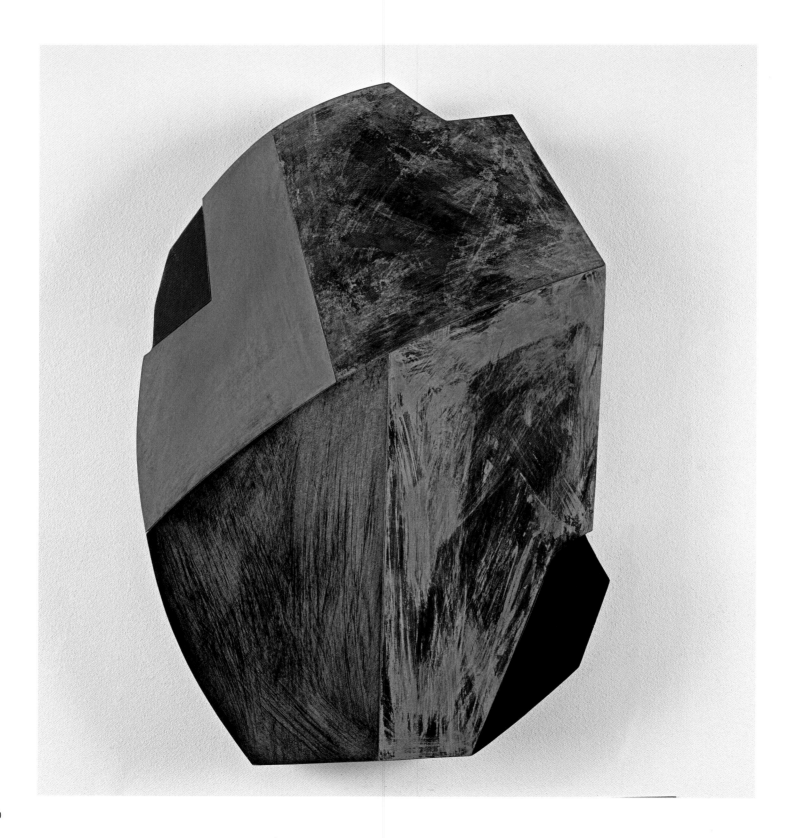

Vox, 1999

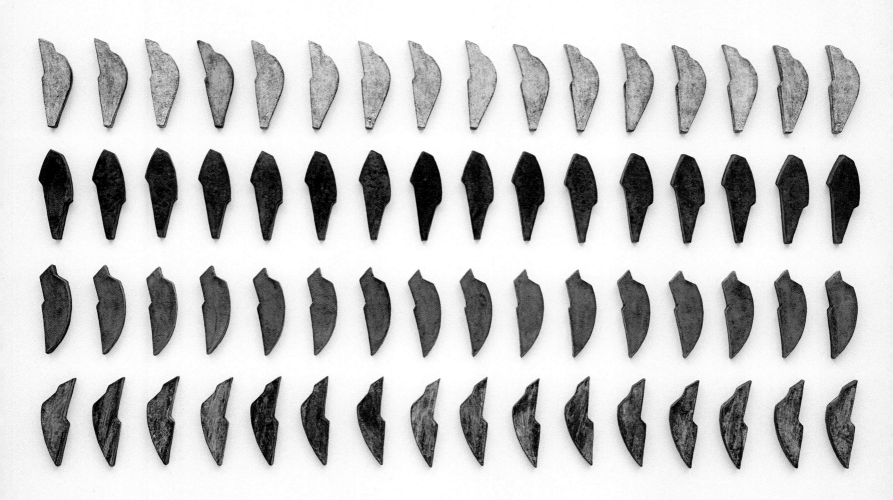

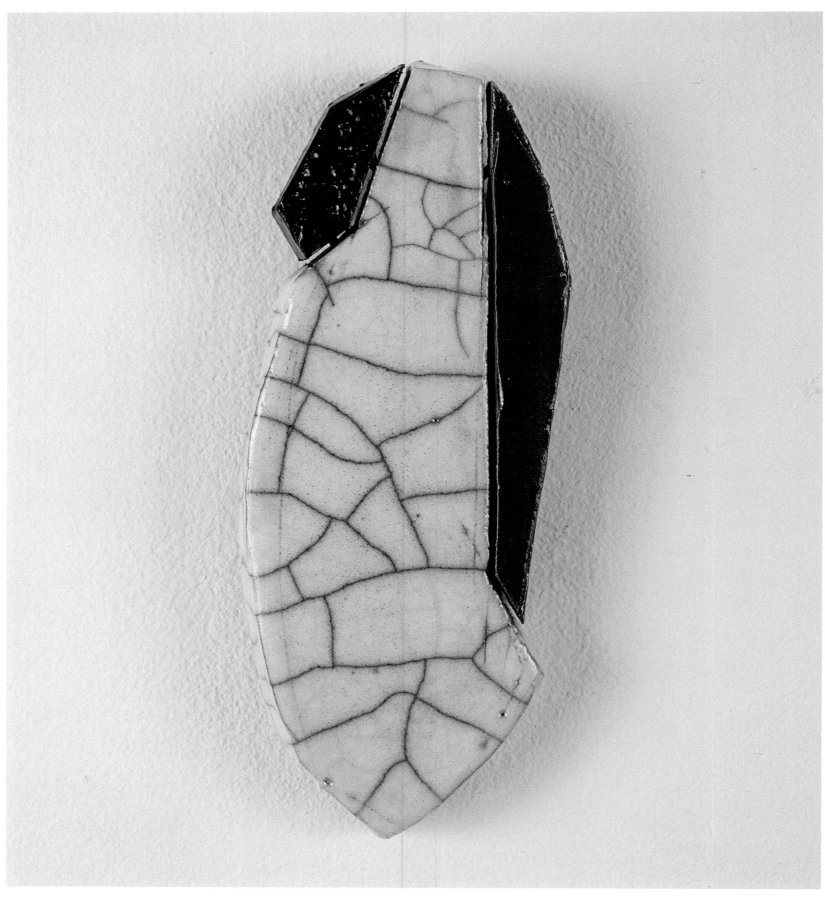

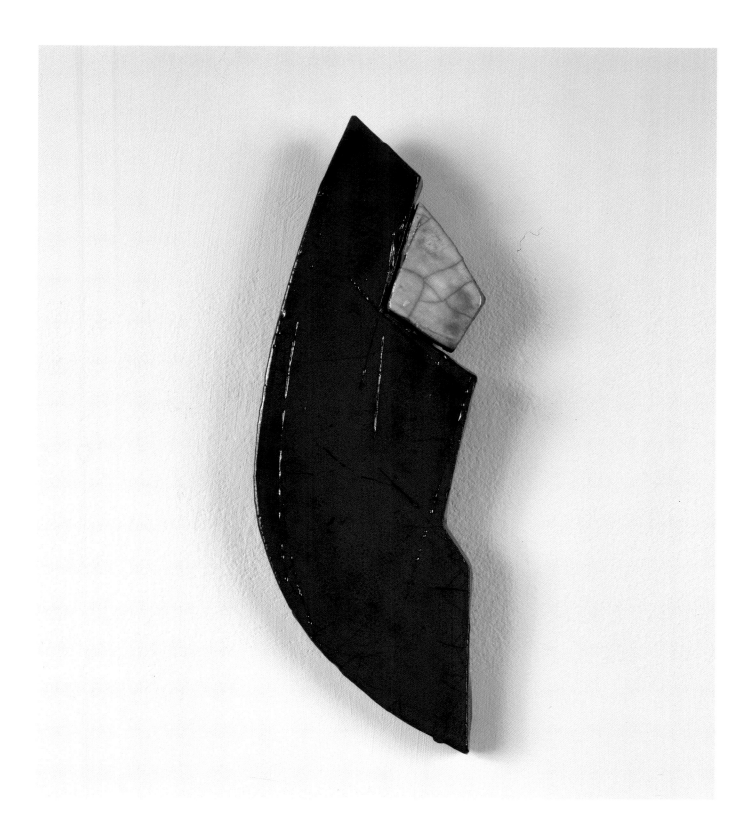

Sibylla,
Sibyls series,
2000

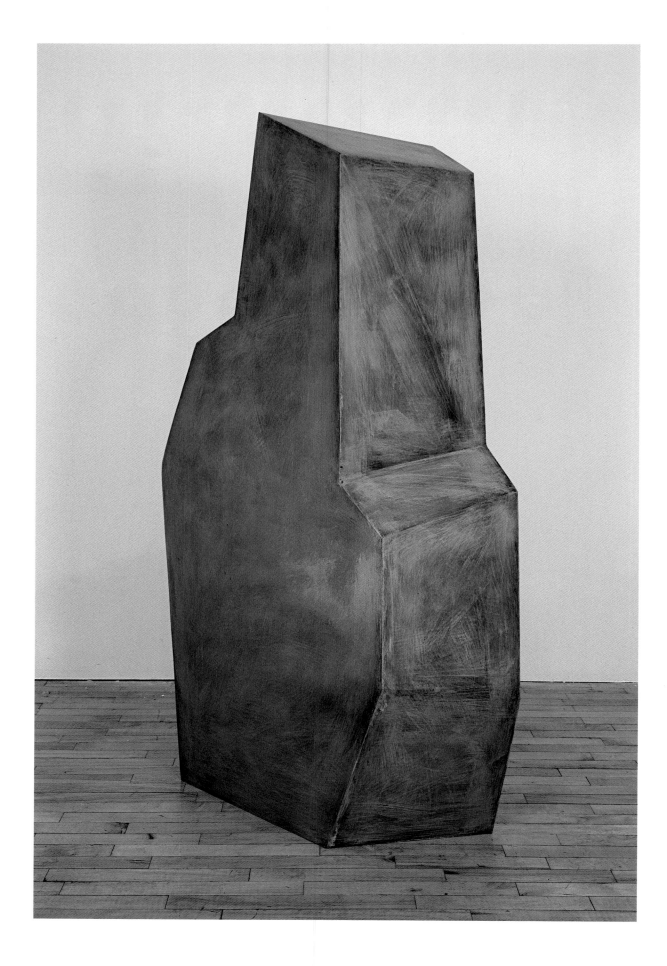

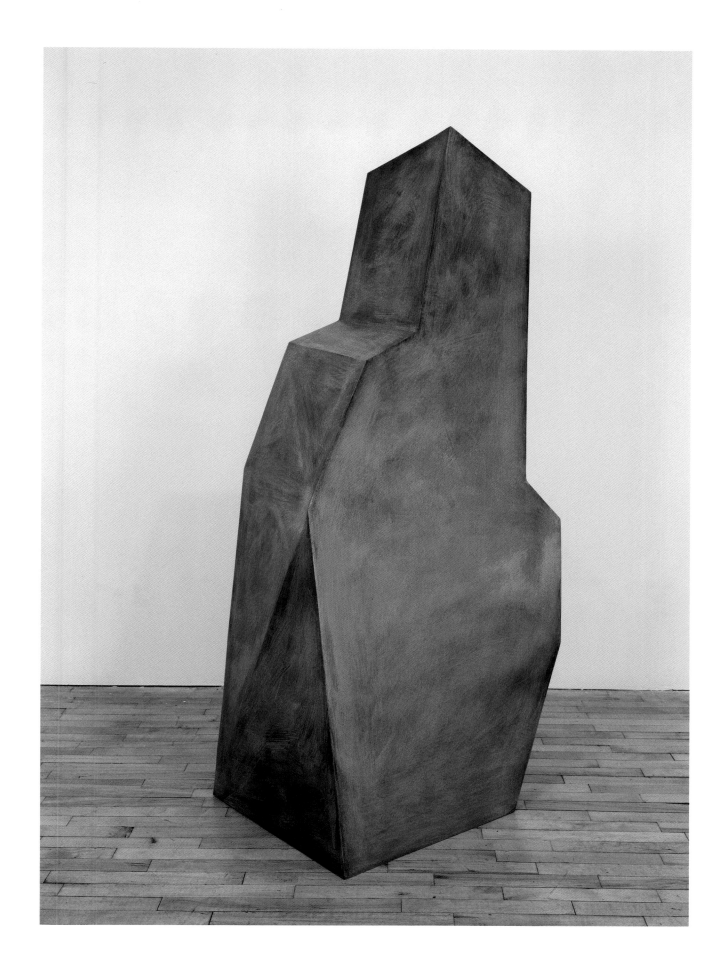

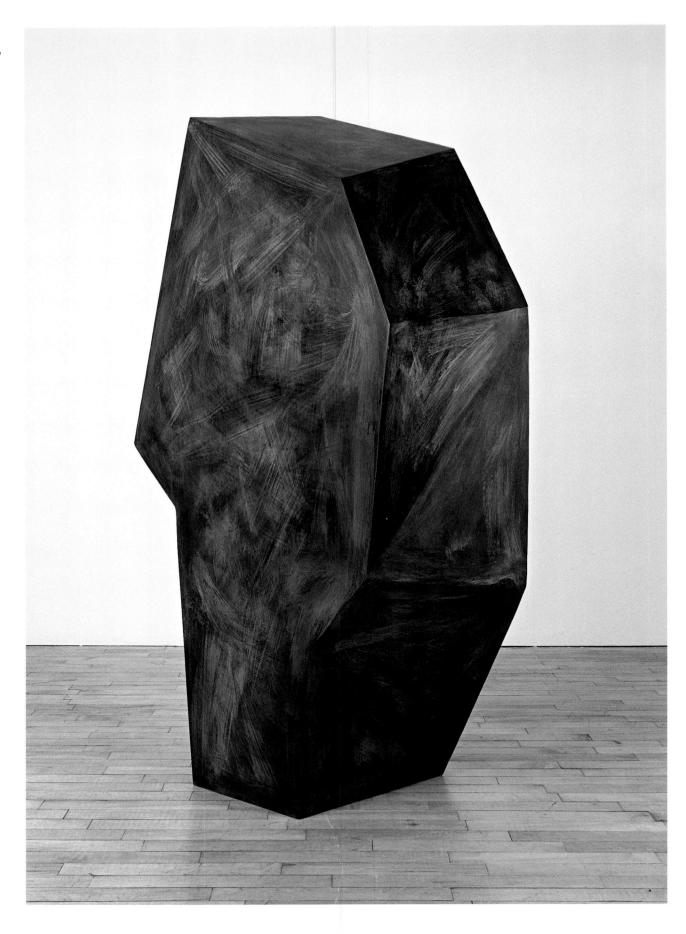

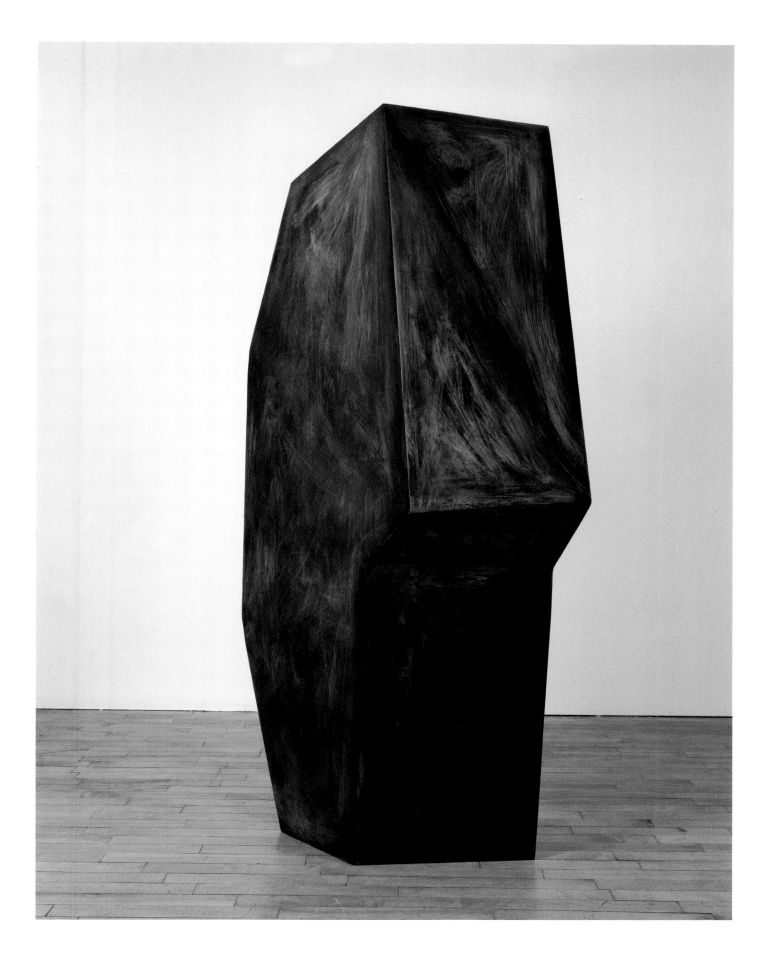

Libica, Sibyls series, 2001

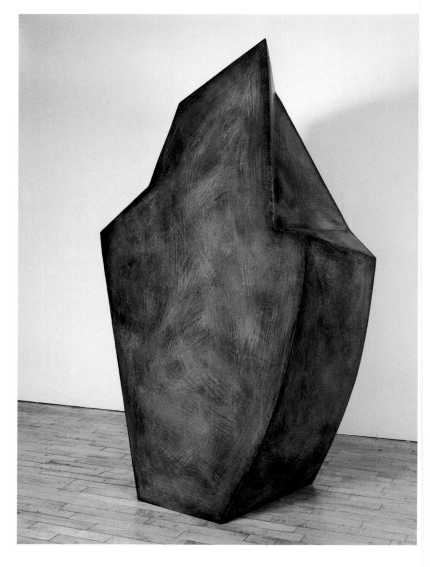

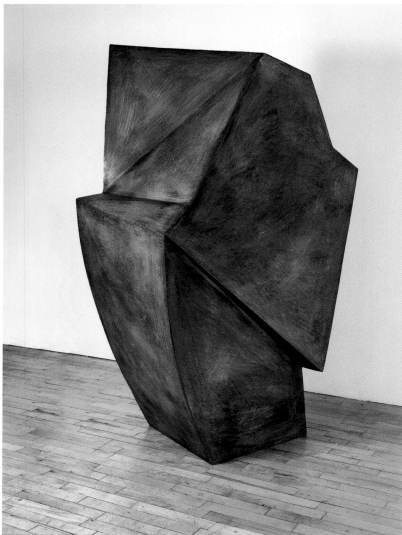

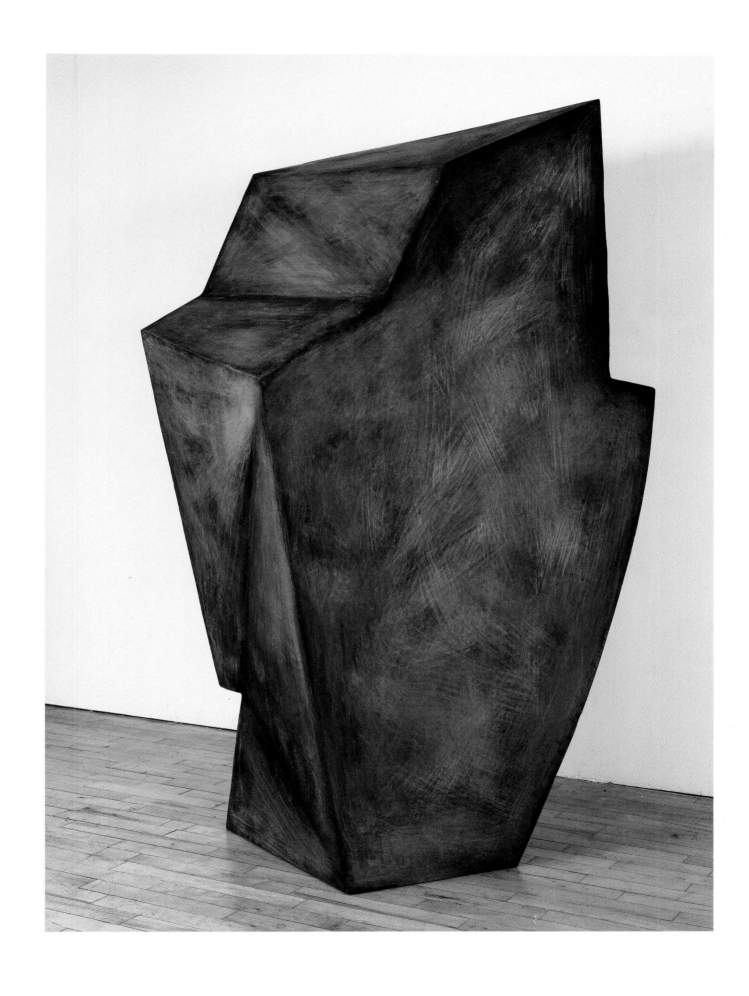

Ice, 2000

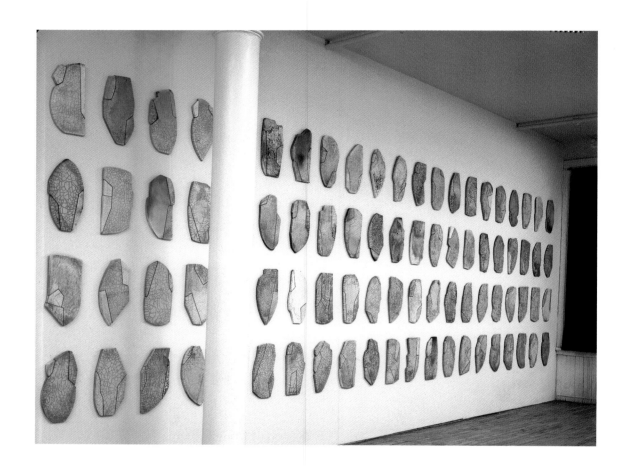

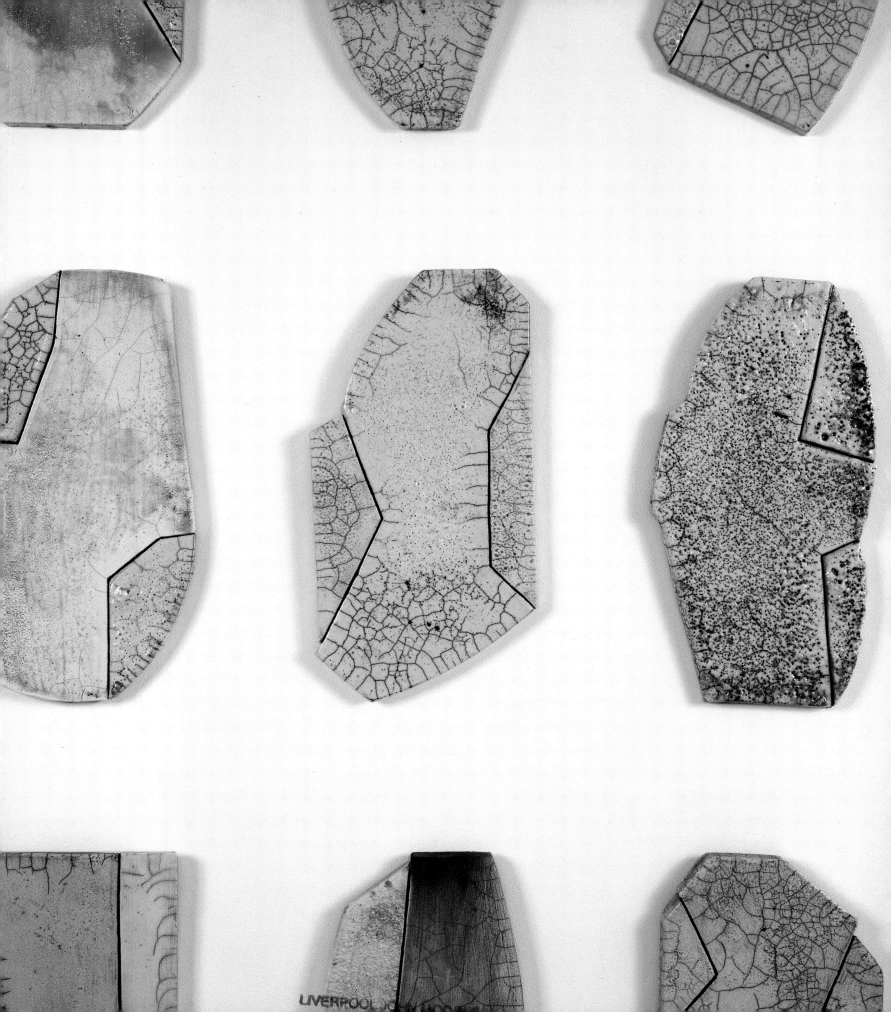

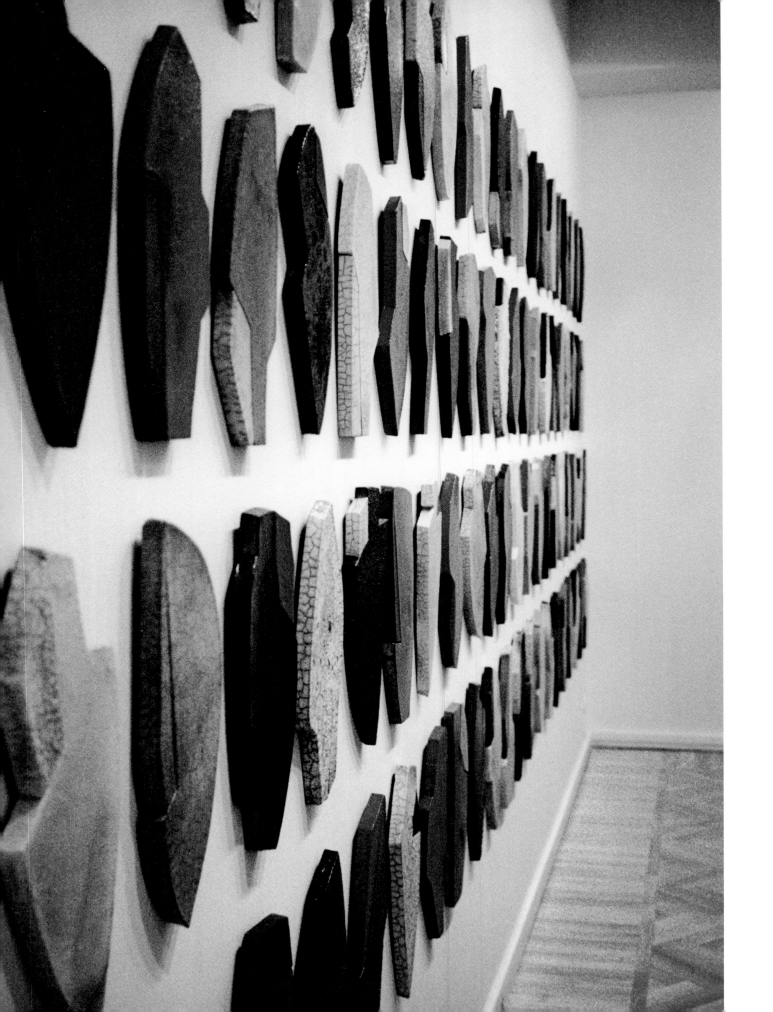

Raku Amends, 2000

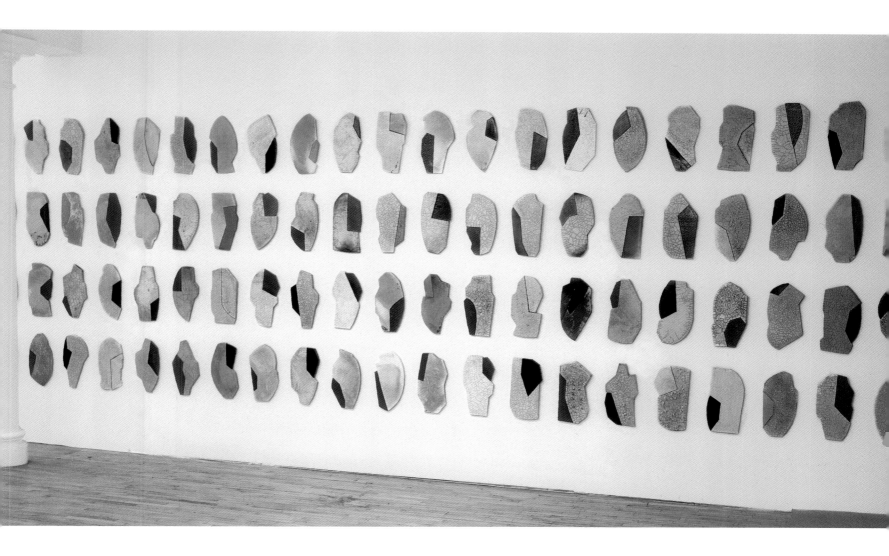

Up, 2000

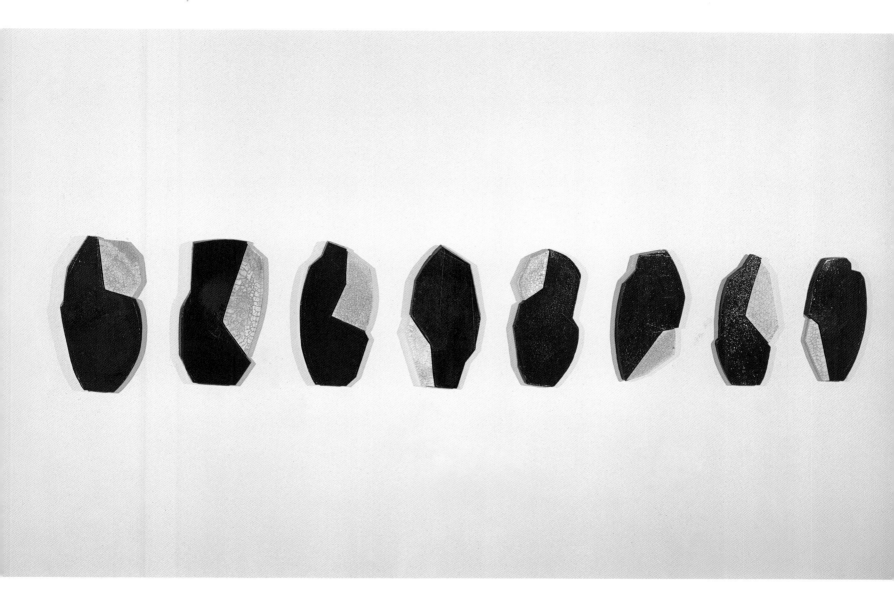

Despite the Silence of the Things . . .
Lóránd Hegyi

Many sensitive interpretations of those aspects of Catherine Lee's work that are based on the repeated unit have been published in the past. Some addressed her consequent transformation from painting to object-making, while others described her position in the context of formal concerns, such as colouration, and of the *internal life* of transcendental abstraction.

I would like to speak about another aspect of her work, namely the *narrative* that focuses on possible extensions of references. The obsessive and at the same time *objective repetition* of her work is crucial to this discourse. Here we have an apparently monotonous positioning, side by side, of similar figures, which on the one hand requires arduous working processes, a sense of permanence in the work, as well as exacting mechanical manipulations, while on the other hand evokes a link that suggests union and further, an anachronistic objectivity of these encyclopaedically collected individual objects.

When I talk about the obsessive and at the same time objective repetition of objects, I wish to distinguish this method from the analytical, experimental, methodological, intellectually systemised painting processes found in abstract painting and instead to point to the physical, material, quantitative accumulation of real objects. What matters here is neither the repetition of certain analytical processes that are carried out within previously clearly defined rules, nor the working method that the artist repeats in the space of the painting, but rather that the real objects are repeated as the physical and material subject matter.

In this context one could cautiously make the assertion that the collection, recurrence and contiguous positioning of the objects could theoretically be understood as the result of a search for the objects and not necessarily as the making of them. One may then imagine that the objects are not necessarily and exclusively produced by Lee but are created by nature and were found and gathered by the artist. In other words, the collection of the objects focuses on the objectivity of the existence—the physical presence—of the gathered objects and not the creation of the objects as an artistic, subjectively chosen, personally performed working process. The objects are presented as facts, provided as real material things, collected and arranged side by side.

It is paradoxical that this strongly emphasised material presence of the objects should arise from a specific type of processing of materials, namely as a result of the sensibility of the surfaces, caused by the burning of the ceramics, by the application of encaustic paints or by the reduction firing technique of raku. Partly by using metal, the distinction is strengthened between the diversity of the individual objects and the anonymity caused by an apparent absence of private and personal influences. The objects vary but nonetheless their differences allow them to also appear similar. That is, they show certain differences, but their design, the proportions of their internal structure, the divisions of their interior zones

show them to be substantially similar. The multitude of individual details strengthens, in a paradoxical manner, the homogeneity of the species. One may get the impression that all belong to the same tribe, that they all come from the same family and that they represent a community.

Two opposing issues are of importance here. On the one hand, it is the presentation that gives the individual objects an interpretational context. These are not presented individually but always in groups. The mechanical repetition and the linear, indifferent, variable grouping suggests an association with one group, or with a certain class, or of a certain character. This kind of presentation points indirectly to the position of an observer looking on from the outside, who selects the objects according to his own criteria and associates them in groups of his own choice. Thus, the observer is no longer on his own but is connected to another observer, even to an earlier observer, perhaps, who collected the objects, made a selection and put them into a certain system.

This selective and categorising, systematic and assessing activity is, as a rule, independent of the reality of the objects: it represents the reality of the observer. It is indifferent to the existence of the objects. Moreover, it is solely occupied with the collection and arrangement of the individual objects into a system that corresponds to their categorisation. This again offers a quasi-scientific objectivity and absence of emotion and it creates a distance from the things. Consequently, this creates a different level that is the level of the observer who is looking on from the outside, the collector, the decisive other person [des entscheidenden anderes].

On the other hand, when a community like the one described above develops, it evokes the feeling of belonging together, of a common history, of similar experiences and destinies. They are like members of a tribe, like animals of a herd, like stones from the same place. They are characterised by the same conditions, and in that way they are like one another and they also differ from one another. This feeling of belonging evokes expressive narratives despite the silence of the things.

We are concerned here with two expressions that require more explanation, namely to suggest and to evoke. Both imply an activity with resulting consequences that are not directly controllable, measurable or verifiable but which arise from imagination, feelings, ideas, fantasies and euphoria. They contribute to the reality of something that is not evident, not present, not distinct and not concrete, but something that may have all these features. To suggest and to evoke also imply effectiveness and influence, which may introduce a narrative characterized by a capacity to generate imagination—which is the poetic dissemination of direct experiences in unforeseen areas that cannot be easily derived from the given reality. Therefore, various unforeseen connotations are included, different levels of references are activated, personal experiences, memories, stories become linked with these given things.

This evocative poetry creates a further level in relation to the perception of the objects created by Lee, namely the level of the narrative, in which observers begin to tell their own stories while viewing the collection of these mysterious, silent, disinterested objects placed beside, above and below one another. The object assemblages such as *Raku Amends* from the year 2000, or the work *Wishes* dating from 1996 and even more explicitly the group *Strung Porcelain*, which dates from last year, are, in effect, texts that the observer can read in his own translation. The objects become letters, the rows become sentences, and the changing colours and forms become poetic or melodious sounds. Stories are evoked that describe conditions, situations and relationships. As a result of this evocation, a potential emotionality runs through the work, somehow unexpected, somehow unintended, but nonetheless present. The thing itself is thus freed from its objective, mechanical, distanced system and from the indifference of monotonous repetition and so contributes to the deepening of a fresh, self-confident, calm and archaic emotionality.

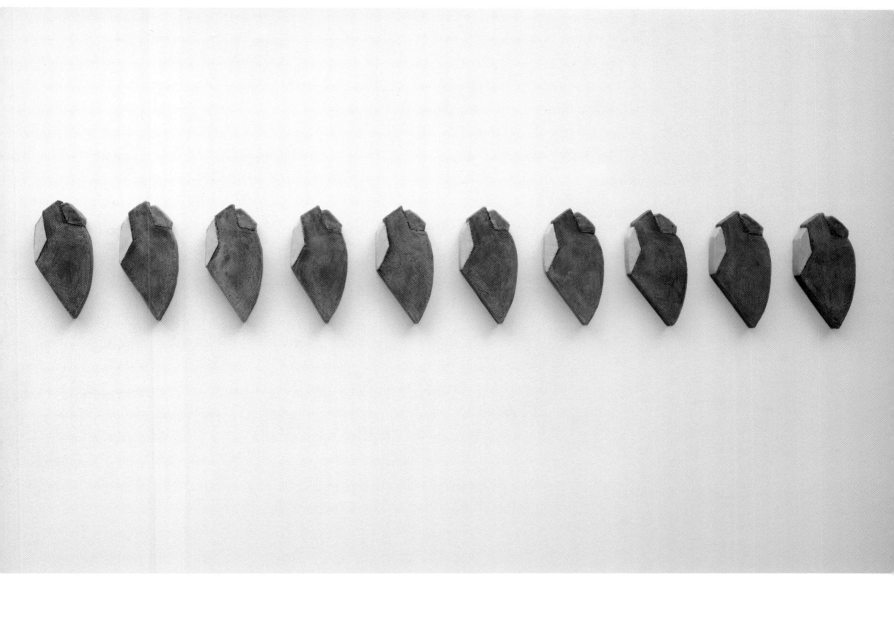

Ferro, 2001

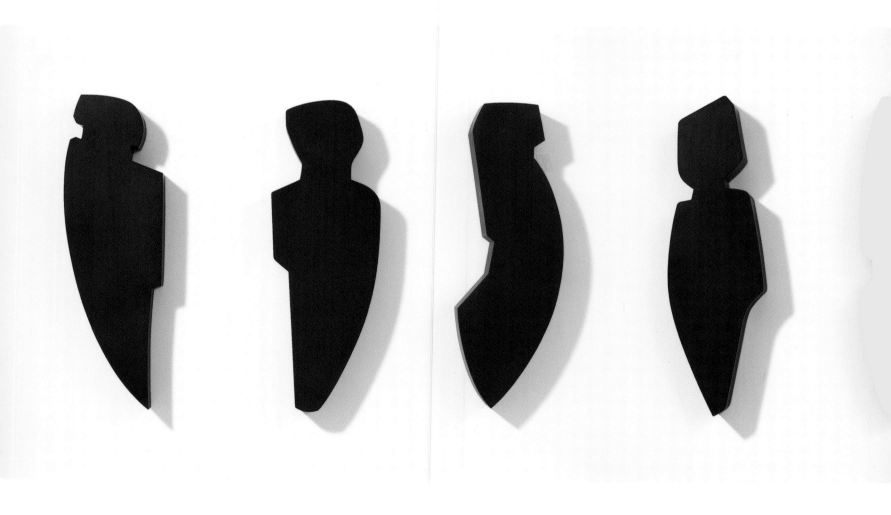

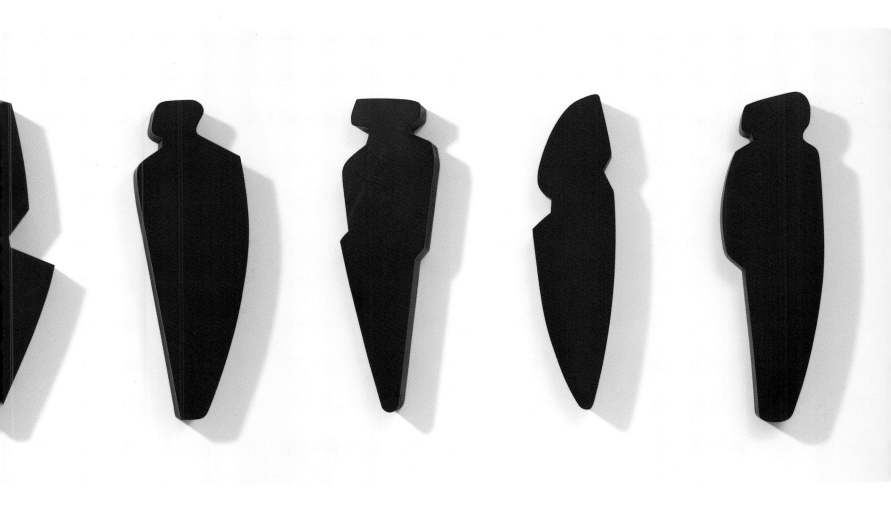

Cubic Celadon, 2003

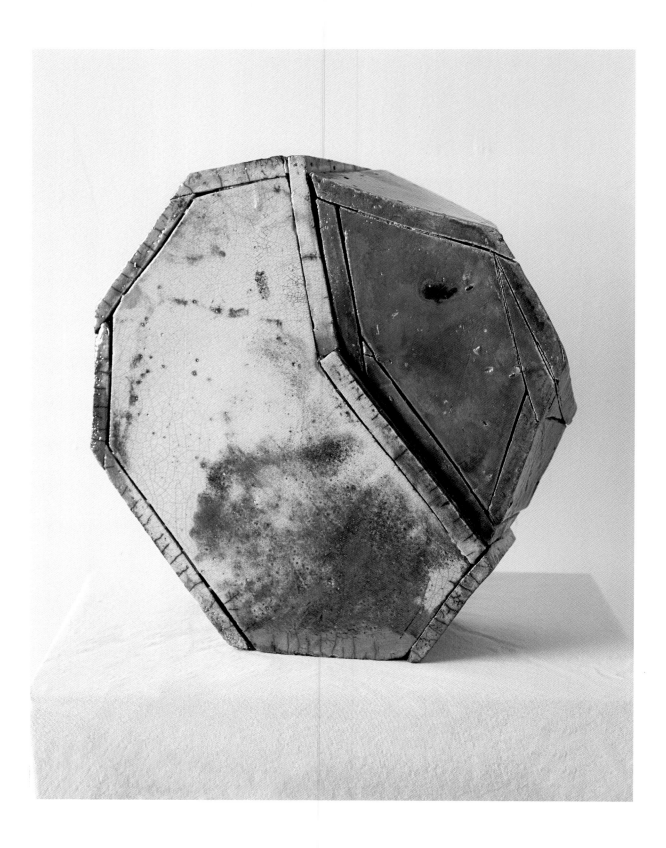

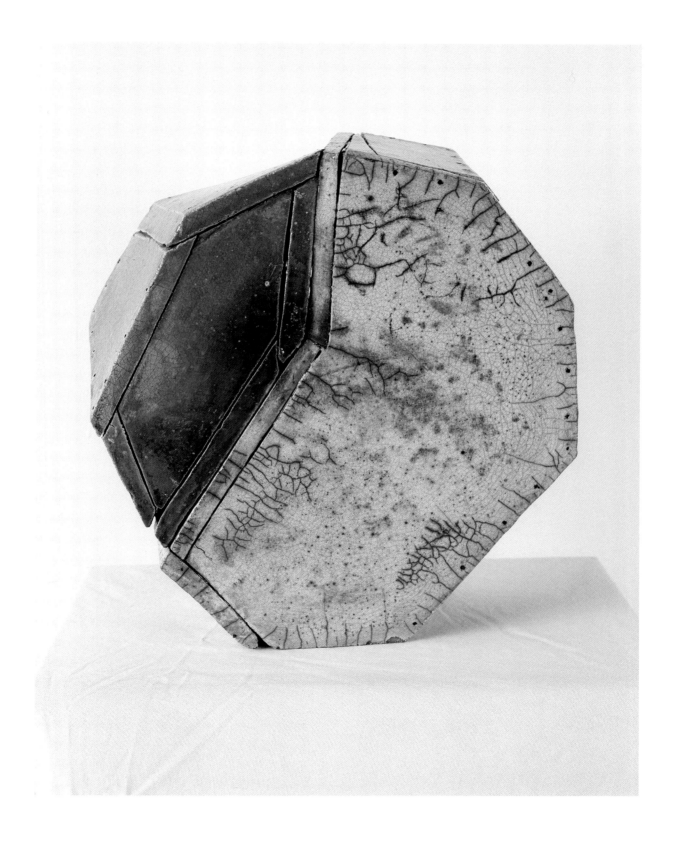

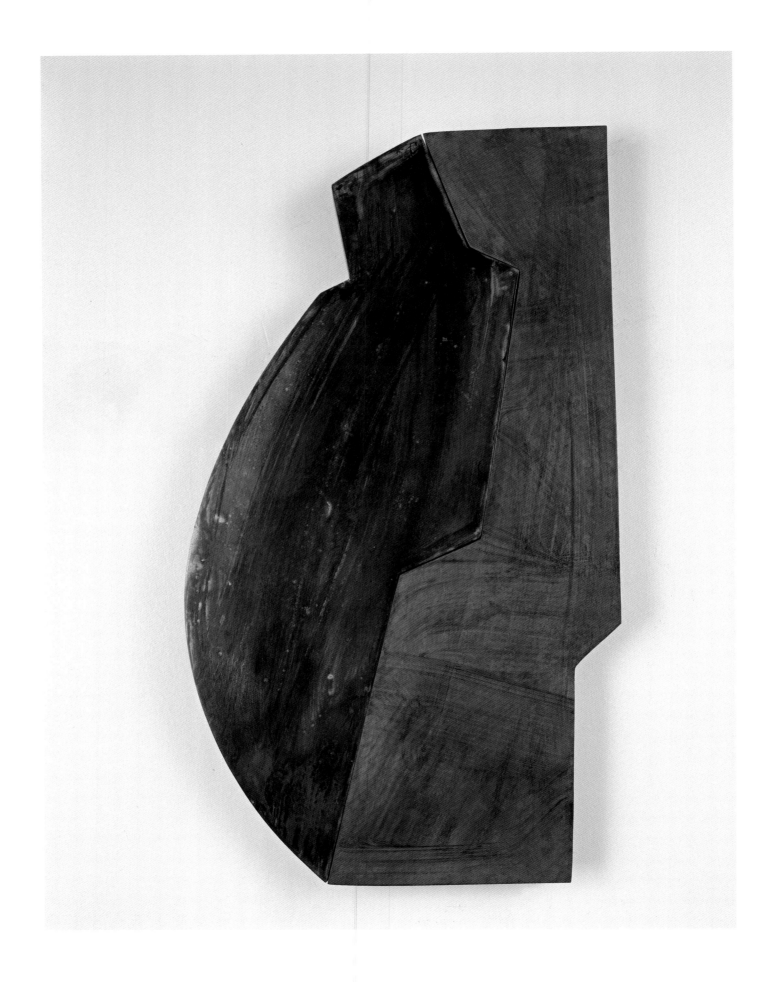

Red River, 2003 Frieze, 2000–2003

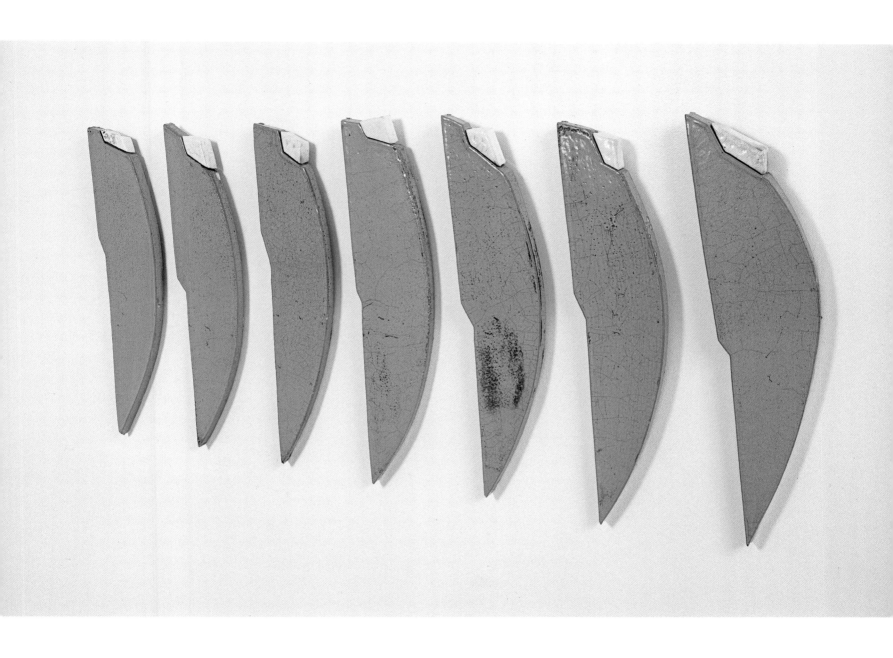

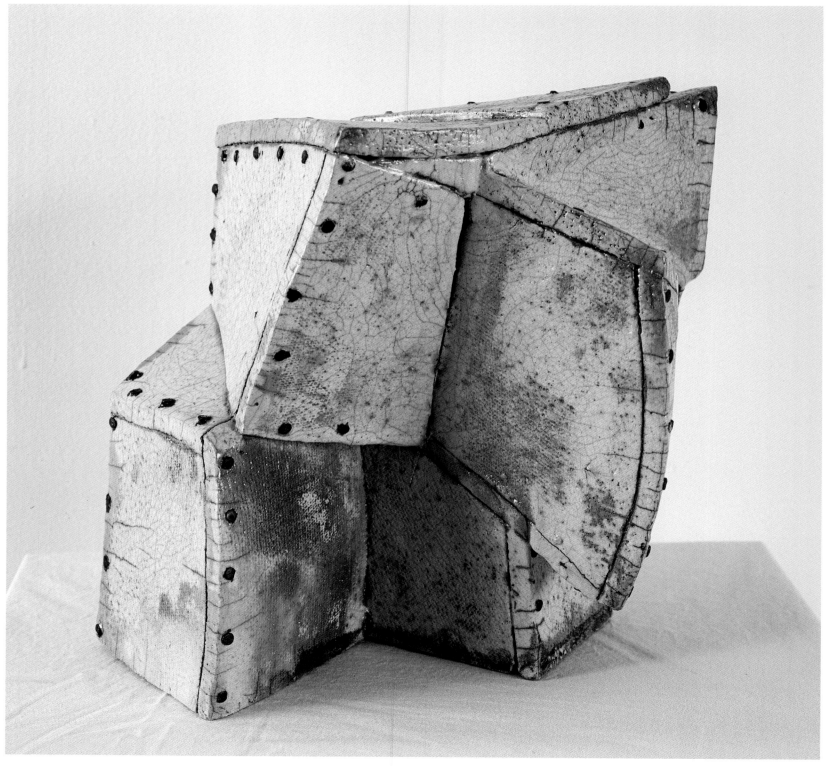

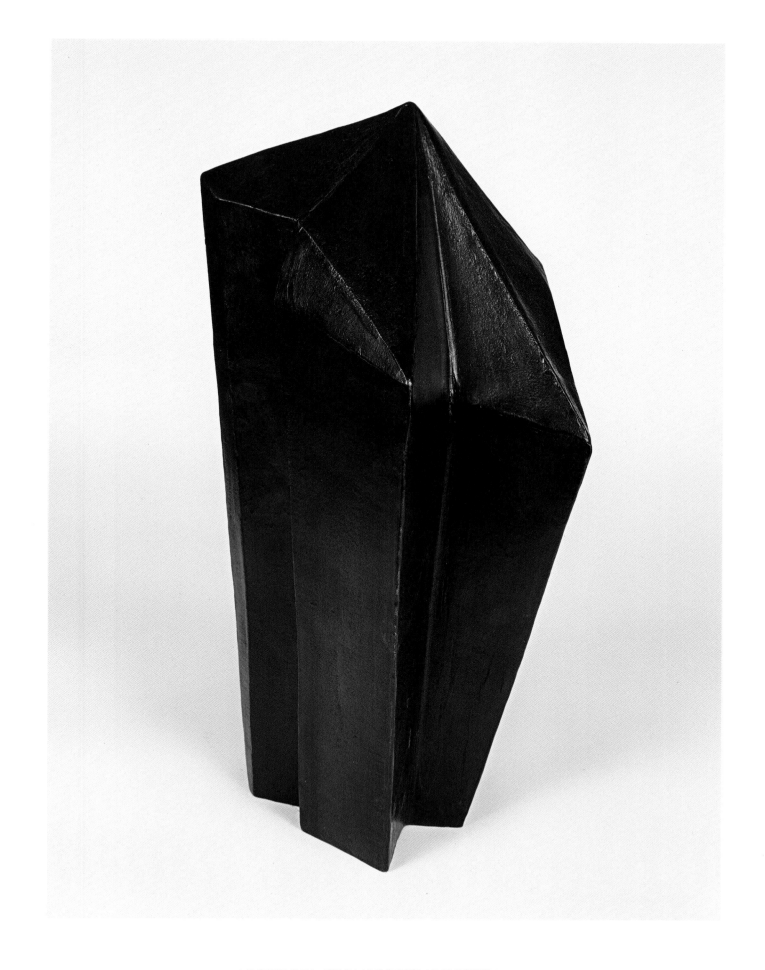

137

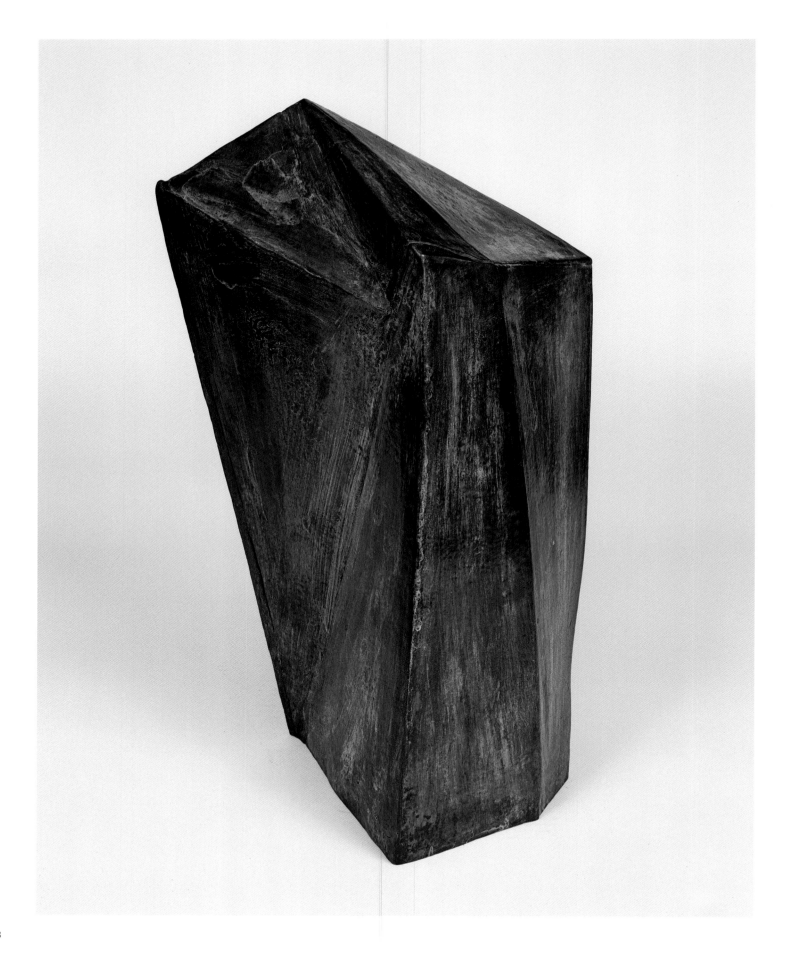

Copper Mount, 2004 Shards, 1989–2004

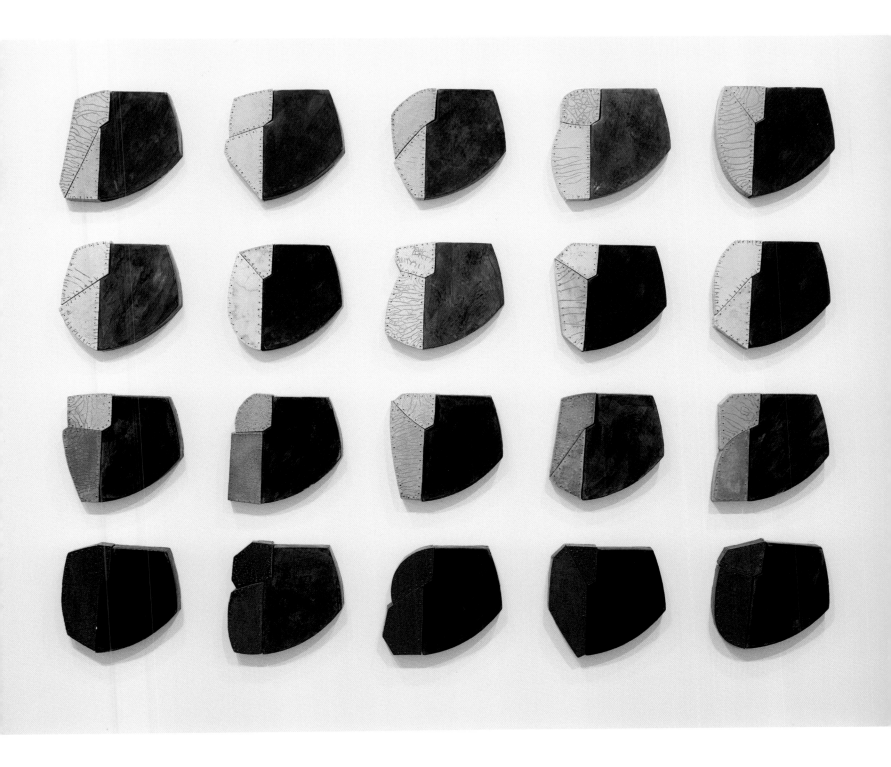

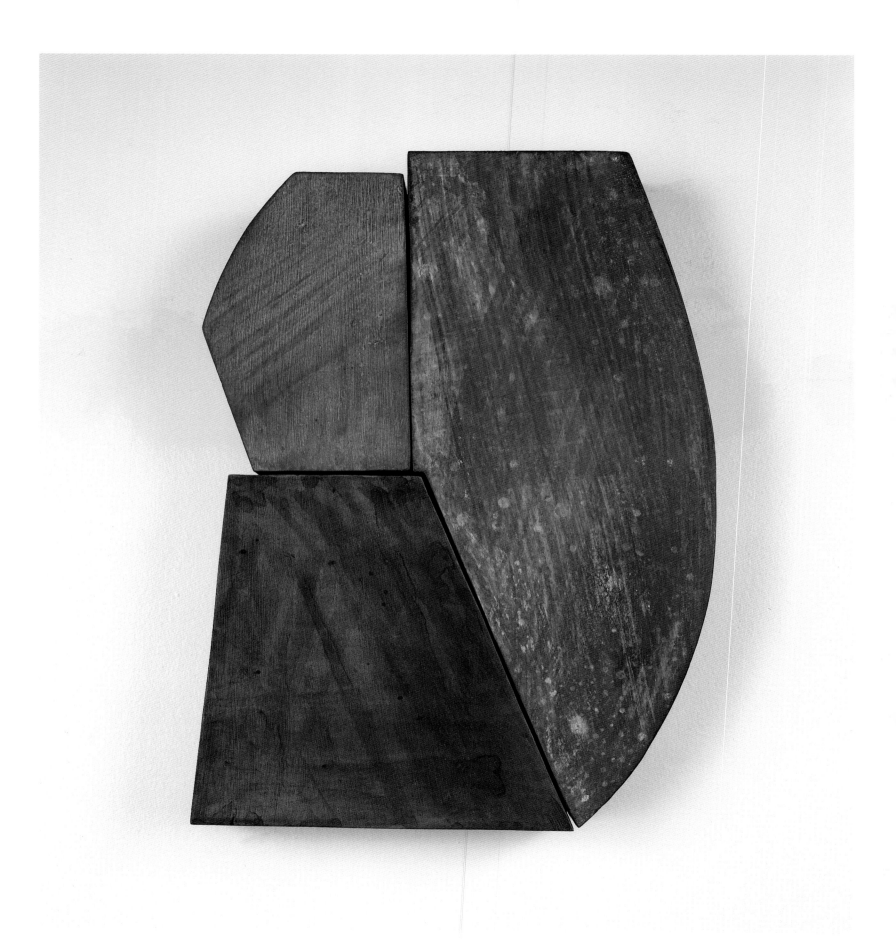

Mask, 2004

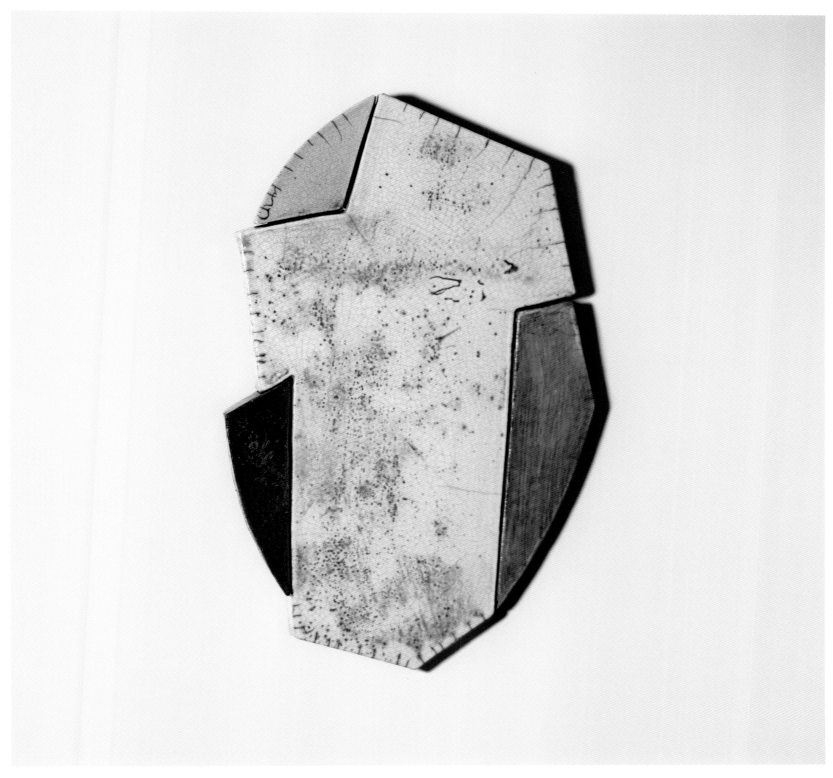

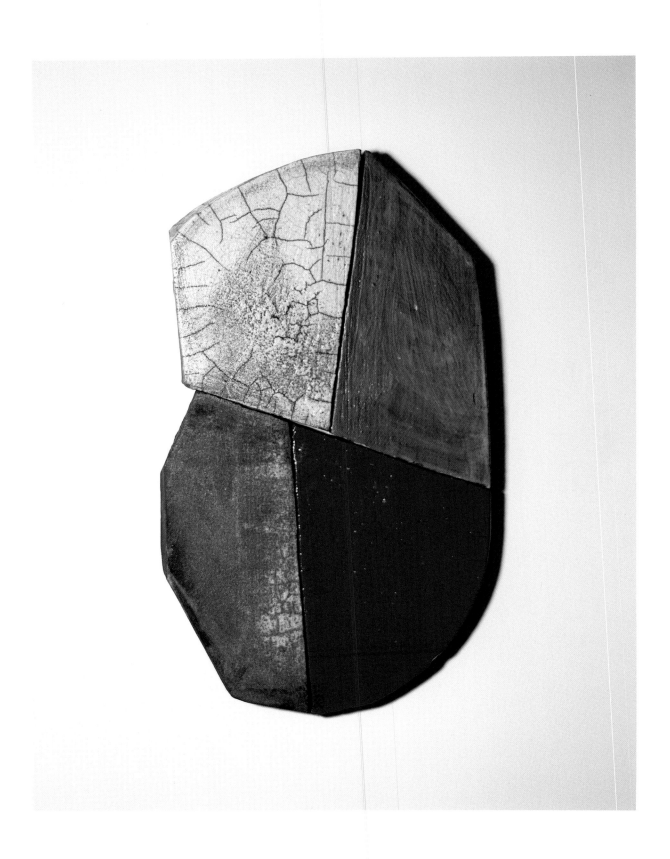

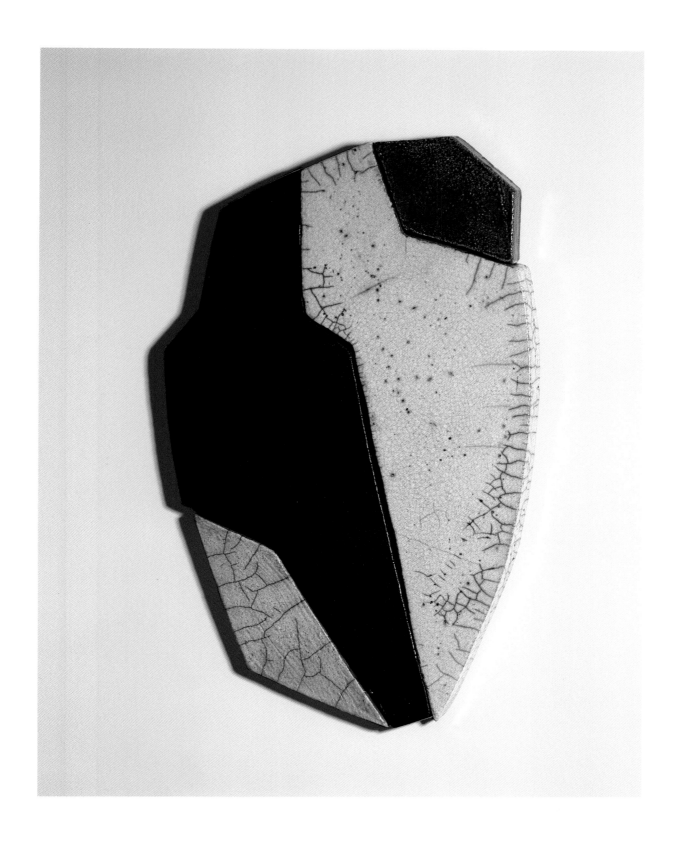

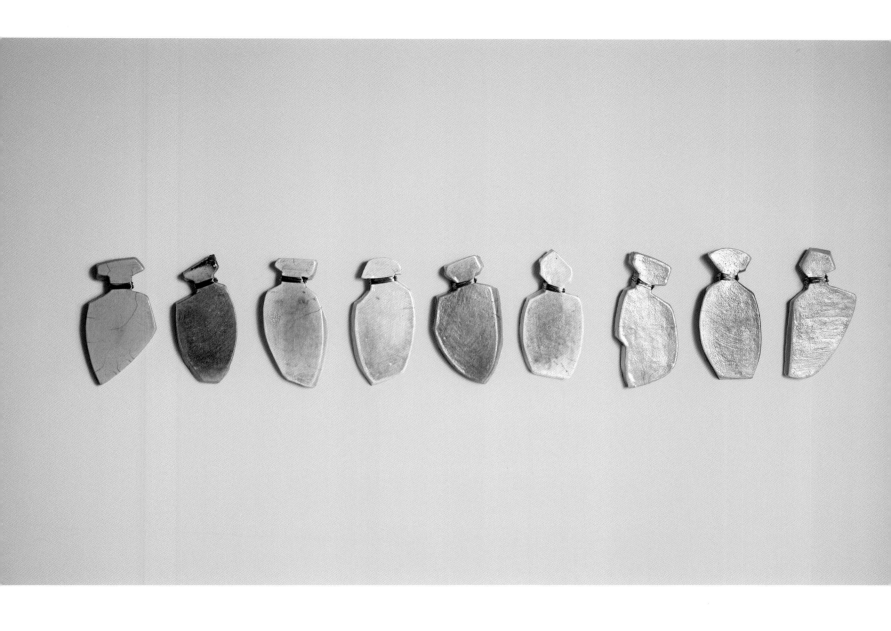

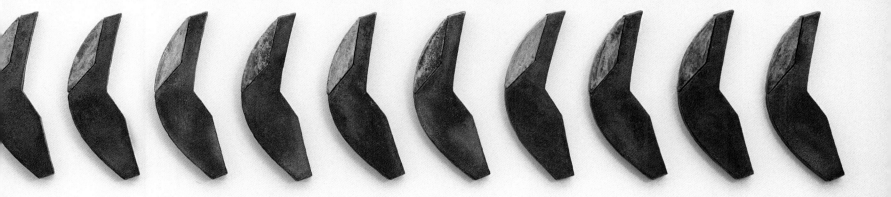

147

Archaic Figures, 2004

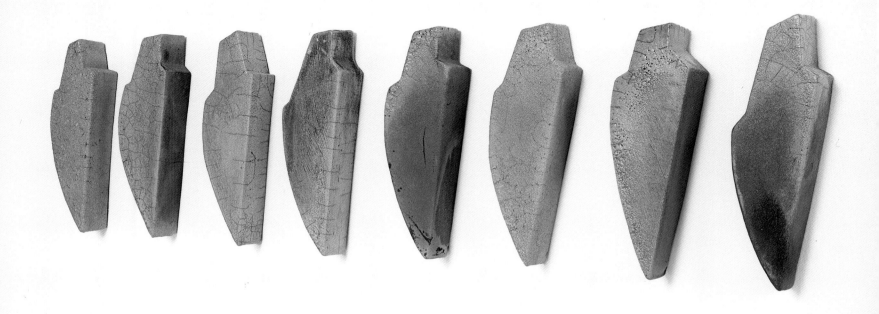

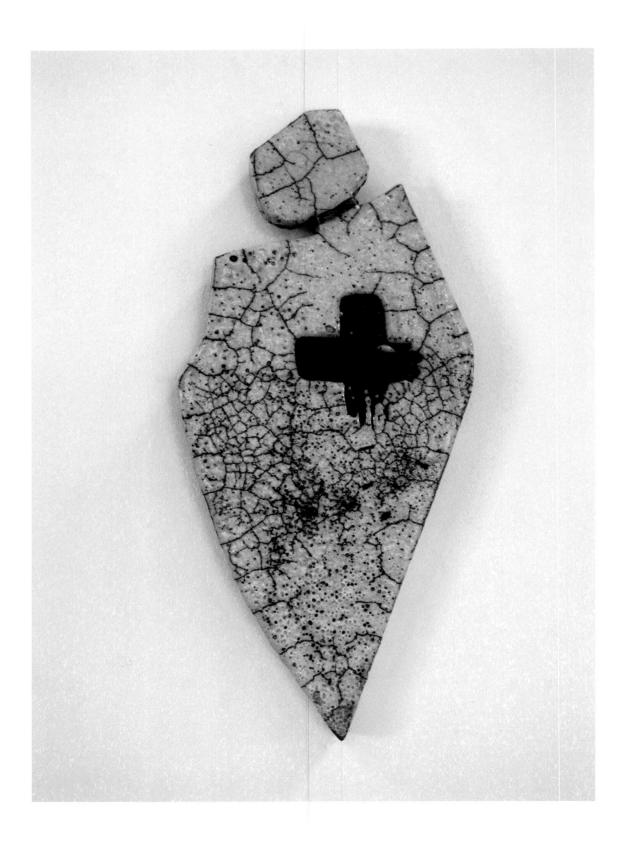

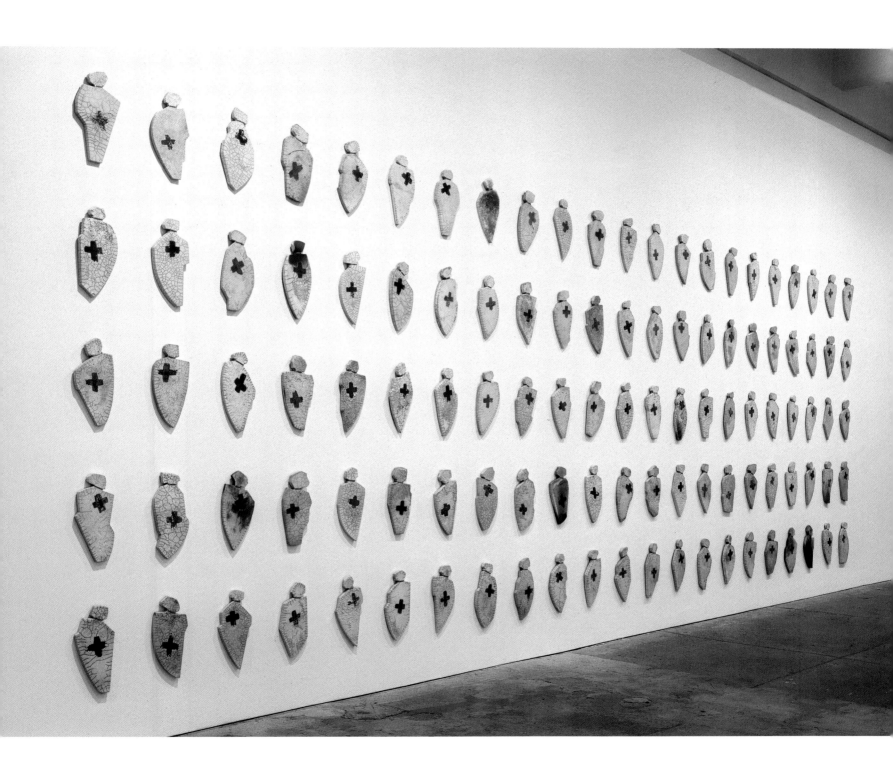

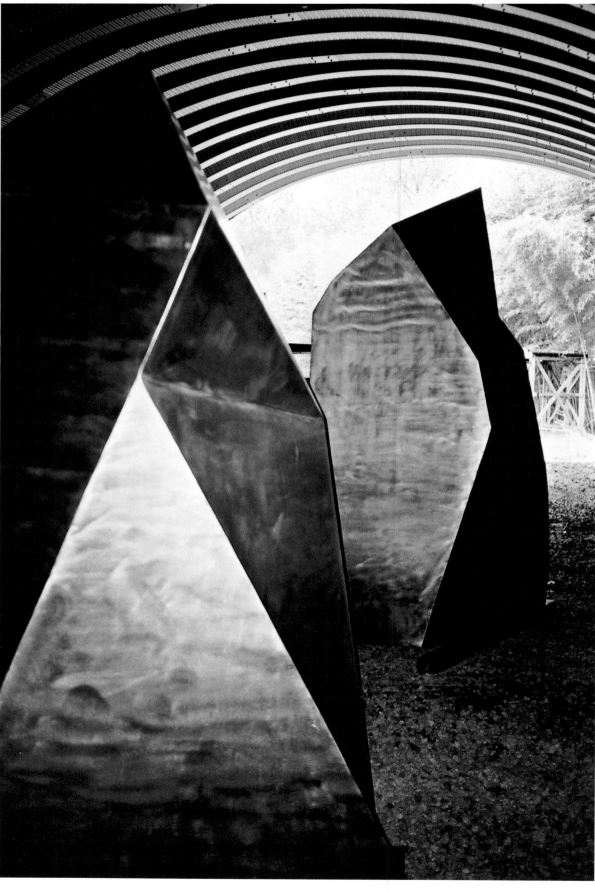

Hebrides series, in progress, 2003-2004

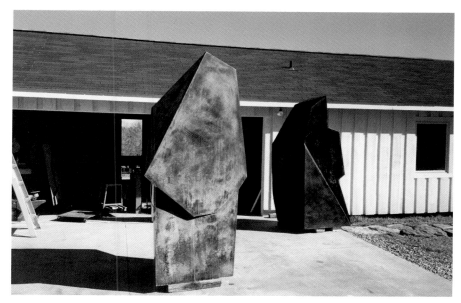

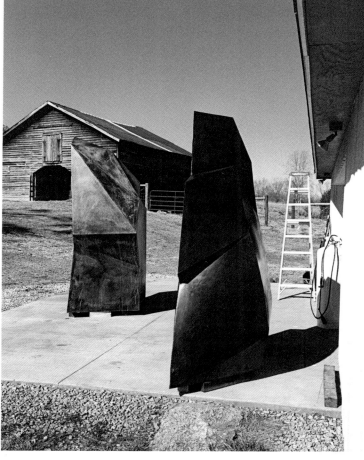

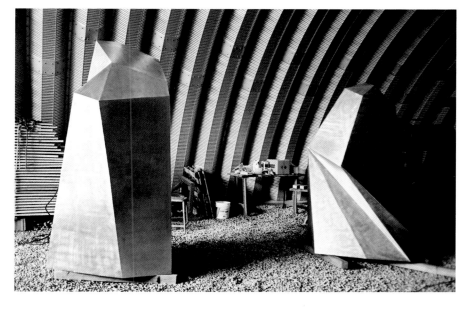

Clach an Trushal, Hebrides series,
2004

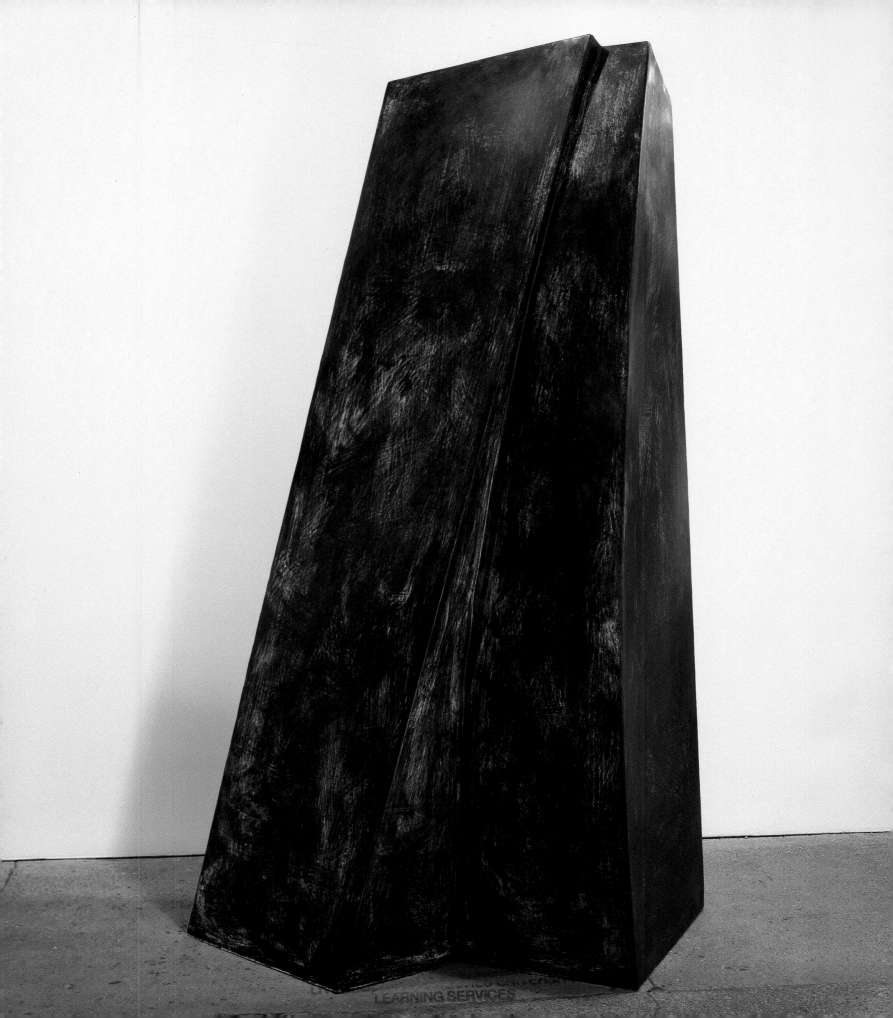

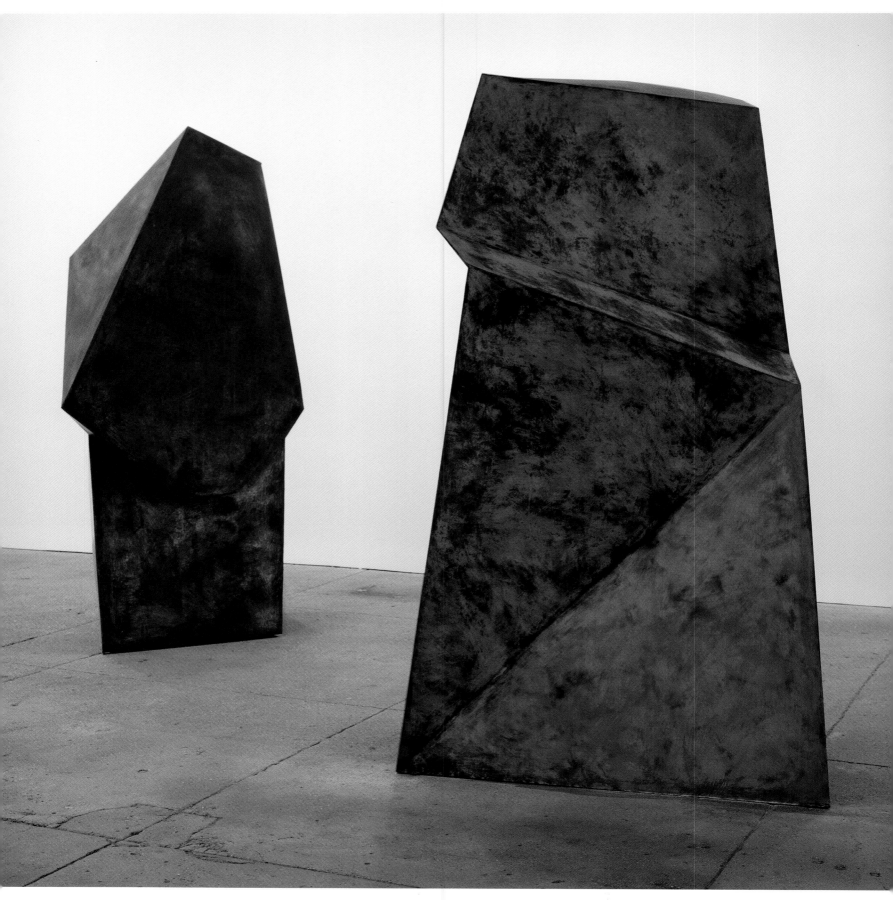

Harris, Hebrides series, 2003
Stornoway, Hebrides series, 2004

pp. 158–159
Calanais, Hebrides series, 2004

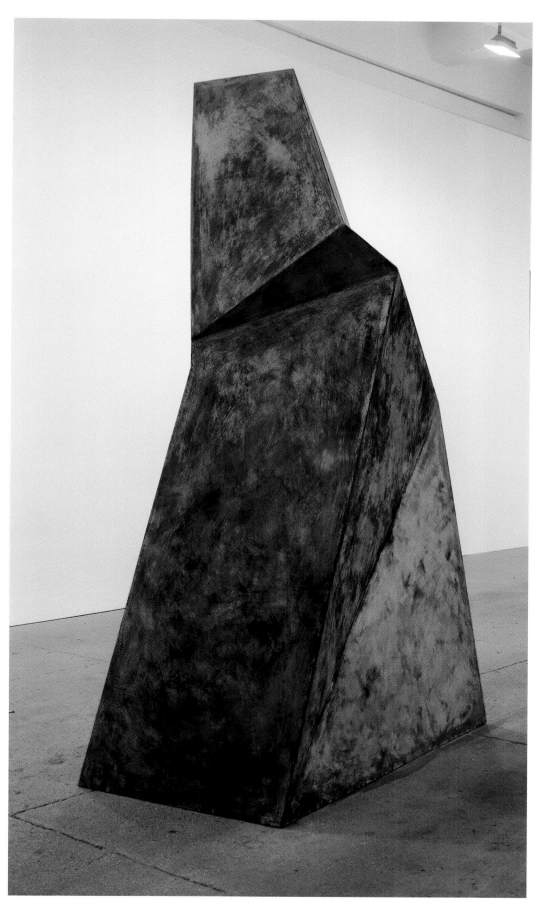

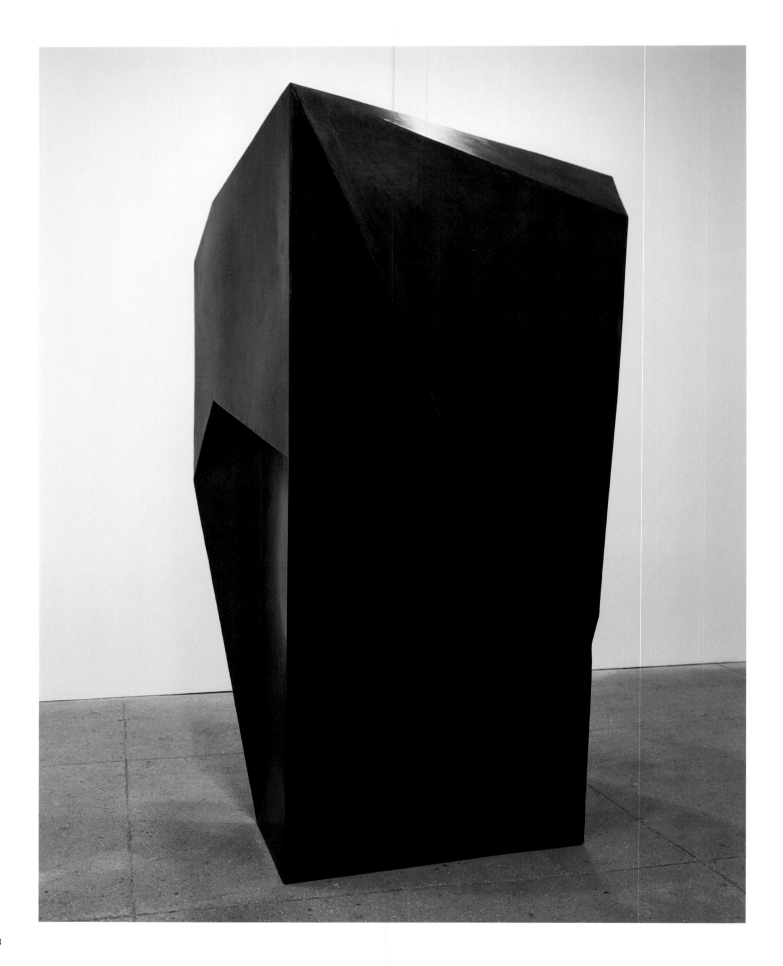

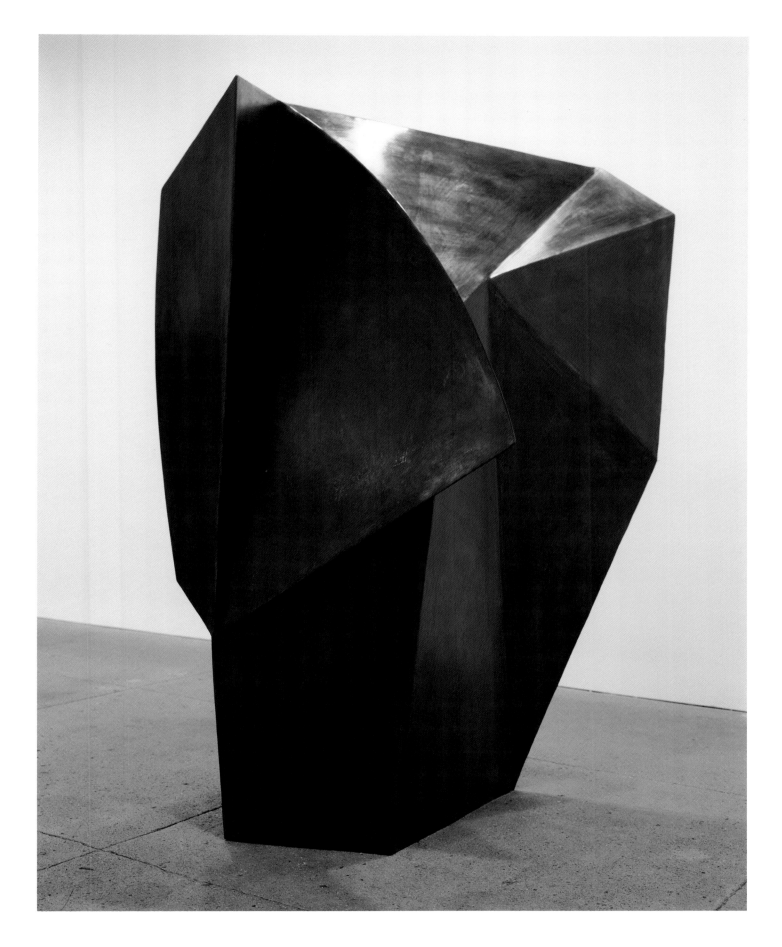

159

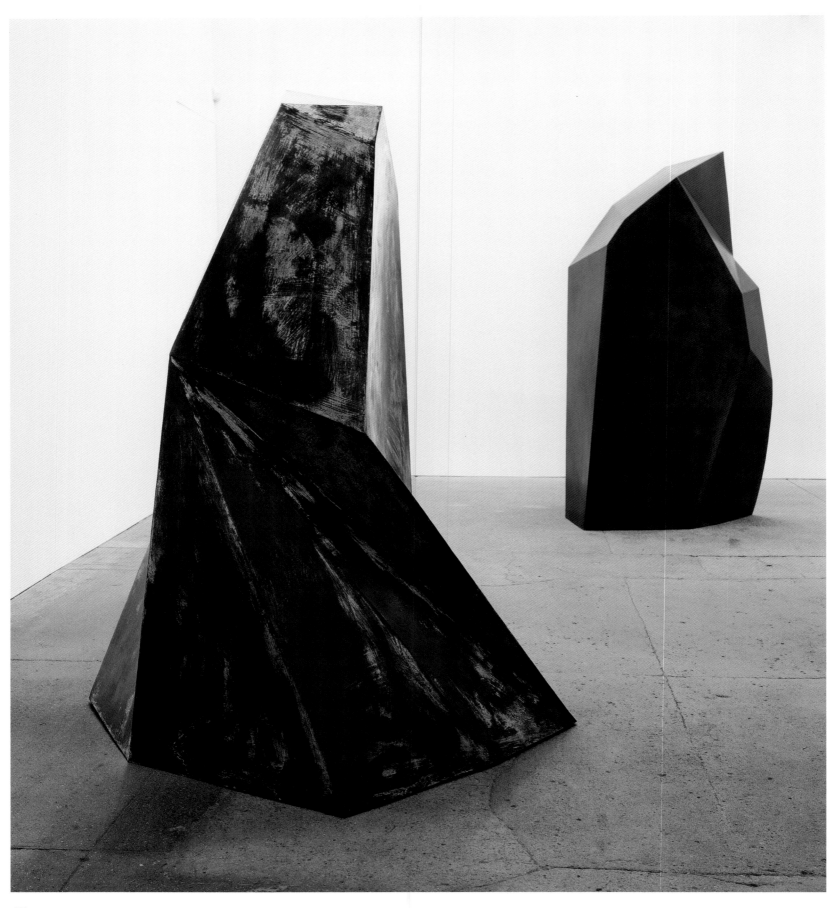

Scalpay, Hebrides series,
2004 (left)
Lewis, Hebrides series,
2003 (right)

pp. 162–163
Red Cubic Copper, 2005

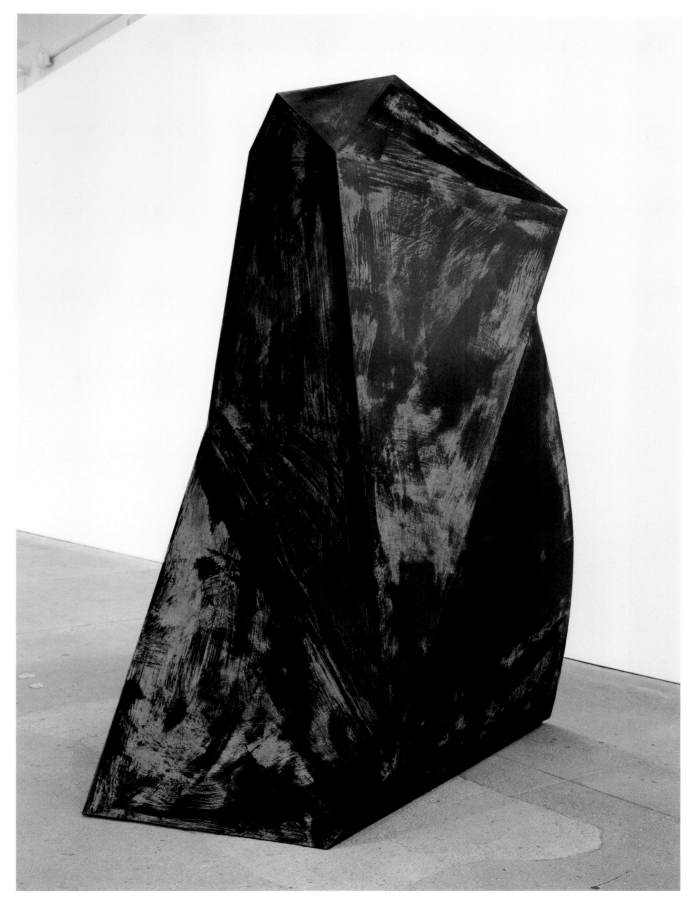

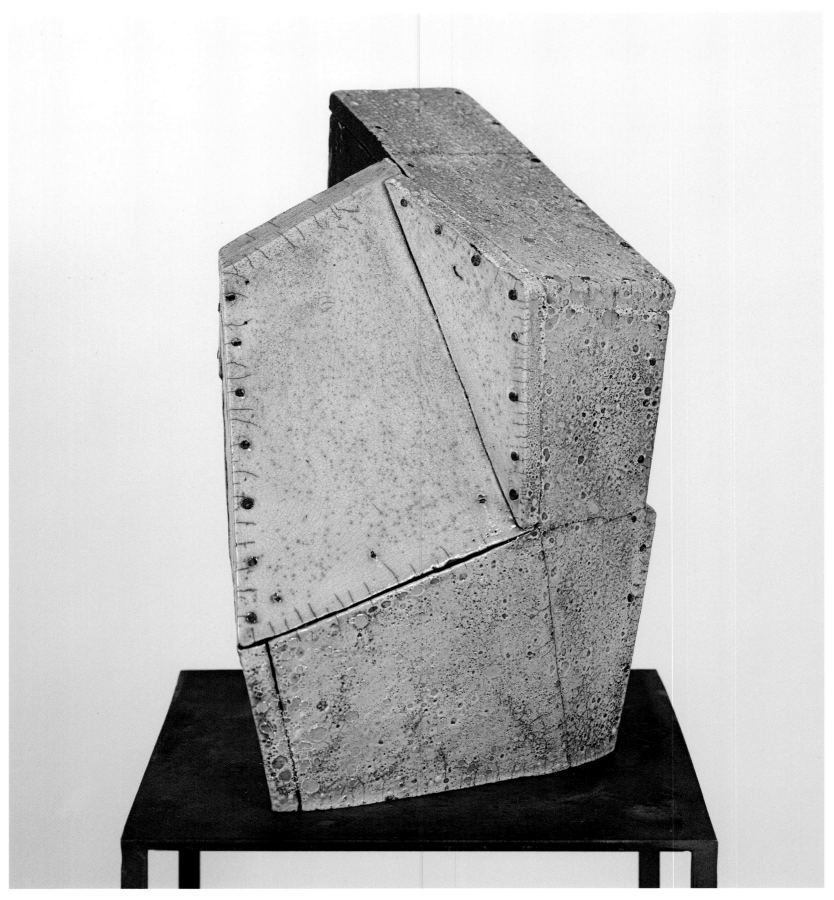

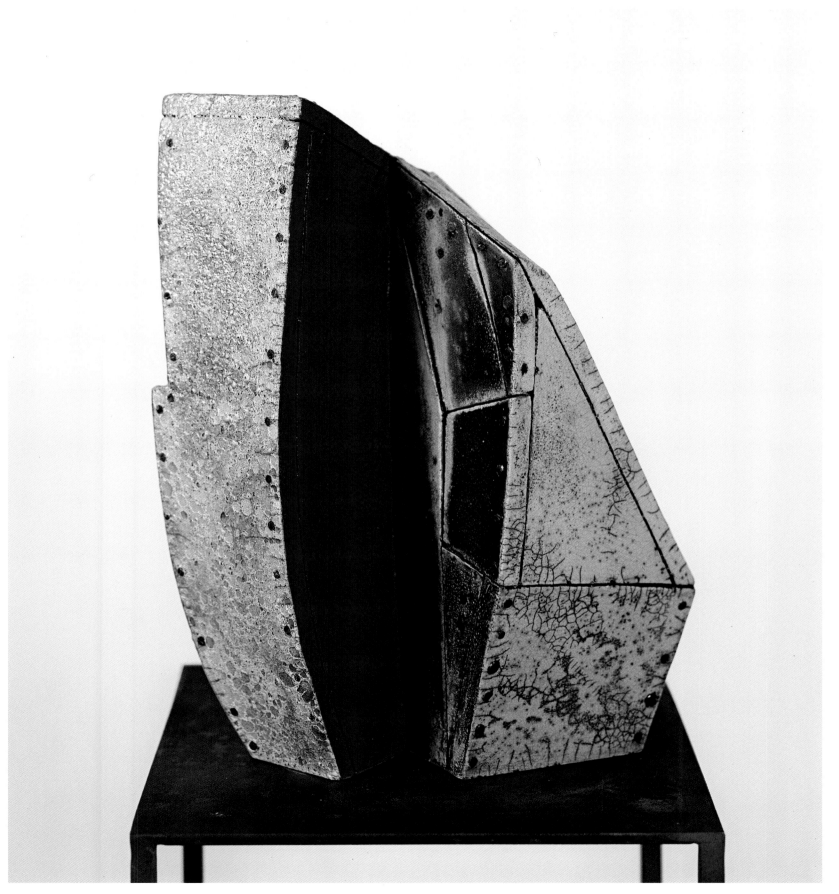

List of works

Thirds, 1980
Oil on canvas
72 x 72 in.
Private Collection
p. 2

White Jungle, 1985
Glazed ceramic, bolts
14 x 16 x 1 in.
Private Collection
Photo: Dennis Barna
p. 4

Sojurn, 1985-1986
Oil on canvas
56 x 41.5 in.
Private Collection
Photo: Dennis Barna
p. 12

The Passenger, 1986
Oil on canvas
84 x 84 in.
Collection of the Museum of Art,
Carnegie Institute
Photo: Dennis Barna
p. 9

Navigator, 1986
Oil on wood
26 x 19 x 3 in.
Courtesy Galerie Academia, Salzburg
Photo: John Riddy
p. 11

Outlaw, 1987-1988
Glazed ceramic
11 x 15.5 x 1 in.
Courtesy Galerie Jamileh Weber, Zürich
Photo: Dennis Barna
p. 19

Undertow, 1988
Oil on canvas
78 x 90 in.
Private Collection
Photo: Dennis Barna
p. 13

Yellow Seas, 1988
Encaustic on wood
9.5 x 11.5 x 3 in.
Courtesy Galerie Karsten Greve, Cologne
Photo: Dennis Barna
p. 17

Past Taps Morning, 1985-1989
Glazed ceramic
15 x 17 x 1.5 in.
Private Collection
Photo: Dennis Barna
p. 15

Adak, 1989
Encaustic on wood

12.5 x 9.5 in.
Courtesy Annely Juda Fine Art, London
Photo: John Riddy
p. 16

Standing Sea, 1989
Cast bronze with patina
82 x 44 x 4 in.
Private Collection
Photo: Dennis Barna
p. 18

40 Faults, 1989
Fabricated bronze with patina
60 x 215 x 2.5 in. total, 26 x 5.5 x 2.5 in.
each, 40 units in 2 rows
Private Collection
Photo: Dennis Barna
pp. 20-21

Dancing Gold, 1989
Cast bronze with patina
84 x 51 x 4 in.
Courtesy Galerie Karsten Greve, Cologne
Photo: Dennis Barna
p. 22

Listing Dusk, 1989
Cast bronze with patina
83 x 57 x 4 in.
Private Collection
Photo: Dennis Barna
p. 23

Machynlleth, 1989
Cast bronze with patina
11.5 x 11.5 x 2 in.
Courtesy Gallery Mizuma, Tokyo
Photo: Dennis Barna
p. 25

Thirdstream, 1989
Encaustic on wood
13 x 12 x 3 in.
Private Collection
Photo: John Riddy
p. 83

Outcasts Water Iron, 1990
Cast iron, oxidised
48 x 360 x 3 in. total, 48 x 13 x 3 in. each,
21 units in 1 row
Courtesy Galerie Karsten Greve, Paris
pp. 29, 42-43

Lead Constellation, 1990
Cast lead
87 x 96 x 3.5 in. total, 13.5 x 6.5 x 3.5 in.
each, 50 units in 5 rows
Courtesy Galerie Jamileh Weber, Zürich
p. 35

Strata, 1990
Cast bronze with patina
96 x 152 x 2.5 in. total, 25 x 16 x 2.5 in.

each, 18 units in 3 rows
Courtesy Galerie Jamileh Weber, Zürich
Photo: Dennis Barna
p. 38

Lag, 1990
Encaustic on wood
13.25 x 16.5 in.
Private Collection
Photo: Dennis Barna
p. 40

Harbinger, 1990
Encaustic on wood
48 x 36 x 3 in.
Private Collection
Photo: Dennis Barna
p. 41

Wyoming, 1990
Cast bronze with patina
11 x 24 x 2 in.
Private Collection
Photo: John Riddy
p. 44

Land, 1990
Encaustic on wood
23 x 22.5 x 2.5 in.
Courtesy Annely Juda Fine Art, London
Photo: John Riddy
p. 45

Bronze Flight, 1990
Fabricated bronze with patina
40 x 240 x 3 in. total, 40 x 10 x 3 in. each,
17 units in 1 row
Courtesy Galerie Karsten Greve, Cologne
pp. 46-47

Callanish, 1991
Cast bronze with patina
20.5 x 18 x 2 in.
Collection of the artist
Photo: Dennis Barna
p. 48

Tempest, 1991
Cast bronze with patina
41 x 144 x 2.5 in. total, 41 x 15 x 1.5 in.
each, 9 units in 1 row
Courtesy Galerie Academia, Salzburg
Photo: Dennis Barna
p. 49

Iron Return, 1991
Cast Iron, oxidised
60 x 336 x 2 in. total, 60 x 21 x 2 in. each,
14 units in 1 row
Courtesy Galerie Lelong, New York
Photo: Dennis Barna
p. 51

Mercury, 1992
Fibreglass, lead

total 10.5 x 70 x 1 in., 10.5 x 4 x 1" each,
14 units in 1 row
Private Collection
Photo: John Riddy
p. 50

Union Two, 1992
Cast bronze with patina
81 x 40 x 5 in.
Courtesy Galerie Karsten Greve, Paris
Photo: Dennis Barna
p. 52

Johnstown, 1992
Cast iron, oxidised and cast bronze with patina
17 x 19 x 2.5 in.
Courtesy Galleri Weinberger, Copenhagen
Photo: Dennis Barna
p. 53

At Odds, 1992
Cast iron, oxidised and cast bronze with
patina, 22 units in 2 rows
Courtesy Annely Juda Fine Art, London
Photo: Dennis Barna
p. 54

Kentallen of Appin, 1992
Cast bronze with patina
16.5 x 16.5 x 3 in.
Courtesy Galerie Jamileh Weber, Zürich
Photo: John Riddy
p. 55

Ore, 1992
Fibreglass resin, cast iron, oxidised
10.5 x 86 x 2 in. total, 10.5 x 5.5 x 2 in.
each, 10 units in 1 row
Private Collection
Photo: Dennis Barna
p. 56

Gift (Lead, Copper), 1993
Fiberglass resin, cast copper, cast lead
31 x 89 x 1.5 in. total, 15 x 3 x 1.5 in. each,
26 units in 2 rows
Courtesy Gallery Mizuma, Tokyo
Photo: Dennis Barna
p. 57

Other Voices, 1993
Cast aluminium, copper, bronze, iron
100 x 141 x 2 in. total, 22.5 x 6 x 2 in. each,
64 units in 4 rows
Collection of the artist
Photo: Dennis Barna
pp. 58-59

Tar Baby, 1993
Cast glass, cast lead
13.5 x 110 x 1 in. total, 13.5 x 4.5 x 1 in.
each, 15 units in 1 row
Courtesy Galerie Academia, Salzburg
Photo: Dennis Barna
p. 60

Red Wait, 1993
Cast bronze with patina
82 x 38 x 5 in.
Collection of the artist
Photo: Dennis Barna
p. 61

Lead Depending, 1993
Cast lead and rope
14 x 225 x 1 in. total, 14 x 5 x 1 in. each,
30 units in 1 row
Private Collection
Photo: Catherine Lee
pp. 62–63

Sleat, 1993
Cast bronze with patina
11 x 7.5 x 2 in.
Private Collection
Photo: Dennis Barna
p. 64

Questa, 1993
Cast bronze with patina
17 x 12 x 2 in.
Courtesy Gallery Mizuma, Tokyo
Photo: Dennis Barna
p. 65

Wicklow, 1994
Cast bronze with patina
15.5 x 9.5 x 3 in.
Private Collection
Photo: Dennis Barna
p. 66

Verona, 1994
Cast bronze with patina
20.5 x 9 x 2.5 in.
Courtesy Galerie Karsten Greve, Cologne
Photo: Lori Lynn
p. 67

Valentine, 1995
Glazed raku ceramic
54 x 236 x 1 in. total, 15 x 5 x 1 in. each,
90 units in 3 rows
Private Collection
Photo: Ray Ballheim
pp. 68–69

Harbour, 1995
Glazed raku ceramic
8 x 3.5 x 1 in.
Courtesy Galerie Karsten Greve, Milano
Photo: Dennis Barna
p. 70

Dayfire, 1995
Cast bronze with patina
10 x 59 x 1 in. total, 10 x 5 x 1 in. each,
10 units in 1 row
Private Collection
Photo: Dennis Barna
p. 71

Cupric, 1995
Cast copper with patina
23 x 148 x 2 in. total, 23 x 6 x 2 in. each,
16 units in 1 row
There are no other authorised works
employing this form
Private Collection
Photo: Dennis Barna
p. 71

Lilies, 1995
Cast glass and cast bronze with patina
11 x 140 x 1 in. total, 11 x 3.5 x 1 in. each,
22 units in 1 row
Private Collection
Photo: Dennis Barna
p. 73

The Blanco, 1995
Glazed raku ceramic
17 x 3.5 x 1 in.
Private Collection
Photo: Lori Lynn
p. 74

Bracken, 1996
Glazed raku ceramic
20 x 12 x 2 in.
Private Collection
Catherine Lee
p. 75

Bronze Plummets, 1996
Cast bronze with patina
89 x 102 x 2.5 in. total, 27 x 16.5 x 2.5 in.
each, 15 units in 3 rows
Courtesy Galeria Carles Taché, Barcelona
Photo: Dennis Barna
p. 76

Forebearance, 1996
Glazed raku ceramic
23 x 16.5 x 2.5 in.
Courtesy Galerie Lelong, New York
Photo: Dennis Barna
p. 77

Wishes, 1996
Glazed raku ceramic
total 12 x 148 x 1 in., 12 x 3.5.1 in.,
30 units in 1 row
Private Collection
Photo: Dennis Barna
pp. 78–79

Granted Wishes, 1997
Glazed raku ceramic
92 x 270 x 1 in. total, 18 x 8 x 1 in. each,
84 units in 4 row
Courtesy Galerie Karsten Greve, Cologne
Photo: Dennis Barna
pp. 86–87

Ixtlán del Rio, 1997
Cast bronze with patina

19.5 x 16 x 2 in.
Courtesy Galeria Carles Taché, Barcelona
Photo: Dennis Barna
p. 88

Ghent, 1997
Cast bronze with patina
16.5 x 8.5 x 2 in.
Private Collection
Photo: Dennis Barna
p. 89

Cape Fear, 1997
Cast bronze with patina
23 x 15 x 2 in.
Courtesy Galerie Lelong, New York
Photo: Dennis Barna
p. 90

Henderson's Swamp, 1997
Cast bronze with patina
19.5 x 14.5 x 2 in.
Private Collection
Photo: Dennis Barna
p. 91

Kilkenny, 1998
Cast bronze with patina
16.5 x 15.5 x 3 in.
Courtesy Galleri Weinberger, Copenhagen
Photo: Dennis Barna
p. 94

Travelers, 1998
Encausic on laminated paper
9.5 x 53 x 1.5 in. total, 9.5 x 4 x 1.5 in.
each, 10 units in 1 row
Courtesy Galerie Jamileh Weber, Zürich
Photo: Dennis Barna
p. 95

Waxen Minds 4, 1998
Encausic on laminated paper
14.5 x 6 x 1.5 in.
Courtesy Galerie Jamileh Weber, Zürich
Photo: Dennis Barna
p. 96

The Sea The Sea, 1998
Cast bronze with patina
9 x 156 x 1.5 in. total, 9 x 4.5 x 1.5 in. each,
30 units in 1 row
Courtesy Galerie Academia, Salzburg
Photo: Dennis Barna
p. 97

Waxen Minds Twelve, 1998
Encaustic on laminated paper
14.5 x 8 x 1.5 in.
Courtesy Galerie Jamileh Weber, Zürich
Photo: Dennis Barna
p. 99

Voyagers, 1998
Encaustic on laminated paper

total 7.5 x 49 x 1.5 in. total, 7.5 x 4 x 1.5 in.,
10 units in 1 row
Private Collection
Photo: Dennis Barna
pp. 100–101

Sentinels, 1999
Cast bronze with patina, stainless steel bases
96 x 550 x 8 in. total, 96 x 45 x 8 in. each
Courtesy Galerie Lelong, New York
Photo: Eduard Heuber
p. 102

Sentinel VIII, 1999
Cast bronze with patina, stainless steel base
96 x 45 x 8 in.
Collection of the Irish Museum of Modern Art
Photo: Dennis Barna
p. 103

Wooden Sentinels, 1999
Latex paint on wood
96 x 550 x 8 in. total, 96 x 45 x 8 in. each
Courtesy Galerie Lelong, New York
Photo: Zindman/Fremont, New York
p. 107

New Orleans, 1999
Cast bronze with patina
19 x 11.5 x 3 in.
Private Collection
Photo: Dennis Barna
p. 108

Martindale, 1999
Cast bronze with patina
16 x 16 x 3 in.
Courtesy Galerie Academia, Salzburg
Photo: Dennis Barna
p. 109

Laredo, 1999
Cast bronze with patina
19.5 x 13.5 x 3 in.
Courtesy Galerie Jamileh Weber, Zürich
Photo: Dennis Barna
p. 110

Vox, 1999
Cast bronze with patina
34 x 64 x .5 in. total, 7 x 3 x .5 in.
16 units in 4 rows
Courtesy Galerie Lelong, New York
Photo: Dennis Barna
p. 111

Highwire, 2000
Glazed raku ceramic
7 x 3 x 1 in.
Private Collection
Photo: Dennis Barna
p. 112

Intransigence, 2000
Glazed raku ceramic, nails

9 x 3 x 1 in.
Collection of the artist
Photo: Dennis Barna
p. 113

Ice, 2000
Glazed raku ceramic
92 x 270 x 1 in. total, 18 x 9 x 1 in. each,
84 unique units in 4 rows
Courtesy Galerie Lelong, New York
Photo: Dennis Barna
pp. 120, 121

Raku Amends, 2000
Glazed raku ceramic
92 x 270 x 1 in. total, 18 x 9 x 1 in. each,
84 units in 4 rows
Courtesy Galerie Karsten Greve, Milano
Photo: Dennis Barna
pp. 122, 123

Up, 2000
Glazed raku ceramic
total 18 x 106 x 1 in.
8 units in 1 row
Courtesy Galerie Karsten Greve, Cologne
Photo: Dennis Barna
p. 125

Sibylla, Sibyls series, 2000
Fabricated bronze with patination
60 x 32 x 30 in.
Courtesy Galerie Karsten Greve, Cologne
Photo: Dennis Barna
pp. 114, 115

Delphica, Sibyls series, 2000
Fabricated bronze with patination
60 x 30 x 34 in.
Courtesy Galerie Karsten Greve, Cologne
Photo: Dennis Barna
pp. 116, 117

Libica, Sibyls series, 2001
Fabricated bronze with patination
60 x 36 x 36 in.
Courtesy Galerie Karsten Greve, Cologne
Photo: Dennis Barna
pp. 118, 119

Wayfarers, 1998-2001
Encaustic on laminated paper
10 x 53 x 1.5 in. total, 10 x 4 x 1.5 in. each,
10 units in 1 row
Courtesy Galerie Jamileh Weber, Zürich
Photo: Dennis Barna
p. 129

Frieze, 2000–2003
Glazed ceramic raku, nails
18 x 41 x 1 in. total, 18 x 4.5 x 1 in. each,
7 units in 1 row
Courtesy Galleri Weinberger, Copenhagen
Photo: Dennis Barna
p. 135

Ferro, 2001-2003
Cast iron, oxidised
23 x 86 x 2.5 in. total, 23 x 8 x 2.5 in. each,
9 units in 1 row
Courtesy Galeria Carles Taché, Barcelona
pp. 130–131

Cubic Celadon, 2003
Glazed raku ceramic, nails
13 x 12 x 5 in.
Private Collection
Photo: Dennis Barna
pp. 132, 133

Red River, 2003
Cast bronze with patina
21.5 x 12 x 1.5 in.
Courtesy Galerie Karsten Greve,
Cologne
Photo: Dennis Barna
p. 134

Ashen Cubic, 2003
Glazed raku ceramic, nails
10 x 10 x 10 in.
Private Collection
Photo: Dennis Barna
p. 136

Quoque, 2003
Cast bronze with patina
15.5 x 12 x 3 in.
Courtesy Galerie Lelong, New York
Photo: Lori Lynn
p. 140

Urn, 2003
Cast bronze with patina
19.25 x 8.75 x 9.5 in., edition #3 of 3
Private Collection
Photo: Lori Lynn
p. 137

Scarista, Hebrides series, 2003
Fabricated bronze with patina
93 x 48 x 37 in.
Courtesy Galerie Lelong, New York
Photo: Dennis Barna
pp. 33, 84

Clach an Trushal, Hebrides series, 2003
Fabricated bronze with patina
96 x 59 x 34 in.
Courtesy Galerie Lelong, New York
Photo: Dennis Barna
p. 155

Lewis, Hebrides series, 2003
Fabricated bronze with patina
102 x 50 x 37 in.
Courtesy Galerie Lelong, New York
Photo: Dennis Barna
pp. 160

Harris, Hebrides series, 2003

Fabricated bronze with patina
102 x 48 x 39 in.
Courtesy Galerie Lelong, New York
Photo: Dennis Barna
pp. 156

Shards, 1989–2004
Glazed raku ceramic, cast bronze with patina
57 x 72 x 1.5 total, 12 x 12 x 1.5 in. each,
20 units in 4 rows
Courtesy Galerie Lelong, New York
Photo: Dennis Barna
p. 139

Mask, 2004
Glazed raku ceramic
13.5 x 8.5 x 1 in.
Courtesy Galleri Weinberger, Copenhagen
Photo: Lori Lynn
p. 141

Copper Mount, 2004
Cast bronze with patina
17 x 11 x 10 in., edition #1 of 3
Courtesy Galerie Lelong, New York
Photo: Lori Lynn
p. 138

Loft, 2000–2004
Glazed raku ceramic, nails
13.5 x 8 x 1 in.
Courtesy Galleri Weinberger,
Copenhagen
Photo: Lori Lynn
p. 142

July, 1995–2004
Glazed raku ceramic
15 x 9.5 x 1 in.
Courtesy Galleri Weinberger,
Copenhagen
Photo: Lori Lynn
p. 143

Strung Porcelain, 2004
Raku fired glazed porcelain, copper wire
5 x 26 x .5 in. total, 5 x 2.5 x .5 in. each,
9 units in 1 row
Courtesy Galleri Weinberger, Copenhagen
Photo: Lori Lynn
p. 145

20 After, 2004
Cast bronze with patina
9.5 x 92 x 1 in. total, 9.5 x 4 x 1 in. each,
20 units in 1 row
Courtesy Galleri Weinberger, Copenhagen
Photo: Lori Lynn
pp. 146–147

Archaic Figures, 2004
Glazed raku ceramic
9 x 35 x 1.5 in. total, 9 x 3 x 1.5 in. each,
8 units in 1 row
Courtesy Galerie Lelong, New York

Photo: Lori Lynn
p. 149

To Alabama, 2002–2004
Glazed raku ceramic & copper wire
107 x 292 x 1 in. total, 15.25 x 7 x 1 in.
each, 110 units in 5 rows
Courtesy Galerie Lelong, New York
Photo: Dennis Barna
pp. 151, 152

Calanais, Hebrides series, 2004
Fabricated bronze with patina
95 x 67 x 49 in.
Courtesy Galerie Lelong, New York
Photo: Dennis Barna
pp. 33, 158, 159

Scalpay, Hebrides series, 2004
Fabricated bronze with patina
97.5 x 65 x 50 in.
Courtesy Galerie Lelong, New York
Photo: Dennis Barna
pp. 160, 161

Stornoway, Hebrides series, 2004
Fabricated bronze with patina
100 x 55 x 65 in.
Courtesy Galerie Lelong, New York
Photo: Dennis Barna
p. 30, 156

Red Cubic Copper. 2005
Glazed raku ceramic, nails
15.5 x 12 x 13 in.
Courtesy Galleri Weinberger, Copenhagen
Photo: John Dyer
pp. 162, 163

Cast bronze or other metals, fiberglass resin
or glass works cast at Lock Bund Studio,
Oxfordshire.
All fabricated bronze sculptures were
welded by Joey Manson and Matt West.
All encaustic works on laminated pater
were created by the artist at Garner Tullis
Workshop, NY.

Appendix

Portrait of Catherine Lee by John Jonas Gruen

Selected Biography

Born in Pampa, Texas, 1950.
She lives and works in New York and Texas.

Solo Exhibitions

1980
P.S. 1, The Institute for Art and Urban Resources, New York City

1983
The University of Texas Art Gallery, San Antonio, TX

1984
John Davis Gallery, Akron, OH

1985
Gallery Bellman, New York City
John Davis Gallery, Akron, OH

1986
John Davis Gallery, New York City

1987
John Davis Gallery, New York City

1988
Michael Maloney Gallery, Santa Monica, CA

1989
Annely Juda Fine Art, London
Thomas Segal Gallery, Boston

1990
Marisa del Re Gallery, New York City
Galerie Karsten Greve, Paris
Gallery Kasahara, Osaka
Stephen Wirtz Gallery, San Francisco

1991
Galerie Jamileh Weber, Zürich
Galerie Karsten Greve, Köln, Germany
Kohji Ogura Gallery, Nagoya, Japan

1992
Städtische Galerie im Lenbachhaus, Munich
Neue Galerie der Stadt Linz, Linz, Austria
Galleri Weinberger, København, Denmark
Galerie Academia, Salzburg

1993
Galerie Lelong, New York City
Annely Juda Fine Art, London
Limestone Press, San Francisco

1994
Hill Gallery, Birmingham, MI

1995
Galerie Karsten Greve, Paris
Galleri Weinberger, København, Denmark
Galerie Lelong, New York City
Galerie Karsten Greve, Köln, Germany
Mizuma Gallery, Tokyo

1996
Galerie Academia, Salzburg
Galerie Jamileh Weber, Zürich
Artpace, A Foundation for Contemporary Art, San Antonio, TX

1997
Sonoma State University Art Gallery, Sonoma, CA
Galleria Karsten Greve, Milan

1998
Bemis Art Foundation, Omaha, NE
Galerie Karsten Greve, Köln, Germany
Galleri Weinberger, København, Denmark

1999
San Diego State University Art Gallery, San Diego
Galerie Lelong, New York City
Lafayette College, Easton, PA

2000
Lyman-Allen Art Museum, New London, CT
Galerie Academia, Salzburg
Galeria Carles Taché, Barcelona

2001
Galerie Karsten Greve, Milan

2002
Galleri Weinberger, København, Denmark

2003
Galerie Karsten Greve, Paris
Galerie Jamileh Weber, Zürich

2004
Galerie Lelong, New York City
Southwest School of Art and Craft, San Antonio, TX

2005
Irish Museum of Modern Art, Dublin
Musée de Arte Moderne, St. Etienne
Galerie Karsten Greve, Köln, Germany
Galleri Weinberger, København, Denmark

Selected Group Exhibitions

1979
New Wave Painting, curated by Per Haubro Jensen, The Clocktower, New York City
Fourteen Painters, Lehman College, CUNY, New York City

1980
Mind Set, John Weber Gallery, New York City
Contemporary Works, curated by Sam Hunter, Princeton University Museum, Princeton, NJ

1981
CAPS at the State Museum, New York State Museum, Albany, NY
Arabia Felix, curated by William Zimmer, Art Galaxy, New York City
New Directions, curated by Sam Hunter, travelling exhibition: The Museum of Art, Ft. Lauderdale, FL; Oklahoma Museum of Art, Oklahoma City; Santa Barbara Museum of Art, Santa Barbara, CA; Grand Rapids Art Museum, Grand Rapids, MI; Madison Art Center, Madison, WI; Montgomery Museum of Fine Art, Montgomery, AL

1982
Critical Perspectives, curated by Joseph Masheck, P.S. 1, The Institute for Art and Urban Resources, New York City
Group Invitational, Sunne Savage Gallery, Boston
Pair Group, curated by William Zimmer, Jersey City Museum of Art, Jersey City, NJ
Pastiche, Emily Harvey Gallery, New York City

1983
New Acquisitions, Franklin Furnace, New York City
All Over Painting, Grommet Gallery, New York City
MCAD Faculty Show, Minneapolis College of Art & Design, Institute of Art, Minneapolis, MN
Third Anniversary Exhibition, John Davis Gallery, Akron, OH
Contemporary Abstract Painting, Muhlenberg College Center for the Arts, Allentown, PA
Multiples, Jack Tilton Gallery, New York City

1984
Exhibition of Contemporary Art, Merrill Lynch Pierce Fenner & Smith, Inc., Akron, OH
Contemporary Art, National City Bank, Cleveland, OH
Fifteen Abstract Painters, curated by Per Haubro Jensen, Susan Montezinos Gallery, Philadelphia

Small Works: New Abstract Painting,
Lafayette College, Easton, PA
Fourth Anniversary Exhibition, John Davis
Gallery, Akron, OH
Acquisition Priorities, curated by Laurie
Rubin, William Beadleston Gallery,
New York City
Summer Group Show, Gallery Bellman,
New York City

1985
The Non-Objective World–1985, curated by
Stephen Westfall, Kamikaze, New York City
An Invitational, curated by Tiffany Bell,
Condeso-Lawler Gallery, New York City
Fifth Anniversary Exhibition, John Davis
Gallery, Akron, OH

1986
Inaugural Exhibition, John Davis Gallery,
New York City
Catherine Lee and Sean Scully, Paul Cava
Gallery, Philadelphia
Past and Present, curated by Steven
Reynolds, The University of Texas Art
Gallery, San Antonio, TX
Gallery Artists, John Davis Gallery,
New York City
Invitational, Saxon Lee Gallery, Los Angeles
Works on Paper, Althea Viafora Gallery,
New York City
Art on Paper, Weatherspoon Art Gallery,
University of North Carolina, Greensboro
24 x 24, Ruth Siegel Gallery, New York City
The Constructed Image, Laurie Rubin
Gallery, New York City

1987
Lee, Lewczuk, Witek, Pamela Auchincloss
Gallery, Santa Barbara, CA
*5 Abstract Artists: Amar, Gitlin, Glick, Lee,
Wiley*, Michael Maloney Gallery, Santa
Monica, CA
Gallery Artists, John Davis Gallery,
New York City
*Monotypes from the Garner Tullis
Workshop*, Laurie Rubin Gallery,
New York City
Art Against AIDS, Rosa Esman Gallery,
New York City
Drawn Out, Kansas City Art Institute
Black in the Light, Genovese Graphics,
Boston
Selected Works, Albright-Knox Museum,
Buffalo, NY

1988
Ten Americans, curated by John Caldwell,
Museum of Art, Carnegie Institute,
Pittsburgh
Collaborations in Monotype, curated by

Phyllis Plous, travelling exhibition:
University Art Museum, Santa Barbara, CA;
Huntington Gallery, University of Texas,
Austin, TX; Cleveland Museum of Art,
Cleveland, OH
Works from the Garner Tullis Workshop,
Thomas Segal Gallery, Boston
*Works on Paper: Selections from the Garner
Tullis Workshop*, Pamela Auchincloss
Gallery, New York City
Seven American Abstract Artists, Ruggiero-
Henis Gallery, New York City
40th Annual Academy Institute Exhibition,
American Academy and Institute of Arts
and Letters, New York City
Works on Paper Invitational, Shea & Beker
Gallery, New York City
Works on Paper, Ruggiero-Henis Gallery,
New York City

1989
Sitings: Drawing with Color, travelling
exhibition: Instituto de Estudios
Norteamericanos, Barcelona; Casa Revilla,
Valladolid, Spain; Museo Barjola, Gijon,
Spain; Calouste Gulbenkian Foundation,
Lisbon; Pratt Manhattan Gallery, New York
City; Schafler Gallery, Pratt Institute,
New York City
*Monotypes from the Garner Tullis
Workshop*, Zolla-Lieberman Gallery, Chicago
Small Paintings, Nina Freudenheim Gallery,
Boston
*Monotypes from the Garner Tullis
Workshop*, Persons-Lindell Gallery, Helsinki
Drawings, Stephen Wirtz Gallery,
San Francisco
Geometry and Abstraction, curated by
Pamela Auchincloss, Persons-Lindell Gallery,
Helsinki
Recent Acquisitions, Prints and Monotypes,
The Tate Gallery, London
18th International Biennale of Graphic Art,
International Centre of Graphic Art,
Ljubljana, Yugoslavia

1990
*Monotypes from the Garner Tullis
Workshop*, Malmgran Gallery, Göteborg,
Sweden
Inaugural Exhibition, Stephen Wirtz Gallery,
San Francisco
Minimal Sculpture, Marisa del Re Gallery,
New York City
Artists in the Abstract, curated by John
Davis, Weatherspoon Art Gallery, University
of North Carolina, Greensboro

1991
Drawings, Pamela Auchincloss Gallery,
New York City

Group Exhibition, Marisa del Re Gallery,
New York City
*Contemporary Sculpture from the
Weatherspoon Collection*, Weatherspoon
Art Gallery, University of North Carolina,
Greensboro
Catherine Lee Monotypes, Pamela
Auchincloss Gallery, New York City
IIIème Biennale de Sculpture, Monte Carlo,
Monaco
Art for Children's Survival, Unicef, Lawrence
Monk Gallery, New York City

1992
*Geteilte Bilder, Das Diptychon in der neuen
Kunst*, Museum Folkwang, Essen, Germany
Reliefs, Konstructive Tendens, Stockholm
*Monotypes from the Garner Tullis
Collection*, Carpenter Center for the Visual
Arts, Harvard University, Cambridge, MA
Women Critics, Bruton Street Gallery, London
Juxtapositions, Annely Juda Fine Art, London

1993
Italia - America, L'astrazione Ridefinita,
Galleria Nazionale d'Arte Moderna, Republic
of San Marino
Couples, Annely Juda Fine Art, London
Art on Paper, The Weatherspoon Art Gallery,
University of North Carolina, Greensboro
Transcending Boundaries, curated by
Cynthia Gallagher and Arthur Williams,
92nd Street Y, New York City
Garner Tullis Workshop, Jan Weiner Gallery,
Kansas City
Contemporary Prints, Ten Years of Acquisitions,
Cleveland Museum of Art, Cleveland
Prints from the Garner Tullis Workshop,
The Australian Print Workshop & the Darian
Knight Gallery, Fitzroy, Australia
*Drawings, 30th Anniversary Exhibition, The
Foundation for Contemporary Performance
Art*, Leo Castelli Gallery, New York City
5 One Man Shows, Galerie Jamileh Weber,
Zürich

1994
Shape, Pamela Auchincloss Gallery,
New York City
Contemporary Prints, The Tate Gallery, London
29th Annual Exhibition of Art on Paper,
Weatherspoon Art Gallery, University of
North Carolina, Greensboro
Sculpture & Drawing, Galerie Lelong,
New York City

1995
Summer Group Exhibition, Galerie Jamileh
Weber, Zürich
Group Show, Galerie Lelong, New York City
Black & White I, Galleri Weinberger,

København, Denmark
*U S Print / Grafiikkaa U S A, Garner Tullis
Workshop*, Retretti Art Center, Punkaharju,
Finland
Recent Acquisitions, Hofstra Museum, Emily
Lowe Gallery, Hempstead, New York City

1996
Jill Moser & Catherine Lee, University of
Rhode Island, Kingston, RI
Serienbilder - Bilderserien, Städtische
Galerie im Lenbachhaus, Munich

1997
Gallery Group Exhibition, Parts I & II,
Galerie Jamileh Weber, Zürich
New Editions, Galerie Lelong, New York City

1998
*Group Show: Chillida, Judd, Lee, LeWitt,
Mangold, Ryman*, Galerie Lelong,
New York City
Zeit und Materie, Baukunst, Köln, Germany
Group Exhibition, Galerie Karsten Greve, Paris

1999
Group Exhibition, Galeria Carles Taché,
Barcelona
Black & White III, Galleri Weinberger,
København, Denmark
25 Years, Galerie Jamileh Weber, Zürich
Encaustic Works, Watermark/Cargo Gallery,
Kingston, NY
*Das Gedächtnis öffnet seine Tore, die Kunst
der Gegenwart im Lenbachhaus, München*,
Städtische Galerie im Lenbachhaus, Munich
*Collaborative Papers: Contemporary Works
of Art from the Garner Tullis Workshop*,
Maier Museum of Art, Lynchburg, VA
Some New York Artists, BGH Gallery,
Los Angeles

2000
New Works, Galerie Jamileh Weber, Zürich

2001
Minimalism, Past and Present, Galerie
Lelong, New York City
X Biennial Visual Arts Faculty Exhibition,
The University of Texas Art Gallery,
San Antonio, TX
20 Years of Collaboration, Garner Tullis
Workshop, New York City

2002
2300F - 2002, curated by Kathleen Whitney,
Grounds For Sculpture, the Johnson Atelier,
Mercerville, NJ

2003
Shift, Galerie Lelong, New York City

Design
Gabriele Nason

Editorial Coordination
Emanuela Belloni
with Filomena Moscatelli

Editing
Emily Ligniti

Translation
Jutta Breathnach

Copywriting and Press Office
Silvia Palombi Arte&Mostre, Milano

Web Design and Online Promotion
Barbara Bonacina

Cover
Stornoway, Hebrides series, 2004

Back Cover
Scalpay, Hebrides series, 2004

Photo credits
Ray Ballheim
Dennis Barna
Stephanie Joson
John Dyer
Manfred Förster
John Jonas Gruen
Eduard Heuber
Lori Lynn
Parker Noon
John Riddy

We apologize if, due to reasons wholly beyond our control, some of the photo sources have not been listed.

Irish Museum of Modern Art/
Áras Nua-Ealaíne Na hÉireann
Royal Hospital, Military Road,
Kilmainham, Dublin 8
Tel. + 353-1612 9900
Fax + 353-1-612 9999
e-mail: info@imma.ie
www.imma.ie

Edizioni Charta
via della Moscova, 27
20121 Milano
Tel. +39-026598098/026598200
Fax +39-026598577
e-mail: edcharta@tin.it
www.chartaartbooks.it

Printed in Italy

Observer, London, 21 March 1993
Gill Saunders, "Sculpture with it's Back to the Wall", *Women's Art Magazine*, London, May 1993
Enrique Juncosa, "Catherine Lee", *Lapiz*, Madrid, May 1993
Catherine Lee, pub. Galerie Academia, Salzburg 1993 (catalogue)
Hoervy Brock, "Catherine Lee", *Art News*, New York, summer 1993
"Catherine Lee", *The Print Collector's Newsletter*, July–August 1993
Danile Kurjakovic, "Frischer Wind von Westen", *Zürichsee-Zeitung*, 11 September 1993
Demetrio Paparoni, "The Self-Regulation of the System", *Italia-America, L'Astrazione Ridefinita*, Galleria Nazionale d'Arte Moderna, Republic of San Marino, 1993 (catalogue)
Carla Steininger, "Back to the Elementary Prerequisites of Art", *Salzburger Nachrichten*, 15 April 1993
Partners, pub. Annely Juda Fine Art, London 1993 (catalogue)
David Carrier, "Italia-America", *Segno*, Pescara, Italy, summer 1993
Arturo Schwartz, "Una Mostra da Non Perdere", *Segno*, summer 1993
Angelo Trimarco, "Italia-America", *Tema Celeste*, autumn 1993
Hans W. Langwallner, "Ex Nihilo. Day and Night", *Nike*, Munich, August 1993
"Prints and Photographs", *The Print Collector's Newsletter*, July–August 1993
Faye Hirsch, "Catherine Lee at Galerie Lelong", *Art in America*, September 1993
Judith Trepp, "Zurich, 5 One man Shows", *Art News*, January 1994
"La Differenzia Tra i Sesi Nell'Arte", *Tema Celeste*, winter 1994
Marsha Miro, "Painting and Sculpture", *Detroit Free Press*, 11 March 1994
David Carrier, "Studio: Catherine Lee", *Sculpture*, November 1994
Eva Pohl, "Infinity in Perspective", *Berlingske Tidende*, 20 January 1995
Oystein Hjort, "Between Sculpture and Painting", *Politiken*, København, Denmark, 3 February 1995
Marjaana Toiminen, "Retretin Kesa: U. S. Print", *Grafiikanlehti*, 23 May 1995
Helmut Friedel, *Color is Indeed a Body*, pub. Mizuma Gallery, Tokyo, 1995 (catalogue)
"Catherine Lee", *Sankei*, Tokyo, 31 December 1995
Eleanor Rait, *Recent Acquisitions 1991–1995*, pub. Hofstra Museum, 1995 (catalogue)
Alicia Faxon, "Figuration Forward", *Art New England*, June–July 1996
Pepe Karmel, *The New York Times*, 5 January

1996
Wolfgang Richter, "Im Dialog der Elemente das Maß feiner Poesie", *Salzburger Nachrichten*, 18 April 1996
Dan R. Goddard, *San Antonio Express-News*, 28 April 1996
Catherine Lee, Galerie Academia, Salzburg 1996 (catalogue)
Geijutsu Shincho, edition no. 2, Tokyo, 1996
Carter Ratcliff, "The Art of Catherine Lee", *Catherine Lee: the Alphabet Series*, pub. Pamela Auchincloss, New York City, 1997 (catalogue, 1st edition)
Faye Hirsch, "Placing Memory: Catherine Lee's Alphabet's Series", *Catherine Lee: the Alphabet Series*, pub. Pamela Auchincloss, New York City, 1997 (catalogue, 1st edition)
Sandy Thompson, "Catherine Lee", *Artweek*, January 1998
Von Renate Roos, "Die Zeit steht heir still", *Kolner Stadt-Anzelger*, 7–8 February 1998
Dan O'Kane, "Catherine Lee from A to Z", *The Reader*, 5 March 1998
Gallery Kasahara 1972–1997, pub. Galerie Kasahara, Osaka, 1998 (catalogue)
Kyle MacMillan, "Artistry in Bronze", *Sunday World Herald*, 5 April 1998
Jurgen Raap, "Catherine Lee", *Kunstforum, International*, April–June 1998
Elena Di Raddo, "Catherine Lee", *Tema Celeste*, March–April 1998
Gudrun Schmidt-Esters, "Steinzeitliche Grube", *Keramic Magazin*, April 1998
Catherine Lee, "The Making of the Thing", *Tema Celeste*, October–December 1998
Graham Shearing, "Collaboration", *Pittsburgh Tribune-Review*, 1 November 1998
David Carrier, *Garner Tullis and the Art of Collaboration*, pub. GTW Press, 1998
Robert C. Morgan, "Catherine Lee: Sentinels", *Review*, September 1999
Kenneth J. Endick, "Elemental Art", *Express-Times*, Easton, PA, 24 September 1999
Helmut Friedel and Ulrich Wilmes, *Das Gedächt öffnet seine Tore; die Kunst der Gegenwart im Lehbachhaus München*, pub. Hatje Cantz Verlag, 1999 (catalogue)
Carter Ratcliff, "The Art of Catherine Lee", *Catherine Lee: the Alphabet Series*, pub. University of Washington Press, New York City, 1999 (catalogue, 2nd edition)
Faye Hirsch, "Placing Memory: Catherine Lee's Alphabet's Series", *Catherine Lee: the Alphabet Series*, pub. University of Washington Press, New York City, 1999 (catalogue, 2nd edition)
Hearne Pardee, "New York Reviews: Catherine Lee", *ArtNews*, October 1999
Lance Esplund, "The More the Merrier", *Modern Painters*, winter 1999
Johnathan Goodman, "Catherine Lee",

Sculpture Magazine, January 2000
Enrique Juncosa, "Choreography and Metal", *Catherine Lee*, Galeria Carles Tache, Barcelona, 2000 (catalogue)
Lily Wei, "Catherine Lee", *Tema Celeste*, February 2000
Robert C. Morgan, *Catherine Lee*, Galerie Academia, Salzburg 2000 (catalogue)
Elizabeth Ferrer, "An Archaeology of Form: Catherine Lee", *Shards. The Work of Catherine Lee*, pub. The Southwest School of Art and Craft, 2004, San Antonio, TX (catalogue)
Francis Colpitt, "In the Realm of the Pictorial", *Shards. The Work of Catherine Lee*, pub. The Southwest School of Art and Craft, 2004, San Antonio, TX (catalogue)
Catherine Lee, "On Things of Truth and Beauty", *Shards. The Work of Catherine Lee*, pub. The Southwest School of Art and Craft, 2004, San Antonio, TX (catalogue)
Reena Jana, "Catherine Lee", *ArtNews*, November 2004
Elaine Wolfe, "Say It Again", *The San Antonio Current*, 11 November 2004
Dan R. Goddard, "Shards Recalls Remnants of Ancient Civilizations", *San Antonio Express-News*, 29 November 2004
Steve Reynolds, *Voices of Art*, December 2004
Nancy Princenthal, "Catherine Lee", *Art in America*, December 2004
Hearne Pardee, Art Circles, http://www.artcircles.org/id15.html, January 2005
Robert C. Morgan, "Catherine Lee", *Sculpture*, April 2005
Catherine Lee, Charta, Milan, 2005

Selected Public Collections

Städtische Galerie im Lenbachhaus
Museum of Modern Art, New York City
The Metropolitan Opera, New York City
Graphische Sammlung Albertina
Cleveland Museum of Art
The Tate Gallery
The San Francisco Museum of Art
Vancouver Art Gallery
Neue Galerie der Stadt Linz
Milwaulkee Art Museum
Museum of Art, Carnegie Institute
Edward R. Broida Trust
United States Department of State
State University of New York
Chemical Bank
Kröller-Mueller Museum
Phillip-Morris, Inc.
Kenan Center, Lockport, New York
IBM Corporation
Buscaglia-Castellani Art Gallery, Niagara University, New York
Weatherspoon Art Gallery, University of North Carolina
The Museum of Fine Art, Boston
Irish Museum of Modern Art, Dublin

2004
Six Visions: Contemporary Ceramics,
curated by Steve Reynolds, The University of
Texas Art Gallery, San Antonio, TX

2005
State of Texas - Clay, The University of
Texas Art Gallery, San Antonio, TX

Selected Bibliography

Hilton Kramer, *The New York Times*, 14
December 1979
John Ittner, *The New York Post*, 14
December 1979
John Russell, *The New York Times*, 19 July
1981
Sam Hunter, *New Directions*, 1981, Museum
of Art, Ft. Lauderdale (catalogue)
Robert C. Morgan, "Abstract Painting, the
New Pictorialism", *New Directions*, 1981,
Museum of Art, Ft. Lauderdale (catalogue)
Daniel Grant, *Newsday*, 28 February 1982
(photo)
Vivian Raynor, *The New York Times*, 10
October 1982
Jan Tips, *San Antonio Express News*, 1 May
1983
William Zimmer, *Catherine Lee*, University of
Texas, 1983 (catalogue)
John Russell, *The New York Times*, 11 May
1984
David Carrier, "Catherine Lee", *Arts
Magazine*, summer 1984
Contemporary Abstract Painting, Center for
the Arts, Muhlenberg College, 1983
(catalogue)
Vivian Raynor, *The New York Times*, 26 July
1985
Centennial Exhibition, MCAD, Minneapolis
Institute of Art, 1985 (catalogue)
Steven Reynolds, *Texans Past and Present*,
University of Texas, 1986 (catalogue)
John Russell, *The New York Times*, 2 May
1986
John Russell, "Bright Young Talents", *The
New York Times*, 18 May 1986
Kay Larson, *New York Magazine*, 19 May
1986
Susan Fisher, *New Art Examiner*, June 1986
Tiffany Bell, *Arts Magazine*, summer 1986
Dan Cameron, "Report from the Front", *Arts
Magazine*, summer 1986
David Carrier, *Art in America*, October 1986
Art on Paper, Weatherspoon Art Gallery,
University of North Carolina, 1986 (catalogue)
Catherine Lee, John Davis Gallery, 1986
(catalogue)
John Russell, *The New York Times*, 17 April
1987
Barry Schwabsky, *Arts Magazine*, summer
1987
Josef Woodward, *Santa Barbara News
Press*, 29 August 1987
John Caldwell, *Ten Americans*, Carnegie
Museum of Art, 1987 (catalogue)
Bill Holmsak, *Tribune Review*, Greensburg,
PA, 14 February 1988
Patricia Lowry, The Pittsburgh Press, 23
February 1988

Phyllis Plous, "Monotypes Today",
Collaborations in Monotype, University Art
Museum, University of California, Santa
Barbara, CA, 1988 (catalogue)
Cathy Curtis, *The Los Angeles Times*, 1 July
1988
Susan Tallman, "The Woodcut in the Age of
Mechanical Reproduction", *Arts Magazine*,
January 1989
Stephen Westfall, *Catherine Lee*, Annely
Juda Fine Art, 1989 (catalogue)
William Packer, *The Financial Times*, London,
21 March 1989
Mary Rose Beaumont, *Arts Review*, 24
March 1989
William Feaver, *The Observer*, London, 12
April 1989
Pamela Auchincloss, *Geometry and
Abstraction*, Persons/Lindell Gallery,
Helsinki, 1989 (catalogue)
Christine Temlin, *The Boston Globe*, 27 July
1989
Timo Valjafka, *Helsingin Sanomat*, Helsinki,
6 December 1989
Dan Sundell, *Hufvudstadsbladet*, Helsinki,
11 December 1989
Susan Tallman, *Contemporary Woodblock
Prints*, Jersey City Museum, NJ, 1989
(catalogue)
XX Century Sculptures, Galerie Academia,
Salzburg, 1990 (catalogue)
Peggy Cyphers, *Arts Magazine*, March 1990
Frances de Vuono, *Art News*, May 1990
Walter Thompson, *Art in America*, June
1990
David Carrier, *Art International*, summer
1990
Geraldine Norman, *The Independent*,
London, 24 September 1990
Height Width Length, Weatherspoon Art
Gallery, University of North Carolina, 1991
(catalogue)
IIIème Biennale de Sculpture, Monte Carlo,
1991 (catalogue)
Anne Rüegsegger, "Catherine Lee", *Artis*,
May 1991
Art for Children's Survival, Unicef, 1991
(catalogue)
Kanpo, Tokyo, November 1991 (cover
illustration)
Petra Kipphof, *Journal*, January 1992
Robert C. Morgan, "The New Endgame",
Tema Celeste, February 1992
Demetrio Paparoni, "A Conversation with
Catherine Lee", *Tema Celeste*, February
1992, English edition
Demetrio Paparoni, "Conversazione con
Catherine Lee", *Tema Celeste*, autumn 1992,
Italian edition
David Carrier, "The Life of Forms in
Catherine Lee's Art", *Outcasts, New Works*

by Catherine Lee, Städtische Galerie im
Lenbachhaus, Munich, 1992 (catalogue)
Helmut Friedel, "Catherine Lee", *Outcasts,
New Works by Catherine Lee*, Städtische
Galerie im Lenbachhaus, Munich, 1992
(catalogue)
Claudia Jaeckel, "Die Freiheit des Geistes",
Süddeutsche Zeitung, Munich; also
Ebersberg, Starnberg, Bad Tölz, 26 May
1992
Barbara Reitter, "Catherine Lee im
Lenbachhaus", *Donau-Kurier*, 22 May 1992
Gert Gliewe, "Catherine Lee im
Lenbachhaus", *Abendzeitung*, Munich,
2 June 1992
Alexander Hosch, "Archaische Mittel,
Postmoderne Kunst", 6 June 1992, appeared
in: *Rottaler Anzeiger, Grafenauer Anzeiger,
Alt-Neuöttinger Anzeiger, Deggendorfer
Zeitung, Bayerwald-Bote Regen, Passauer
Neue Presse*
Barbara Reitter, "Mit Sauer und Feuer",
Bayerische Staatszeitung, Munich,
12 June 1992
Joachim Goetz, "Der Bildgrund und die
Oberfläche", *Trostberger Tagblatt*,
19 June 1992
Maribel Koniger, "Catherine Lee", *Tema
Celeste*, autumn 1992
Catherine Lee, "The Question of Gender in
Art", *Tema Celeste*, autumn 1992
Torben Weirup, "En Amerikaner i
København", *Berlingske Tidende*,
22 November 1992
Oystein Hjort, "Forfinet Forhold til Farven",
Politiken, København, Denmark,
8 December 1992
Peter Klimitsch, "Austellung, Catherine Lee",
Kurier, Linz, Austria,
3 December 1992
Peter Moseneder, "Ausgestossen",
Nachrichten, Linz, 4 December 1992
Jacqueline Brody, *The Print Collector's
Newsletter*, July–August 1992
Catherine Lee, Galerie Academia, Salzburg
1992 (catalogue)
Sister Wendy Beckett, *Art and the Sacred*,
1992, Random Century, Sydney
Gerhard Finckh, *Geteilte Bilder - Das
Diptychon in der neuen Kunst*, Museum
Folkwang, Essen, Germany, 1992 (catalogue)
Elio Cappuccio, *Verso Bisanzio, Con
Disincanto*, Sergio Tossi Arte
Contemporanea, Prato, Italy, 1992
(catalogue)
David Carrier, "La vita delle forme nell'arte
di Catherine Lee", *Titolo*, Perugia, Italy,
autumn 1992
Catherine Lee, pub. Annely Juda Fine Art,
London 1993 (catalogue)
William Feaver, "Catherine Lee", *The Sunday*

Published on the occasion of
Catherine Lee
Irish Museum of Modern Art
22 June – 4 September 2005

Curator
Enrique Juncosa (Director)

Editor
Seán Kissane (Curator Exhibitions)

To find out more about Charta, and to learn
about our most recent publications, visit

www.chartaartbooks.it

Printed in June 2005
by Tipografia Rumor srl, Vicenza
for Edizioni Charta